PRAISE FOR

T0017584

"I am stunned that no one has written an in-depth book like *Necessary Death* before now. It is insightful, entertaining, and incredibly educational."

—**Dee Wallace,** actress *(E.T. The Extra-Terrestrial, Cujo)* and author of *Born*

"*Necessary Death* is a handbook for dealing with our most primal and ultimate fear. Grosso and Fassel pull off the amazing feat of using horror films as a way of making peace with the reality of impermanence. This is a special book."

—**Michael Imperioli,** actor, writer and musician (*The Sopranos, The White Lotus, The Perfume Burned His Eyes,* ZOPA)

"This is an absolutely unique look at not just horror movies, but mental health and wellness and how those seemingly disparate things connect. It's a must read not just for horror movie fans, but lovers of cinema in general and anyone who has ever felt alone and in need of some friendly advice. I highly recommend and love seeing a former student excel as masterfully as has Preston Fassel."

—**P.C. Cast,** author of The House of Night series

"If you've ever wondered how Leatherface's collection of human-skin masks relates to Jungian ego death, your own sense of self, and the genuine benefits of loving-kindness meditation, *Necessary Death* is 100 percent the book for you. Never before has a book about such abject horrors been filled with such warmth and

care—reading it is like sitting down with a couple of old horror-obsessed friends who are equally happy to discuss brain-eating zombies and the kind of trauma-informed self-care practices one would need to employ after, well, surviving something like brain-eating zombies. Entertaining, erudite, and all-around lovely, Grosso and Fassel's ode to the beauties of both horror film and humanity is full of hard-fought wisdom, cool trivia, and damned good advice."

—**Jeremy Robert Johnson,** author of *The Loop*

"If you thought horror was just about beasts, blood, and violence, think again. Chris Grosso and Preston Fassel take us into the depths of the genre and show us how we can use it to help grow and shape our own lives. Could it be that these monsters actually make us more . . . human? Grosso and Fassel have such insights to show you."

—**Ben Scrivens,** owner and founder of Fright Rags

"*Necessary Death* is an airy deep dive into the psychological shadow self of classic and modern horror films. Chris Grasso and Preston Fassel take the reader on a thoughtful tour and a twist in approaching our beloved genre monsters."

—**Heather Drain,** film critic and historian

"Analytical writing can often veer too far into cold, God's eye clinical observations removing the reader's ability to engage with the subject. In *Necessary Death,* Fassel and Grosso pull off a bit of otherworldly magic in bringing a deeply familiar humanity and effortlessly readable touch to life's toughest subjects. As you breeze through passages on Candyman, Pennywise, or Pinhead, before you know it, you're packing away kernels of wonderful wisdom applicable to any challenge life throws at us. As someone who often finds themselves preferring to be alone, I didn't realize how much I truly needed the chapter on Stephen King's *It* and how it

teaches us to reach out more—that being solitary can only get us so far. I found myself profoundly moved by the section in ways I wasn't prepared for."

—**Brandon Streussnig,** film critic, *Secret Handshake Cinema* podcast

"Horror wakes our inner shadow-man, that old archetype from fairy tales that haunts the psyche and reminds us that we all have one foot in the grave, that we are most alive when we tend a kinship with death . . . As the old Irish proverb goes, may you be in heaven an hour before the devil knows you're dead; horror films invite you to meet your monsters so you might stay one step ahead of them. To that end, if you're still breathing, *Necessary Death* is an essential addition to your library. Read it, and someday your ghost will thank you."

—**Danielle Dulsky,** author of *Bones & Honey: A Heathen Prayer Book, The Holy Wild: A Heathen Bible for the Untamed Woman, The Sacred Hags Oracle,* and founder of the Hag School

"*Necessary Death* doubles as a dual exploration of horror films and human psychology. Never thought you'd relate to the desperation of the mask-wearing Leatherface or get a life lesson from the troublesome shark from *Jaws?* Think again. It's a delightful (and thoughtful) read!"

—**Daniel Dockery,** author of *Monster Kids: How Pokémon Taught a Generation to Catch Them All*

"For anyone doing the work and wants to do it in the dark scared out of your wits, this book is for you. The teachings will surprise you, as will some things on the screen."

—**Damien Echols,** author of *Life After Death, High Magick,* and *Ritual.*

"*Necessary Death* dares to take on the biggest of monsters . . . horror films and the human psyche. The fact that Chris Grosso and

Preston Fassel have created a spiritual wellness narrative wherein horror film stories and plot lines are the lens for the reader to view this through is wickedly thought-provoking and its execution is masterfully spot on. They seamlessly prove that spirituality and wisdom can be found behind any veil, we just need to allow ourselves to be bold enough to pull that veil back and absorb it all. Prior to viewing any horror film from now on, I will always recall the nudge *Necessary Death* gave me to know there's always more there than just the scare!"

—**Dan Cortese,** actor and author of *Step Off!*
My Journey from Mimbo to Manhood

"Using the underlying theme of some of the horror genres most celebrated films, *Necessary Death* acts as its own form of therapy/therapist for readers. Grosso and Fassel share humbly, vulnerably, and often humorously about their own difficult life experiences. The result is a fun and engaging book that shows readers how horror movies can help their potentially bloodied and battered hearts become ones filled with more hope, healing, and how to live with a more ghoulishly serene disposition toward life."

—**Acey Slade,** musician, Joan Jett & the
Blackhearts, Dope, Murderdolls

"A terrifically important work and a wonderful read as well. Highly recommended!"

—**Ken Wilber,** author of *Finding Radical Wholeness*

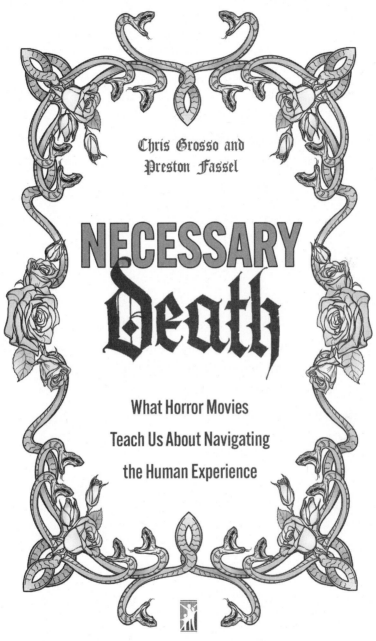

Chris Grosso and
Preston Fassel

NECESSARY Death

What Horror Movies Teach Us About Navigating the Human Experience

Health Communications, Inc.
Boca Raton, Florida

www.hcibooks.com

BOOKS BY CHRIS GROSSO

Indie Spiritualist

Everything Mind

Dead Set on Living

BOOKS BY PRESTON FASSEL

Our Lady of the Inferno

The Despicable Fantasies of Quentin Sergenov

Landis: The Story of a Real Man on 42nd Street

Beasts of 42nd Street

**Library of Congress Cataloging-in-Publication Data
is available through the Library of Congress**

© 2023 Chris Grosso and Preston Fassel

ISBN-13: 978-0-7573-2488-8 (Paperback)
ISBN-10: 07573-2488-6 (Paperback)
ISBN-13: 978-07573-2489-5 (ePub)
ISBN-10: 07573-2489-4 (ePub)

HCI, its logos, and marks are trademarks of Health Communications, Inc.

Publisher: Health Communications, Inc.
 301 Crawford Boulevard, Suite 200
 Boca Raton, FL 33432-3762

Cover, interior design, and typesetting by Larissa Hise Henoch

For my forever ride or die brother
in life and in all things horror, Justin Mehl.
I wouldn't be alive without you, dear friend.
Thank you for everything.
(P.S. Since this is for you,
I'm gonna let this slide one time, and one time only.
. . . Voorhees > Myers. Ouch, that hurt.)

—Chris Grosso

For all of those who've kept me
sane over the years.

—Preston Fassel

"Death is a stripping away of all that is not you. The secret of life is to 'die before you die' and find that there is no death."

—**Eckhart Tolle,** author of *The Power of Now*

"I think of horror films as art, as films of confrontation. Films that make you confront aspects of your own life that are difficult to face. Just because you're making a horror film doesn't mean you can't make an artful film."

—**David Cronenberg,** writer and director of *The Fly*

"Some people ask why people would go into a dark room to be scared. I say they are already scared, and they need to have that fear manipulated and massaged. I think of horror movies as the disturbed dreams of a society."

—**Wes Craven,** writer and director of *A Nightmare on Elm Street*

"Horror is like a serpent: always shedding its skin, always changing. And it will always come back. It can't be hidden away like the guilty secrets we try to keep in our subconscious."

—**Dario Argento,** writer and director of *Suspiria*

CONTENTS

FOREWORD

If you ask me, the best moment in life is the one that comes just after waking from a nightmare. That's the window of time in which your real life is slowly revealed back to you as something new and wonderful. You are not, in fact, being chased through a dark tunnel by an unseen monster or struggling to take an exam for a class you never attended or preparing to give a eulogy at a funeral while nude from the waist down. You are safe and warm in your bed, and whatever problems infest your life, they're not so bad compared to *that*.

Hi, my name is Jason Pargin, and I was once declared America's Greatest Master of Horror by *Fabricated Quote* magazine. I have a PhD in Horror Psychology from Print Your Own Degree for $39.99 University, and I have thought long and hard about why horror exists as a genre and what, exactly, audiences get out of it. I'm required to possess a thorough understanding of the subject matter as otherwise my novels might not work as intended and I'd be forced to get some kind of real job.

The answer to the central question isn't obvious on the surface—why *would* a mind wish to frighten itself? Isn't real life scary enough? From an evolutionary point of view, why would a human spend precious brainpower thinking about zombies when cancer and taxes exist? The answer, to a large degree, is that it isn't about the nightmare but rather that blissful moment after waking. "Hold on," you're probably saying, "are you implying that we seek out horror stories because they make our own dreary lives look better by comparison? That's like someone intentionally spending their spare time eating bad food and sleeping on a hard bed just so they can feel better about their home life!" To which I would reply that people do that all the time; they call it "camping."

But to be fair, there is a little more to it. The thing about humans is that we are extremely complex beings, and also, we kind of only ever want one thing: control. We are primates and tool users, and as such, our brains like to know that we have properly subdued our surroundings. A horror movie "jump scare" is thus nothing but an abrupt, uncontrolled change in our environment, something our nervous system hates so much that we'll jolt out of our seats in response to even an artificial scare viewed on a screen. This innate obsession with control creates a problem, which is that our modern, chaotic world cannot be controlled to any real degree, it simply contains too many possible bad outcomes to fit into our brains. This causes anxiety, and one way we soothe that anxiety is to spend every night and weekend getting incredibly drunk, but another, less expensive way is to have storytellers deliver to us fears that are compelling but also *harmless*. Because they are not real, they are contained, like a wild animal at the zoo. You may

not know whether the final girl is going to make it to the end of the film, but you definitely know that she wasn't real either way. No matter how much my novels scare you, in the end, you can banish all my monsters just by flinging your book or e-reader out the nearest window or into the nearest toilet. In fact, the stronger your urge to do that, the more effectively I will have done my job.

If we have, therefore, established that there is a provable psychological utility to horror, then that means even the cheapest, trashiest, sleaziest direct-to-VoD slasher movie serves a purpose. Furthermore, examining exactly *which* fears we choose to manifest and/or have manifested for our consumption tells us a great deal about who we are and what we want out of our lives. If you showed *Alien* to an actual alien, they would instantly understand in surprising detail the landscape of the modern mind; they would sense primal fears that cross eras and regions (bodily violation, forced pregnancy, unfamiliar predators in the dark) as well as some that are distinctly modern and culture-bound (anxieties over capitalism and corporate exploitation, a mistrust of technology, worries that the coworkers we depend on have secret opposing agendas, the sense that a high-tech spaceship shouldn't be damp all the time). All that, from one film.

So, if you're looking for an art form that provides a clear window into the human soul, horror cinema is as good an option as any. Maybe the creators behind *Leech Clown IV* couldn't write a detailed essay on the evolutionary psychology that makes their work resonate with audiences, but they do instinctively know what makes viewers scream and squirm in their seats (and if they're even a little competent at their jobs, they also know what makes them

PREFACE

Horror and Healing Forever

"There are two different stories in horror: internal and external. In external horror films, the evil comes from the outside, the other tribe, this thing in the darkness that we don't understand. Internal is the human heart."
—John Carpenter

I was roughly seven or eight when I began watching horror movies. It was the mid-'80s, a time that many horror fans contend was the genre's prime. I remember sleeping over at friends' houses, and we'd stay up late anticipating whatever horror movie would be on—*Friday the 13th, A Nightmare on Elm Street, Halloween, The Blob, Poltergeist*—it didn't matter if the movie was good or bad, we

just wanted to be scared and were grateful for whatever we got. I also recognize a big part of the excitement was our awareness that we were being "bad." We weren't supposed to be watching these films at such a young age, and the parents of whoever's house we were staying at of course had no idea what we were doing. So there we were, these young, "the higher the death count, the better," horror-enamored kids.

As I write this, I'm just shy of turning forty-one, and to this day, I still absolutely love horror movies. Some of you may know this already, but I have three books published to date in the mental health/spirituality/psychology fields, and while those of course were the main focus of each book, I dedicated at least one chapter in each to horror films and the impact they've had, or continue to have, in my life. That's part of the reason I'm so excited to coauthor this book with Preston Fassel, a man very much after my own heart when it comes to horror.

I believe there's so much we can learn about ourselves from horror movies. Whether the experience is joy, fear, humor, escapism, it's all relevant as far as I'm concerned. And with horror being such an "extreme" film genre, I believe that it can teach us more about ourselves than the majority of other film genres. That is, if we're willing to get uncomfortable for a bit while watching.

My childhood into teen years were relatively normal. I had a pretty solid functioning family unit. I am the first of two boys. My parents were twenty-two at the time they had me, basically kids themselves. I had no major traumas in my childhood, but after years of therapy, I've learned there were plenty of things I experienced, many of which had nothing to do with my family,

that left deep wounds and would typically be considered "minor traumas." I'd later find out these "minor traumas" left unspoken, or unexamined, were a large part of the root cause of several years of addiction to drugs and alcohol, and I nearly died several times as a result. I've been in jail cells, psychiatric hospitals, emergency rooms (even intubated at one point because I could no longer breathe on my own due to excessive drinking), detoxes, rehabs—you name it, I've been through it. The fact that I'm alive today is nothing short of a miracle, especially since I've lost so many good people in my life who've experienced half (at most) of what I have regarding drug, alcohol, and depression symptoms. As I write this, I've lost two dear people to me in less than a week, and yet life continues on.

Why bother mentioning all this? Well, first of all, hey, I'm Chris, and though we haven't met, I just shared some of the darkest, most honest, and most vulnerable things I can think of. May it garner some trust from you, dear reader. Aside from that, beginning in my early teenage years, when depression and self-cutting were a heavy part of my daily existence, I started having recurring dreams about Michael Myers trying to kill me. On one hand, that was awesome because the *Halloween* film franchise is easily my favorite, so it was like starring in my own *Halloween* movie a few times a week. This went on for several years, and while sure, it was cool in its own right, it also took a toll on me. One can only be chased to near death in their dreams so many times (unless you're in *A Nightmare on Elm Street,* in which case, you know you're screwed).

I mention these recurring dreams because I began seeing a therapist many years ago, and as we began working with the trauma

and hardships of my past, I recognized the dreams had lessons and symbology. Yes, it was a bummer that there were less *Halloween* movies starring me in my dreams, but what I learned was that Michael Myers was representing what Swiss psychologist Carl Jung called "the shadow self," which essentially refers to those parts of ourselves that we've disowned or dissociated because they are too painful to look at and deal with. The only problem is that when we suppress those unpleasant feelings and experiences, they're still there, repressed into our unconscious, reeking all kinds of havoc on our emotional well-being—and for many of us, we're completely unaware of this. That is, until we become willing to look at, explore, and reassociate/reintegrate them. At least, that was the case with me.

Michael Myers is also known as "the Shape" because he's just that, a "shadowy" force that, if he's coming after you, won't stop until one of you is dead—and yep, usually it's going to be you, not him. How Jungian of director John Carpenter.

We all have our "shapes," scars, traumas, fears, and wounds. Not a single one of us lives life without them. Sometimes seeing all the aforementioned on the big screen can help us feel that pain in a way we otherwise wouldn't. It's not that we're enjoying seeing other people dying or being hacked to pieces (well, aside from the entertainment aspect at least), but there's something deep within us that, if even just metaphorically, can relate to the pain—and often, of both the killer and the victims. I've come to learn that watching any slasher stab someone on-screen, in most cases, resonates because the loss and betrayal I've felt in my life is reminiscent of being *metaphorically* stabbed. Seeing someone running for their

life or fighting whoever the monster/villain in the film may be for their life, with all their grit, well, that's very reminiscent of all the mental health issues I, and many others like me, have struggled with. We're running or fighting for our lives in real life. Perhaps those who die on-screen fill some unfulfilled part of us that wishes to die. Now, that one may be tough to swallow. Trust me, I know. Yet I feel confident that you'd be hard-pressed to ask any laudable therapist or psychologist who, regardless of whether we're depressed, suicidal, having a run of a few bad weeks, or even feeling completely "normal," would disagree that every single human has a part within ourselves that wants to self-destruct or self-sabotage.

Kinda crazy, right? Yet at the same time, if you're willing to truly reexamine your entire life, I believe you'll find at least one occasion, if not multiple occasions, where this begins to make sense. That's part of the reason for writing a book like this—in the hopes that it can show not only the correlation of the varying unpleasantries in our everyday lives and how the horror genre can help us uncover them but also to begin work on becoming a better, more fully integrated person as a result.

As I said earlier, I *love* horror movies. Always have, always will. I've received no shortage of confused looks and head scratching for that in the mental health/spirituality genre I typically write and speak in, but my sincerest hope is that this book shows you in both a serious and playful way how horror can be just as beneficial in our spiritual, self-development, and well-being endeavors as any other book that approaches it from the more straightforward spiritual, religious, or psychological perspective.

May the pages that follow inspire you in your healing journey

PREFACE

My Love Affair with Horror

"We make up horrors to help us deal with the real ones."

—Stephen King

There was a time when I thought the story of my love affair with horror was unique. That unlike all the other boys, horror and I had something special—we hadn't locked eyes across a crowded room or gone steady in high school. We weren't Meg and Tom or Bogie and Bacall; we were Carrey and Winslet, Harold and Maude. Turns out, though, the way I became interested in horror movies isn't terribly different from the stories of so many other people my age. Turns out, horror is a promiscuous little tart. But oh, do I still love it so.

I've heard from so many other horror fans that their fascination began as revulsion; so, too, did it for me. My first exposure to horror came from the staircase scene in *Beetlejuice*. You remember—the banister is replaced by Beetlejuice in the form of a snake, and he tries to kill the Dietz family. I have no idea why—in a movie featuring hanged men, burned up bodies, and a decaying corpse as the antagonist—that one scene in particular terrified me, but, oh boy, did it ever. I loved the movie—I loved Day-O, I loved that house, I especially loved Beetlejuice himself—but every time I watched it, I cowered in fear when that snake showed up. I hid my face in the couch. I had nightmares.

But damn if I didn't keep going back to watch *Beetlejuice*.

The same went for the librarian scene at the beginning of *Ghostbusters*, though I had the VHS permanently set to begin after the *Ghostbusters* run out of the library, so I never even had to face that one down unless I got overzealous with the rewind button. My pattern of being drawn to things that disturbed me continued into kindergarten when I asked for *In a Dark, Dark Room*, a collection of scary stories for children in one of those onion-skinned Scholastic catalogs they handed out at school. If *Ghostbusters* and *Beetlejuice* disturbed my dreams, then *Room* disturbed my every waking hour. Looking back now, all the stories are very silly—some of them turn out to not even be horror stories at all but seemingly scary stories with a punch line—but the sight of the little girl with the green ribbon's head falling off scarred. Me. For. Life. (Or what seemed like life to a five-year-old). I didn't want to eat. I sure as hell didn't want to sleep. That yellow skeleton (the Ghost of John, if I recall correctly) didn't do me any favors, either. I didn't

know what I was experiencing at the time, but I've since come to recognize what happened to me as a full-blown, long-lasting panic attack. (Looking the book up while researching this book, I discovered I'm not the only 1980s baby this book traumatized. I also realize that the morbid illustrations probably had a lot to do with that. I mean, look at them. Just look at them. It kept me away from horror stories for the next two years, but when I went back, I went back big.

My third-grade teacher inexplicably had a library filled with YA horror books clearly geared toward a slightly older crowd, and I ate them up. Again, I found myself drawn to the very stuff that terrified me—I'd read a story, not be able to sleep that night, invariably have nightmares, swear never to read another scary story, and then find myself reading another one in two weeks. In an instance of patterns repeating themselves, a particularly traumatic story gave me a massive panic attack and kept me away from horror stories for a while—in this case, a classmate's unusually disturbing retelling of the Bloody Mary legend, which to this day makes me think he was either a budding psychopath or grew up to be Ryan "American Horror Story" Murphy.

At the same time I was indulging in this on-again, off-again relationship to horror stories, I was also taking part in another '80s–'90s child ritual: ogling the horror movie boxes at the video store. If you never had the opportunity to go to Schnucks' video in St. Louis, let me tell you: It was a thing of beauty. For a rental joint tacked onto the front of a grocery store, they had everything. Given the choice between Blockbuster and Schnucks, my parents inevitably chose Schnucks because they had stuff Blockbuster had

never even heard of. They had the selection of a chain store combined with the esoteric finds of a mom-and-pop, all in the safety and cleanliness of a well-lit suburban grocery store. My mom was friends with the manager, and sometimes when she had to do a big grocery trip, she'd leave me there to occupy myself so I wouldn't get bored and wander off or cause a scene. I could spend hours there between the horror movie section and the video games alone. I'd stare at the boxes, horrified but unable to look away, my mind concocting ever more warped and uncanny scenarios to explain what I was seeing. A favorite box of mine to stare at for minutes on end was the one for the Nintendo *Friday the 13th* game. I'd heard kids at school talk about Jason—an older boy had gone to a haunted pumpkin patch where someone called Jason chased you—but beyond him being some guy in a hockey mask, I had no idea who he was or what he meant. To my child's eyes, the thing on that NES box was an incomprehensible, Lovecraftian abomination, and I couldn't look away.

It was a pattern that repeated itself through middle school until the fantastic day that my parents agreed I was old enough to rent movies on my own. With a Hollywood Video card informing the clerk I was allowed to rent anything I wanted short of XXX (and good luck finding that anywhere but a truck stop in rural Oklahoma in the early 2000s), I went to the store with a mission. My mistake, I figured, had been in reading those scary stories and then not going straight back. Somehow, after reading about immunizations and inoculations, I'd gotten the idea that I could apply a similar principle to fear. I had to give myself a veritable horror overdose. By exposing myself to as many horror movies as

I could, with incremental levels of uncanniness, terror, and gore, I would never be scared again.

Damn if it didn't sorta work.

No, I don't claim to be some sort of psychopath or blowhard who's incapable of feeling fear—I still tense up in Texas traffic like any sane, rational person—but it became very difficult for a horror movie or story to scare me the way they once did. What's more, as I began to watch more and more horror movies, my fascination with them turned to full appreciation. I started to pick up the underlying social themes of movies such as *Dawn of the Dead*, with its anti-consumerist message and bleak assessment of the state of Carter-era America. I began to appreciate the gritty aesthetics of *The Texas Chainsaw Massacre*, which utilized a stripped-down, voyeuristic camera approach to put the viewer in the shoes of a passive spectator to carnage. Horror movies became art to me.

My appreciation of the horror community came later. What was important was that I'd won a great victory and that in doing so, I'd discovered that what had once been an impediment to me was now an ally, a source of joy and endless wonder. I had a friend, a voice. Thanks, horror. I know you'll never be mine, but I know it would be selfish not to want to share you. You have so much to give.

—Preston Fassel

AUTHORS' NOTE

Because they're often the product of multiple people working separately from one another with a purely financial goal, horror movies—especially horror *series*—can be incredibly confusing. Look at *Friday the 13th*—is Jason a zombie or just a homicidal mountain man or *what*? Thankfully, we wrote this book together, so navigating its chapters will be a breeze. Think of each entry as a sort of matinee double feature: in the first part, "Oh, the Horror," Preston provides a concise summary and offers a critical analysis of a given horror movie, looking at how the film explores different ideas of mental health, well-being, and self-improvement. In the second section of each chapter, "Oh, the Humanity," Chris provides his personal perspective on the film, coupled with practical, real-world exercises tied to the themes discussed in Preston's section. This way, there's no confusion, and the reader can be certain of who's discussing what in each half of the chapter; don't worry—neither of us are zombies or homicidal mountain men. Are we ready then? Great! Take a seat, and let's roll the movies.

Chapter 1

Becoming Your Best Self Isn't Just a Dream

Freddy Krueger from *A Nightmare on Elm Street*

"Every town has an Elm St."

—Freddy Krueger (*Freddy's Dead: The Final Nightmare*)

Oh, the Horror!

Coming at the tail end of the slasher wave of the late '70s and early '80s, the *A Nightmare on Elm Street* series managed to accomplish something none of the other franchises had: It became a legitimate American institution. Yes, *Friday the 13th*'s Jason Voorhees was a pop icon throughout the Reagan era, showing up on Arsenio Hall and inspiring myriad knockoff Halloween costumes, but Freddy was the monster movie your parents might actually welcome into the living room. Jason and Freddy might both have inspired tons

1

of merch, but Freddy got his own television show. (Though the writers long promised it, Jason, recall, never popped up on the ill-conceived *Friday the 13th* series.) Freddy got his own attraction at Six Flags. Freddy got *positive* critical reviews; was named one of the greatest villains of all time by the American Film Institute, *Wizard* magazine, and British television station Sky2; and, as portrayed by Robert Englund, has appeared on more covers of *FANGORIA* magazine than any other actor/character combination. Even if *Friday the 13th* ruled the box office, Freddy himself arguably ruled the hearts and minds of 1980s and early '90s horror fans as a charismatic, articulate, and genuinely frightening villain.

For all the attention that Krueger himself garners, though, it's easy to forget how little actual screen time the character receives and the unique focus given to the protagonists in the *Nightmare* films. While other horror franchises may focus on the efforts of their characters to survive and ultimately defeat the monster, the *Nightmare* films set themselves apart from the other slashers in the '70s and '80s in that their heroes had to grow, evolve, and become their best selves to defeat Freddy.

For the uninitiated, the *A Nightmare on Elm Street* series follows the 1980s' most beloved undead serial killer, Freddy Krueger, a child murderer burned to death by his victims' parents in an act of vigilante justice after he was released from jail on a technicality. Having returned from the dead as a disfigured wraith, Krueger now stalks the surviving "children" (in reality a revolving door of sexually attractive, racially and ethnically diverse twenty-somethings playing "teens") of his killers in their dreams, turning their worst fears against them and slaughtering them in elaborate

set pieces featuring complex special effects that are the hallmark of the films.

While the initial film in the series treats Krueger as a figure of nearly satanic menace and subtly implies a pedophilic motivation for his killings, the movie's fantastic box office success softens this notable character in subsequent entries to a universal monster-style broad-appeal villain who delivers James Bond-esque one liners before delivering the coup de grace, with the films themselves taking on a lighter, more action/fantasy undertone. Each film finds Krueger targeting an ever-broadening circle of "Elm Street Children" (while in the first movie Krueger only seeks to kill the kids of the people who burned him alive, later entries find him going after *every* teen in the fictional town of Springwood, Ohio). After realizing what they're up against, the heroes of each film must both band together to form a unified front against Freddy and determine a way to defeat him, which more often than not involves one-upping their tormentor in a psychological battle of wits.

Unique for an '80s horror franchise, surviving characters from earlier films often return to help subsequent heroes: Nancy Thompson, who defeats Freddy in the first film by relinquishing her fear of him and rendering him powerless over her, returns as a therapist at a sleep clinic in Part 3, aiding a cadre of teens who've been placed in psychiatric care in the belief that their dreams of Krueger are delusions born of suicidal mental illness. With Nancy's help, the teens learn to take control of their own dreams, granting themselves mystical powers that allow them to fight back against Krueger; some survivors from Part 3 crop up in Part

4 as classmates of shy, retiring Alice, herself a Krueger victim. As Krueger begins picking them off, Alice absorbs the powers they gained in the previous film until she herself is a one-woman army who takes down Freddy at the film's climax before returning as the heroine of Part 5.

A look at the "final girl sequence" of other slasher franchises demonstrates a consistent pattern. After the bulk of the cast has been killed, one or, in a few cases, a small number of survivors engage in a climactic battle with the monster. During this sequence, which finds the protagonist(s) in a sort of run-and-gun fight, they either improvise weapons from their surroundings to survive long enough that a more well-armed outsider arrives to save the day, destroy the monster themselves, or (such as in *Halloween*) some combination of the two. The shared trait here among most slasher films is that the protagonists find themselves ambushed, unprepared, and forced to react in the moment to the threat facing them; their survival is wholly dependent on their physical adeptness, speed, strength, and ability to quickly and efficiently exploit their surroundings.

This, however, is rarely—if ever—the case in the *A Nightmare on Elm Street* films. As opposed to most other slasher films, the narrative structure of the *Nightmare* series permits their characters to know from a relatively early point the exact nature of the threat against them: The kids in *Friday the 13th* and *Halloween* may have heard *stories* about Jason and Michael, but the respective antagonists whittle down their prey in such a manner as to keep them in the dark until the eleventh hour. In the *Nightmare* films, conversely, Freddy makes his explicit presence known from

the start, terrorizing multiple potential victims in such a way that they have the opportunity to band together and fight back against him; as a result, the offense against Freddy is not one of mere physical combat but of psychological warfare bolstered by the protagonists actively working to defeat him.

Consequently, the *Nightmare* protagonists must develop themselves mentally and spiritually in order to reach a point at which they are capable of defeating Freddy. In the first film, Nancy learns to let go of fear and confront Freddy face-to-face for the sniveling, predatory creep he is. In *Part 2: Freddy's Revenge,* depending on the viewer's interpretation of whether or not the film is a metaphor for coming out, Jesse must either come to grips with his own sexual identity or simply discover an inner strength he never knew he had. *Part 3: Dream Warriors* presents an evolution of the theme, making it into an actual plot point. While the previous two films featured characters developing defensive tactics against Freddy, this time, it's the Dream Warriors—Kristen, Joey, Kincaid, Taryn, and Will—who form a plan of attack and take the fight to *him.* Providing the crew with a "coach" in the form of the returning Nancy (who, in her role at the dream clinic, might as well be a proxy for a psychiatrist), they must learn to recognize, embrace, and develop their own abilities and learn how to employ them against Freddy. It's a fantastic metaphor for recognizing one's own talent, embracing it, and then learning how to develop that talent and employ it to better one's own life.

The theme of self-actualization and both realizing and rising to one's own best potential again becomes a plot point in *Part 4: The Dream Master,* which personalizes the concept of growth and

development by focalizing it through a single individual rather than a team. The viewer follows Alice on what could be described as a textbook journey of self-actualization, during which she must learn to survive and thrive without the support of her friends while simultaneously incorporating their best traits into her own person. When we first meet Alice, she's shy, retiring, and unsure of herself; when faced with trauma, she must steadily learn to adapt to the threat facing her, especially as her support system is stripped away from her person by person until she, herself, is the only person on whom she can rely. It's a powerful metaphor not only for personal growth and development but for learning self-efficacy and positive coping mechanisms—Alice rises to face the challenge of Freddy rather than retreat or sink into self-destructive behavior. Later, in *Part 5: The Dream Child*, she must go on a similar journey of self-growth and discovery, this time learning what it means to be a positive mother, in the process confronting and conquering fears about whether she herself can be a good mother—or the sort of woman who would give birth to a man like Freddy Krueger, who both literally and symbolically attempts to take the place of her own unborn child.

The role of the protagonists in the *Nightmare* films, then, is active rather than passive. Rather than live in ignorance of the threat until they have no choice but to face it, they acknowledge it and then take proactive steps to combat it. In this way, it's perhaps the most empowering of the various horror franchises in that it presents not an unstoppable threat who can only be delayed in the heat of a life-or-death battle, like a wild animal stalking the suburbs, but something more closely approximating real-world fears

that can be acknowledged and confronted head-on—and gives us protagonists to serve as models who rise to the occasion.

Although Freddy comes to represent the individual fears of each character in the *Nightmare* series, he himself is something of a metaphor for broad, adult fears in general. None of us will ever be transformed into human cockroaches or living puppets by an undead dream ghost, but we will face self-doubt and addiction and we'll fear for our job security, the safety of our children, the state of the world. Every day, a new tragedy crops up on the six o'clock news—the latest mass shooting, the latest hate rally, car attacks at crowded pedestrian locations, global pandemics that seem to act as harbingers of the end of the world. Indeed, for Gen Xers and millennials who came of age during the relative domestic peace of the '80s and '90s, the world of the 2020s seems like something of a waking nightmare. Like Freddy, these fears may seem all-consuming and insurmountable, but by recognizing them and our ability to cope with them, we can avoid giving in to fear and rather take proactive steps toward addressing those fears by becoming our best selves.

Oh, the Humanity!

On the topic of "best selves," let's take a brief segue away from the realm of fictional horrors and examine some advice from someone who survived a real-life atrocity. In the book *Man's Search for Meaning*, Austrian psychologist and Holocaust survivor Viktor Frankl wrote: "We must never forget that we may also find meaning in life, even when confronted with a hopeless situation,

when facing a fate that cannot be changed. For what then matters is to transform a personal tragedy into a triumph. To turn predicament into a human achievement. When we are no longer able to change a situation, that is when we are challenged to change ourselves." The tragically inhumane experience Frankl and millions of others suffered is virtually unimaginable and a nightmare on an entirely different level. There can be a connection made, however, between the sentiment found in Frankl's words and the *A Nightmare on Elm Street* series. In the *Nightmare* films, Freddy's victims also died tragically and inhumanely (again, honoring that the film is fiction whereas Frankl's experience was, of course, horrifically real).

Of all the films explored in this book, a decent percentage of Freddy's victims could be considered semi-lucky (at least in the short term) as they usually had a chance to learn about Freddy, why he appeared in their dreams, and potential weaknesses he may have. This provided his victims with an opportunity to look within themselves and cultivate inner strengths they didn't know they had, resulting in an actual fighting chance when facing off against Freddy and his infamously bladed, bloodstained work glove.

The characters' development of inner wherewithal is most clearly expressed in *Nightmare*'s third installment, *Dream Warriors*. Largely regarded by fans of the series as equal in quality to, if not better than, the original film (a unique occurrence for any sequel in general but especially horror, a genre known more for soulless cash-ins than quality follow-ups), this entry in the franchise focuses on a group of teenagers—Kristen, Joey, Kincaid,

Taryn, and Will—locked up in a mental institution, where, co-incidentally, Nancy Thompson just so happens to be working as an intern therapist. Unbeknownst to Freddy, Nancy—having mastered control of her own dreams following her defeat of Krueger in the first movie—begins training the teens to not only control their own dreams but also to develop their own Freddy -style dream powers by harnessing their own skills or turning weaknesses into strengths. Hothead Roland learns to channel his waking rage issues into superhuman strength; D&D fan Will becomes a sorcerer; mute Joey possesses a deafening voice capable of temporarily immobilizing Krueger; insecure Taryn becomes a punk-rock beauty who's a master knife fighter; and suicidal Kristen is able to pull other people into her own dreams to act as allies against Krueger, transforming her desire for death into a will to fight back that makes her the ultimate leader of the titular *Dream Warriors* after Freddy kills Nancy. It's only by tapping into these inner warriors that they stand a chance at surviving an encounter with Freddy; sure, while most of them die heinously, they all put up a pretty decent fight, and Freddy is ultimately defeated.

The setting of the mental institution in *Dream Warriors* is frighteningly relatable, not only because I've been in several of them myself but also because I've lived with depression, anxiety, suicidal ideations, suicide attempts, self-harm, substance abuse, and of course, all the self-loathing that comes along with that. The lack of feeling any semblance of inner strength, let alone self-love or self-respect, as clearly expressed in *Dream Warriors*, is rampant among so many of us. However, instead of taking it upon ourselves to acknowledge and work with these senses of lack,

many people often bury their feelings in pills and booze, empty sex, overspending, excessive consumption of unhealthy food, and more. My hand is sheepishly raised.

As an example, I played guitar and sang for a band called Mouthfulofshotgun (the name alone pretty much says it all) circa 2005. This was during one of the darkest periods of my life. We recorded a three-song demo called *Spirit Crusher* at Austin Enterprise, which belonged to Steve Austin of the band Today Is The Day. (You can find the recording on YouTube if interested.) The third song on the demo is called "Ghosts, Flowers, and Graveyards." The lyrics came from unbearable pain and despair, a time when I was also obsessively revisiting the *Nightmare* films, especially *Dream Warriors*. The lyrics begin:

> Pills in mouth. Fifth in hand. Cocaine eyes can't see through the haze. Compassion through addiction is all I have left to give. Can't even lift this gun, this gun in my hand. Ghosts. Flowers. Graveyards.

Having had experiences with sobriety and healing from a few of the rehabs and mental institutions I'd been in before writing this song, I knew there was still some semblance of strength within myself. Meditating upon that, the lyrics took a slightly more hopeful turn.

> And through this haze, I see a mother's face, I see a father's eyes, I see a brother's smile. And through this pain, I don't know why. So, I'm left only with the possibility that maybe today, maybe today I don't want to die. And here's my prayer. A prayer for the dead. All the ugliness of yesterday laid to rest. But I won't forget.

I share these lyrics here in the hopes that they show how deep despair and lack of inner strength can be experienced, yet this doesn't mean all is lost. No matter how awful your mental and emotional states may feel—from the experience of a once degenerate, scumbag, loser—things truly can, and do, get better. But we have to be willing to do the work, just like Kristen, Joey, Kincaid, Taryn, and Will did in *Dream Warriors*.

There are so many means and methods of developing inner strength. And while there are a number of them shared throughout this book, there are so many others that may be helpful for you. Google and YouTube are your friends.

To start, something that's helpful is realizing that when we find ourselves in difficult life situations, expanding our view of the experience can be very beneficial. It's so easy to become completely consumed by the adversities we face, and this often results in feeling like failures in how we deal (or perhaps, more apropos, don't deal) with them. A pivotal moment of each of the *Nightmare* films finds the characters either initially learning about Freddy Krueger or, in those films featuring returning characters, realizing that he's come back and his last defeat was only temporary. In each case, it requires a paradigm shift on the part of our heroes in which they come to understand and then accept that they're up against a supernatural threat and no longer dealing with the world as they have known it. Perhaps the most memorable example occurs in the first film when Nancy manages to pull Freddy Krueger's signature fedora with her into the real world while waking up from a dream and subsequently confronts her mother, Marge, with it. This leads to the now iconic scene in which a drunken, sorrowful Marge explains to Nancy (and therefore the viewer) Krueger's

backstory. It's this acceptance of Freddy's presence and nature and a willingness to expand their worldview beyond what they've accepted up until this point in their lives that allows the teens to fight back. So, too, must we be willing to broaden our horizons and learn new strategies and skills in order to confront our own adversities.

There's a saying—one that's obviously not applicable to the majority of characters in the *Nightmare* films—but it goes something like "So far you've survived 100 percent of your worst days. This, too, shall pass." Sitting in contemplation of the profound perspective that saying offers can be very helpful in broadening our scope of shitty situations we find ourselves in. Yes, whatever we're dealing with at the time may suck, but we've been through suck-tastic situations before, right? We may not have handled them gracefully or with much composure, but we did make it through. That takes strength and resolve. Nice work, you.

PRACTICE: Mindfulness and Identifying Negative Thoughts

Just like Freddy's victims in the *Nightmare* franchise, you've gone through no shortage of difficult experiences in your life. Take a moment to look at and reflect on some of them. Honor the inner strength it took to make it through those experiences. Perhaps it was the loss of a pet, family member, or friend. Maybe it was going through withdrawals or surviving a near-death experience. Whatever the case, you've made it this far, and there's a lot to be said for that. You (yes, *you*) have survived 100 percent of your worst days. Please don't ever forget that.

We all have a unique set of strengths. Find yours. When we face the demons of our past (and present)—the hurt, scars, blood, tears, and all the other messiness life has dragged us through—it's not easy, but it is doable.

We all have inner strength. The fact that you're alive and reading these words is positive proof of that. We just need to recognize, and develop, our relationship with it. This doesn't happen overnight. It's an ongoing relationship with ourselves that's nurtured for the rest of our lives. As we do this, it helps us to follow our dreams with greater confidence, knowing that we have what it takes to face any adversity that may stand in our way of reaching them. Unless, of course, it's Freddy Krueger, in which case, you can pretty much kiss your ass goodbye.

Here's a couple of quick and easy practices to get you started.

Mindfulness Meditations

Mindfulness is a grounding exercise to focus on the precise moment in which you exist, focusing neither on the past nor the future but centering yourself in the here and now. It's essentially "pressing pause" on your own life for a few minutes, taking a deep breath, clearing your mind of concerns, anticipations, and worries, and asking yourself, "How and what am I feeling right now?" This practice is great because it helps us become more aware of our mental and emotional states, among countless other benefits, which helps us catch ourselves when slipping into old, self-defeating thought and behavior patterns. How do you practice? Simple. As my beloved teacher Ram Dass often said, "Be here now." Become aware of your thoughts, physical sensations, surroundings.

That's it. Just become aware of your experience in this moment. You don't need incense burning or Enya playing. Hell, you can throw on *Dream Warriors* (or whatever your personal favorite entry into the *Nightmare* franchise is) and just be present with your joy, shrieks, laughter, frustration, fear. Pay attention to what your body does throughout the movie. Feel the tension as Freddy slashes someone up. Become aware of the sensation you have when Freddy says, "Welcome to prime time, bitch." That's all there is to it. Welcome to mindfulness. And of course, this is applicable to literally every other moment of your life. For some, it may just be a bit more enjoyable to practice while watching some good old-fashioned horror. Either way, simply *be here now*, and you're good to go.

Identify Negative Thoughts

We are our own worst critics. Nothing new there, but by becoming mindful of how often we're actually shitting on ourselves helps us to stop that cycle. Get in the habit of replacing those thoughts with something positive. Not in some Pollyannaish, everything is love and light sense. Instead, identify something positive about yourself that you know for a fact is true—maybe you're a good musician or an excellent mechanic, or you can honestly say you're always there for your friends when you need them; perhaps some professional achievement you've attained, or some good deed you performed that had appreciable positive impact on the world. Make it something positive that you can, without question, completely own about yourself—and focus on that. Just like anything else in life, it takes practice, but boy, is this one definitely worth it.

Taking a Chain Saw to the Unnecessary Masks We Wear

Leatherface from *The Texas Chainsaw Massacre*

"You boys don't want to go messin' around some old house. Those things is dangerous."

—Old Man (*The Texas Chainsaw Massacre*, 1974 version)

Oh, the Horror!

A practiced exercise in the uncanny, *The Texas Chainsaw Massacre*'s relative lack of a plot works in its favor rather than against it. Far from possessing a weak script, the movie is more concerned

with mood than narrative and operates as something between a filmed nightmare and a snuff movie. With the minimal dialogue and characterization, cinema verité style, and seemingly random and unexplained events, the viewer is pulled into what seems to be a doomed world: For the first two-thirds of the film, the soundtrack is punctuated by radio broadcasts all recounting war deaths, murders, and other tragedies in a seemingly endless stream of bad news. To the extent that there's a linear story, *Chainsaw* follows flower power siblings Sally and Franklin Hardesty as they make a road trip to West Texas following news reports of vandalism in the cemetery where their grandfather is buried (the viewer knows, from the tone-setting opening sequence, that "vandalism" entails someone having exhumed, mutilated, and ritualistically posed a corpse atop one of the graves king-on-his-throne style). Accompanying the pair are Sally's boyfriend, Jerry, and another couple of friends of theirs, Pam and Kirk.

After finding their granddad's grave intact, Sally and Franklin decide that, as long as they're in this neck of the woods, they should check out the state of the old family home. En route, the quintet picks up a hitchhiker, a twitchy, nervous weirdo who initially seems to be tripping on acid but who proves lucid enough to educate the kids on the devastation of the local economy. This area relies on the cattle industry, and with the mechanization of the slaughterhouse and the introduction of pesky instruments such as the captive bolt gun and electrified floors, animals can now be killed more quickly and humanely, putting the good, decent slaughterhouse workers who used to bash their heads in with a

sledgehammer out of work. The hitchhiker's visceral descriptions of all the ways you can kill a cow and prepare headcheese with it may freak the kids out, but it's when he pulls a knife on them and tries to set the van on fire that they finally give him the boot.

Suitably spooked, the quintet makes it to the old "neighborhood," reduced to just a few abandoned homes out in the Hill Country. Well, mostly abandoned. As our tragic youths (to paraphrase John Laroquette's opening narration) are about to find out, one of those homes still has people living in it, or, at least, they used to be people. The way writers write and doctors heal, it turns out some slaughterhouse workers just have the murder in them, and one family hasn't quite been able to get it out of their system even in unemployment, routinely killing and eating passersby.

Never named on-screen[i] (another convention of the film's uncanniness and distancing effect on the viewer), the family consists of "Grandpa," a barely living, semi-catatonic, blood-drinking ghoul well into his nineties, if not older; "Grandma," his long-dead, lovingly mummified bride; and their three grandsons. We've already met one of them, the Hitchhiker, the resident schmuck of the family and the person responsible for the grave vandalisms. The man in charge is credited simply as the Cook, a genial, fifty-something country gentleman who chastises his brother for potentially drawing unwanted attention to their operation and who seems to be running this whole cannibalism business almost compulsively, expressing regret that his family's even doing this in the first place at the same time he's arranging to kill a woman for consumption. The third brother? The third brother is

i The name "Sawyer" was only appended to the family in the second film, and they've been called the Hewitts ever since the 2003 reboot.

the one who's entered the pop-culture lexicon. At a whopping six-foot-four and 300-plus-pounds, Leatherface is a mallet-wielding[ii] brute with the mental faculties and general temperament of a not-especially-bright guard dog, tasked with watching over the family home while his brothers are away and butchering their kills. As each of the kids meets their fates at this hulking killer's hands,[iii] the film's tagline becomes the question on every viewer's mind: Who will survive, and what will be left of them?

Although we learn precious little information about any of our protagonists or villains—indeed, the contextless nature of the movie contributes to its sense of unease—there's a deleted scene from the film, available now on most DVD releases, that not only resolves what at first seems to be a continuity error, but which draws attention to a small detail that has tremendous implications for understanding Leatherface. It's a fascinating exploration not only of the psychology of the fictional monster but a more graphic and literal example of something we do every day—and the risk it can carry.

The deleted scene finds Leatherface silently excusing himself from the table in the middle of the film's notorious dinner sequence, in which the cannibal clan that serve as the film's antagonists attempt to revive their decrepit grandfather by feeding him blood from final girl Sally Hardesty. The audience then sees Leatherface slip into his bedroom, a dilapidated rat's nest of filth

ii Despite the title, only one person actually dies by chain saw, and Leatherface doesn't whip it out until we've entered the final stages of the film.

iii A darkly comic footnote: three of Leatherface's four victims are trespassing in his house when he whacks them, and, under Texas state law, their killings would technically be justified.

and human remains that somehow appears even more insalubrious than the rest of the household, and that features as its primary accoutrement a fixture that could be charming if not for its contents: what appears to be either a repurposed barrel or wine cask, strung up from the ceiling to form both a decorative and functional hanging basket. Of course, Leatherface being the sort of fellow that he is, it doesn't contain a fern or begonias but rather the masks made of human flesh that give the killer his name. Sorting through the basket, he briefly considers what appears to either be a wig or another mask before instead picking up a mirror and sloppily applying makeup to the mask he's wearing, transforming it into what the late Gunnar Hansen (who played Leatherface in the original film) called "the Pretty Woman Mask."

From a practical, real-world standpoint, the deleted scene explains why Leatherface's mask appears to suddenly change in the film. However, the scene also would have drawn into sharper focus an aspect of the character lost on many audience members upon their first viewing: that Leatherface changes his masks multiple times throughout the film, each time replacing or modifying it depending on the role he's fulfilling in a given situation.

Far from simply being a creepy touch to further unnerve viewers, writers Tobe Hooper and Kim Henkel were conscious of a deeper psychological meaning to the scene. "The reason he wore a mask, according to Tobe and Kim, was that the mask really determined his personality," Gunnar Hansen told *Trauma*'s Jakob Schultz in 1999. "Who he wanted to be that day determined what mask he put on. So when the Cook comes home, with Sally, Leatherface is wearing the 'Old Lady' mask, an apron, and carrying a wooden spoon—he wants to be domestic, helpful in the kitchen. At dinner he wears a different face—the 'Pretty Woman,'

which has makeup. Behind the mask, really, Leatherface was very simple . . . he obeyed his brothers, he loved his Grandpa." While most human beings, of course, have their own fully formed personalities and aren't ciphers who have to artificially craft identities for ourselves out of literal masks, the fact is that most of us, at least on occasion, if not a regular basis, wear metaphorical masks of our own.

Who among us doesn't pretend to like something to endear ourselves to a partner or business associate? Who doesn't act cordially to coworkers or acquaintances we find off-putting or offensive? Not rocking the boat is a social grace older than boats themselves while role-shifting is simply a part of the human condition: We're slightly different people depending on who we are with—our friends, parents, children, coworkers, or the folks we meet and interact with as a part of everyday life. To a certain extent, these are all different sorts of subtle masks, hiding, to varying degrees, aspects of our personalities that we may not want to show to different people in our lives. While we may feel free to drink and swear around our closest friends, the thought of doing so around our parents may be a little less appealing while a night out with the girls for a group of women friends would almost certainly look different from an evening out with coworkers.

These role shifts aren't only healthy, but they are necessary to maintain positive relationships; they're less masks that conceal our identity and more akin to spiritual surgical masks, blocking out negative elements that may be harmful or prove detrimental. Psychoanalyst Carl Jung called this concept the "persona," and even likened it to a mask himself, writing in his *Two Essays on Analytical Psychology* that the persona is "a kind of mask, designed

on the one hand to make a definite impression upon others . . . the other to conceal the true nature of the individual." Indeed, aside from the idea of the persona being conceptually masklike, the word itself is derived from the Latin *persona,* itself derived from the Greek *prosopon,* the name given to the elaborate masks worn by actors in Greek theater to make their characters readily recognizable to audience members seated in large, outdoor auditoriums. The very source of the term, then, conjures up the image of putting on a literal mask to fulfill a prewritten, predetermined role with expectations and obligations.

When a play ends, the performers take off their costumes and go home, though. What happens, then, when that mask becomes more complex, and, like Leatherface, it comes to define us? Leatherface, of course, didn't come into the world wearing other people's faces to determine who he was on a given day—at some point, a decision was made, and a process begun, one that ended in a half-formed human being. Did Leatherface ever have a chance? The film heavily implies that there's some degree of mental impairment at play but also demonstrates he has a high degree of autonomy: He's capable of "dressing" his kills in preparation for cooking and preparing meals, all of which he's trusted to do by his brothers, who leave him alone for prolonged stretches of time in the knowledge that he's capable of taking care of himself and not just wandering off into town for blind killing sprees. Note a particular phrase in Hansen's assessment of the character: "He *obeyed* his *brothers.* He *loved* his *grandpa.*" Especially as we see that Leatherface's "love" for his grandpa is primarily expressed through blind devotion, carrying the barely living human corpse around the house and attempting to feed him, we can understand

that Leatherface's lack of a distinct personality is the result of his constantly changing that personality to please others. He has given himself too readily and easily to roles at the expense of a fully formed personality.

As Jung wrote in his book *Memories, Dreams, Reflections,* "The danger is that [people] become identical with their personas—the professor with his textbook, the tenor with his voice." The idea is further explored by Jungian analyst Anthony Stevens in *On Jung:* "It's possible for individuals to lose themselves in their own personas—to live them so rigidly, like a spy losing themselves to a role, that they begin to lose sight of their own distinct personality and *become* the mask, resulting in 'the shallow, brittle . . . kind of personality which is "all persona," with its excessive concern for what people think.'" Jung called this phenomenon "ego death"— the total loss of our own identities when we cease being *us* and entirely become our personas.

This is precisely what has happened to Leatherface, to a very literal degree: When he wishes to kill, he dons his kill mask and, when he wishes to cook, the old woman mask. It's easy to imagine that the dozens of other faces hinted at by the barrel in his room contain his other personas, specifically crafted, requiring him to slip back into his room every time he wants to shift personalities. There's no free time, no hobbies, no personal interests; Leatherface's existence has become an endless, joyless succession of switching masks to please other people. Notably, one of the few times we get to see him express a genuine emotion in the film, it's fear: After killing Jerry, the latest interloper to meet his fate after trespassing into the house, Leatherface—dropping his

sledgehammer almost as if in exasperation—sits down and visibly panics; as Tobe Hooper explains on the DVD audio commentary, the thought passing through his head is "Where do all these people keep coming from?" It's a moment that underscores the utter joylessness of his existence and how the lack of a distinct personality has rendered him almost animal in his free moments.

Although Leatherface's example is extreme, the phenomenon of ego death is real and much more insidious in the world outside of horror movies. In its subtlest form, it happens in the way we can begin to change ourselves for other people. Although not a horror movie (at least not for most viewers), the romantic comedy *Runaway Bride* demonstrates an extreme example through Julia Roberts's character, who modifies her interests, fashion sense, occupation, and even the way she likes her eggs based on what she thinks her current romantic partner will find pleasing—a less homicidal, if not any more healthy, alternative to the stitched-up, cobbled-together faces that make up Leatherface's masks.

So, too, in real life we may find ourselves changing too much for other people so that our own personalities—our hobbies, our likes and dislikes, even our sociopolitical views—become so deeply hidden that we stop wearing the mask and become it. How often do we hear of the parent who complains that, lacking any free time or emotional support and fully consumed by the care of their children, has become "just" a mother or father with no life or role outside that of caretaker? Or the businessperson who's so consumed with a twenty-four-hour lifestyle of making deals and climbing the corporate ladder that they cease to exist as anything other than a moneymaking machine? These are all different

roles—different masks—we risk subsuming us if we wear them too long.

I found this happening to myself after I first got published and began using social media to interact with readers of my magazine writing and fiction work: I felt compelled by colleagues and internal pressure to present a certain persona to the world. Endlessly positive, mindful of social causes, and occasionally performatively supportive, I began taking cues from other, more established writers on how to present myself to the world, cobbling together an identity Leatherface-style, so as to present the most pleasing rather than most authentic version of myself. As time went on, though, the shibboleths of social media and the rigid persona through which I "interacted" with others began to impact my daily thinking: I considered how I thought and felt about things, not how I genuinely responded to them but rather how I would filter things through "online me." I could no longer enjoy a piece of media, or a hike in the park, or a visit to a museum or historical site without thinking about how the experience could or would be mediated through my online personality. It wasn't a happy experience, and I began to feel a bit of sympathy for and a dark camaraderie with Leatherface.

While I at least had a *buried* identity that was being subsumed and that I could fight to get back, Leatherface appears to be the victim of *total* ego death. Notably, the audience never sees Leatherface remove his mask—each change occurs off-screen, and the closest we ever come to seeing a modification take place is in the makeup scene. Consider, too, the old colloquialism "put my face on" for donning makeup—not only does Leatherface not remove one face, he puts another one on top of it. The effect is the subtle

implication that the mask never comes off—that there's only a re-volving door of roles played for the benefit of others.

Jung called the process of breaking away from our persona "disintegration"—the image being the collapse or destruction of the metaphorical mask to reveal our true selves beneath. For those who've experienced ego death, it's a necessary process to be-come healthy, happy, individuated human beings again and enjoy life as a fully formed person—not the shallow mask that's come to dominate their lives. It's a process that involves extensive ther-apy and soul-searching, not only identifying the aspects of one's personality that are artificial and part of the persona, but under-standing how and why that persona was formed in the first place and how to avoid repeating the process in the future.

For me, it entailed a growing honesty in how I presented my-self to the world, to allow for a more authentic version of me to begin seeping through—I don't completely open my whole life to the world on my social media, as, in many ways, I'm an inherently private, suspicious person, but the "me" you'll find online these days is much more of a moderated version of the real me versus the artificially crafted persona of 2018. For Leatherface, it would take a very skilled therapist indeed to achieve any modicum of disintegration (and, of course, he'd have to stop eating people).

Hopefully, most of us can vary our lives enough and live enough for ourselves that ego death doesn't occur in the first place; nonetheless, it's important for everyone to be mindful of the slippery slope that leads to it and the oftentimes slow process of donning a mask that becomes increasingly difficult to take off. For those of us who do find ourselves subsuming our personalities more and more to the wills and expectations of others, though, it

may be helpful to keep Leatherface in mind as an example of what *not* to do and who *not* to become. Even though he may own his own home and have a steady line of work, he doesn't seem to lead a very happy life.

Oh, the Humanity!

In 1943, psychologist Abraham Maslow wrote a paper titled "A Theory of Human Motivation," which included his five-tier model of human needs. The intention behind this was to help better understand the motivation behind human behavior. Of course, as with anything in life, any blanket statement or model can be dangerous as we're all unique human beings, but overall, Maslow's theory still holds strong to this day.

The hierarchy begins with humanity's basic needs and progresses incrementally into deeper personal development. So here's the quick 101 of Maslow's hierarchy of needs:

1. **Physiological needs** (food, clothing, shelter, sleep);

2. **Safety needs** (the feeling of security in the personal, emotional, and financial aspects of life);

3. **Social belonging** (family, friends, intimacy);

4. **Esteem** (recognition, status, respect, to be valued by others); and

5. **Self-actualization** (to pursue and fulfill one's goals in life).

Later in life, Maslow would add a sixth hierarchy titled "Transcendence," criticizing his own fifth hierarchy of self-actualization and believing that man's highest goal should be that of understanding oneself in relation to the totality of life, from subatomic particles to the farthest reaches of the universe.

It's imperative to have a basic understanding of our motivations in life, not only the things that fuel our behaviors, passions, attitudes, *ad infinitum*, but more important, the *why*. And for film and literary nerds such as myself, I believe the horror genre is easily the most versatile and effective way (save going to a therapist or other formal and professional routes) to get a glimpse into our deeper self without having to sift through countless pages of tedious and monotonous psychology texts.

Looking back at Maslow's list, social belonging and self-esteem rate very high on his scale. There is, of course, absolutely nothing wrong with the desire for social belonging and self-esteem (though to be clear, Maslow refers to esteem from the perspective of cultivating it based on how others view us rather than how we view ourselves).

This is where the concept of wearing metaphorical masks comes in. Unless it's Halloween, you're robbing a bank, or are into some kinky sexual stuff (I'm not here to judge), we typically don't wear literal masks. On a daily basis, however, we wear many masks. A recent episode of the show *Black Mirror* focused on a fictional society that functioned based on social ratings given to us by others, which, in turn, dictated what we were and weren't able to do in life (from renting cars to attending social gatherings and such).

Unfortunately, this episode significantly strikes us too close to home for the era in which we live. We're excessively worried about and focused on how others see us. Whether we're aware of it or not, our minds (mine included) are constantly plagued by thoughts such as "Am I good enough, thin enough, have a cool

enough job, house, clothes, appearance, demeanor?" As I said earlier, blanket statements are dangerous, so it's not my intention to speak on anyone's behalf, but if you were to take a few moments and really explore those examples, or some of a similar nature, I believe you'd be hard-pressed to honestly say you can't relate.

So again, the masks. We all wear them whether it's at work, or with family and friends, in social situations, essentially anytime we're not alone and in our own company. And even then, when we are alone, we still have our super rare, collector edition–style masks, the ones that if we're lucky enough to find them after years of searching, we place them in a very safe and secure place, rarely allowing others, as well as ourselves, to see them.

Like any good horror fan, we have a vast collection of "masks" that we've accumulated over the years based on our life experiences. Some of these masks are still in good condition and relevant while others are old and nothing more than clutter. Yet we keep them because of outdated paradigms we hold on to. It's terrifying to let others see who we really are, if for nothing else, out of a fear of rejection. It can be even more terrifying to take an unflinching look within ourselves at all the raw emotions, memories, traumas, and straight-up shitty life experiences we've endured. For most, we hide from these because they're incredibly unpleasant to acknowledge and sit with, so people turn to drugs and alcohol, unhealthy eating habits, empty sex, compulsive shopping, and binging on video games, TV shows, and movies. Let me be clear that I'm not here to lecture anyone and that none of those things in moderation are bad or wrong whatsoever (unless it's crack or heroin because that is obviously whack). It's when we're

using them as a means of evasion, which is to say escape, from our emotions and feelings, that they become a problem. We're so desperate to be liked and accepted that many of us compromise our integrity and authenticity and put on whatever mask the situation calls for just so we'll fit in.

Another reason people wear masks is because sometimes they're so out of touch with themselves, they have no idea who the hell they actually are, which brings us back to Tobe Hooper's 1974 horror masterpiece.

Unlike the individuals who wear their metaphoric masks to fit, Leatherface obviously couldn't care less about that. He was, however, very uncomfortable in his own skin (no pun intended) because he had no idea who he was in the world. He was severely abused growing up in every way imaginable, hence his creation of various masks to represent what he believed represented his various states of being. (In the original 1974 *Texas Chainsaw Massacre* film, Leatherface wore three different masks. Each had its own name such as the "Killing Mask," "Old Lady Mask," and "Pretty Woman Mask.")

While Leatherface is a villain in *The Texas Chainsaw Massacre*, if you look deeper at his character, he's a scared human being hiding behind the mask. When he kills, it's in obedience to his family's orders out of fear rather than malice. In the documentary film *The Texas Chainsaw Massacre: The Shocking Truth*, Gunnar Hansen, who played the original Leatherface, is quoted as saying, "He is the most powerful character in the film, physically. He is the most violent of the characters in the film. He is also the most frightened character in the film."[1] And later, Tobe Hooper, the

film's writer, producer, and director, says, "He's a big baby. Inside the movie he freaks out because he doesn't know where in the hell they are coming from. Where are all these people coming from?"[2]

I'm aware that killing people who peacefully come onto your property because they are lost is an extreme example, and the majority of those reading this aren't killers. But it's still an example of how we can both act and react in life when we're not in touch with our true self and are constantly wearing masks either to fit in or hide behind because we don't know our inner selves.

And therein lies one of the countless beautiful aspects of the horror genre (and dare I be so bold as to say this book?)— its ability to address virtually any topic whether metaphorically, abstractly, straight on, or sometimes, even inadvertently. David Cronenberg, writer and director of *The Fly*, is quoted as saying, "I think of horror films as art, as films of confrontation. Films that make you confront aspects of your own life that are difficult to face."[3] I believe Cronenberg couldn't be any more accurate in that assessment. Swiss psychologist Carl Jung referred to what Cronenberg was postulating as "shadow material," which are the life experiences and emotions that we've suppressed into our unconscious.

This is important to be aware of because aside from wearing our masks, while we think we're in conscious control of ourselves during the day, scientific studies tell a very different story. While the percentages may vary slightly depending on the study you read, it's been shown that up to 98 percent of our daily actions and reactions—essentially the way we behave in the world—is based on the unconscious material that is deeply ingrained in us.

So why do we wear our masks? Because, like Leatherface, we, too, are afraid, just in different ways: afraid of rejection, afraid of lack of security, afraid of not being valued by others, all things Maslow addressed in his hierarchy of needs. The masks we wear are based on a lifetime of experiences and they're not all bad. We would certainly be doing ourselves a favor though by becoming more mindful of the various masks we wear throughout the day and taking time to explore why we've put them on in the first place. Are they really necessary in that moment? Sometimes they will be, like while disciplining a child if you're a parent, or if you have a meeting with your boss at work, but overall, the majority of our masks are fear based and unnecessary. They're worn as a form of protection against hurt and societal rejection, but when we celebrate who we are as individuals and look at all the incredible things that make us *us*, the masks are no longer needed.

The more we become aware of this, and the more we learn about ourselves, we are afforded the opportunity to become more in tune with our own being—to celebrate the infinitely unique, strange, wonderful, and creepy self that we truly are. Now own that shit like it's your job (because it kinda sorta is).

PRACTICE: Loving-Kindness Meditation

Compassion and care were certainly not offered to Leatherface in the *Texas Chainsaw* films, the lack of which—along with the sheer insanity of his familial surroundings—played an integral role in him acting out in the vicious and violent ways that he does. I've never felt the need or desire to get all chain saw-y

with another human, but I have struggled with a lack of self-care and compassion for much of my life. One of the most profound ways I've experienced inner healing in this regard is through a meditative practice called loving-kindness. I especially like to use it when I'm experiencing feelings of self-doubt and worthlessness or when I feel disconnected from others—family, friends, or the whole goddamn world. It's a way to cultivate a deeper sense of joy, compassion, equanimity, and friendliness toward others and yourself.

Here are some basic instructions to help get you started.

- Begin by closing your eyes and taking two or three long, slow, deep breaths into your belly. Breathe in through the nose, out through the mouth. Take a moment to relax and bring your awareness to what's right here and now.

- Loving-kindness originates with you and then spreads out into the cosmos. I'm good with the "sending love out into the universe" part, but beginning with myself can be tricky, and it might be for you as well if you've struggled with self-love and self-worth issues. Stick with it!

- Bring awareness into your heart center, located in the middle of your chest. Don't think about this area, but rather, be attentive. You may feel it begin to grow warm or tingle or both, or nothing (and that's fine). Just hold your awareness there for a moment. I like to place both hands over my heart center, as I find it helps me go deeper as an added act of self-care and compassion.

- Next comes the aspiration or intention, like a mantra: "May I be safe. May I be happy. May I be healthy. May I live with

ease." If this language doesn't work for you, make up your own.

- After you've had a taste of loving-kindness toward yourself, move on to someone you love. This can be your partner, a child, a spiritual teacher, an artist who inspires you, or even your dog—any being you can love easily. With eyes closed, send this person loving-kindness from your heart to theirs. Again, state the aspiration or intention: "May you be safe. May you be happy. May you be healthy. May you live with ease." Or whatever words you feel most comfortable using.

- Move on to sending loving-kindness to a positive person, someone you feel goodwill toward, perhaps a friend or relative. I usually picture one of my friends who has seen me through some difficult times or someone whom I may not know personally but who has inspired me to be better in one way or another in my life. And from your heart to theirs, mentally send them loving aspiration.

- Then think of someone neutral. This can be a barista at your local coffee shop or maybe the person next to you on the subway. Perhaps it's the person you pass from time to time in your apartment building but have never spoken with, or anyone else you're impartial toward. And again, from your heart to theirs, send them loving-kindness.

- From the neutral person, move on to a difficult person. This is where it can get a little tricky. For example, this can be a boss or coworker, an in-law, politicians, a neighbor who leaves his dog in the backyard all day, or generally anyone who is a source of irritation in our lives. Because this can be

such a challenging part of the meditation, I like to suggest taking a moment to contemplate how this person, just like you—in fact, just like every single person who's ever been here on Earth—has experienced some form of pain and suffering. Take a moment to remember a time when you've experienced pain or suffering. It doesn't have to be the worst experience of your life—just something to help you soften your heart toward this difficult person. From there, as best you can in the moment, send loving aspiration.

- After you've sent loving-kindness to yourself, a loved one, a positive person, a neutral person, and a difficult person, picture all of them standing together in a room with you. Say their names and your own, and then state: "May we all be safe. May we all be happy. May we all be healthy. May we all live with ease."

- Now picture your love as a glowing white light extending out from your heart center, gradually engulfing all the people in the imaginary room. Marvel at the light as it spreads out to include the entire Earth, the moon, and the stars, and continues on to the farthest reaches of space, until all that is left is a radiance of loving-kindness and compassion. From this place that is no place, state your final aspiration or intention: "May all beings be safe. May all beings be happy. May all beings be healthy. May all beings live with ease."

Chapter 3

On Embracing Yourself and Finding Your Own "Losers' Club"

Pennywise from *It*

> *"I am the eater of worlds, and of children. And you are next!"*
>
> —Pennywise (*It*, 1990 version)

Oh, the Horror!

We live in an aggressively individualistic society. From the myth of the Old West and the veneration of the cowboy as the icon of rugged American perseverance to our admiration of "lone wolf" heroes who play by their own rules, the absolute best thing some-one can be is independent, self-reliant, and free from the need for the help, support, or influence of other people. Of course, the things we admire and to which we aspire are often not only

unrealistic but potentially unhealthy: living on a diet of junk food and beer and sitting around watching TV all day may be fun in theory, but it's going to lead to a host of problems down the road, and while we might cheer action heroes engaging in daring feats on the big screen, trying to climb an elevator shaft or jump across rooftops in real life would most likely result in severe injuries at best.

While the idea of going against the odds alone and surviving and thriving without the need for other people's support may seem exciting and brave, the truth is more complex than that. Individuality is an important and necessary factor for a healthy mind and life: Those who subsume themselves too much to a collective risk are doing so to their own detriment, allowing others' needs and expectations to supersede their own. Too, we risk losing our own unique identities if we try too aggressively to please other people in the name of group acceptance or "not rocking the boat." At the same time, people *do* need other people to face life's challenges. No one is an island, and without human interaction, cooperation, and occasional reliance on one another, there are challenges in our lives, be they mental, physical, or spiritual, that we can't handle on our own. Humanity has survived and thrived thus far not through the sort of aggressive individualism championed as "the American way" but through the formation of clans, tribes, villages, poleis, cities, and countries.

The story of humanity's growth and evolution throughout history is the story of cooperation and alliance. This is why the need to belong—to feel accepted as part of a group, to have a shared identity, to be part of a team—is so endemic to the human

experience: How many of us, as part of forming our identity as young people, search for our own "tribe"? At the same time, though, how often do we find our sense of individuality being subsumed by the group dynamic—be it due to peer pressure in a friend group or corporate culture in a work environment? The question becomes, then, how does one maintain individuality while still being a part of a cooperative group? And how, then, does that group of individuals face challenges successfully? That's something of the central conceit of Stephen King's *It,* a film whose entire premise is built around the idea of a disparate array of children first embracing their own unique identities before coming together as a group under the ironic moniker "The Losers' Club" to confront a seemingly unstoppable evil.

It's 1988,[iv] and *something* is preying on the children of Derry, Maine. This may be the height of stranger danger and the satanic panic, but whatever is trawling the streets is decidedly less than human—after all, it's not your run-of-the-mill pervert in a panel van or demented serial killer that tears the arms off children and leaves them bleeding to death in the rain with reptilian bite marks, but that's precisely the fate that's met poor little Georgie Denbrough after he goes out to play one day and never comes home. As it turns out, Georgie's demise is but the opening salvo in a reign of terror for the children of Derry, all of whom find themselves being menaced by that *something.* To sweet, insecure Ben, his stalker is a headless child; for germophobe guttermouth Eddie, it's a ghoulish leper; and poor Mike is haunted by images

iv I'm using the remake for my portion, folks. All apologies to Tim Curry, John Ritter, and company, but it's my preferred iteration. So sue me. Chris gets into the OG below.

of his parents burning alive. Ultimately realizing that they're all the target of the same supernatural force and that their parents will be of no use, a small collective of the children of Derry come together to form the Losers' Club, a unified force against whatever *It* is.

As it turns out, they're going to need to realize the best in themselves and one another if they're going to succeed: The thing whose favorite form is a demonic dancing clown called Pennywise isn't your run-of-the-mill small-town secret but something of a fusion of Freddy Krueger, the Thing, and something cooked up by H.P. Lovecraft during a particularly bad drug trip: hailing from another realm, It is an abomination that's been slumbering beneath the streets of Derry for eons, emerging every twenty-seven years to sustain itself by feasting on the souls of the town's children via their darkest fears, eventually reentering hibernation after wreaking unfathomable tragedy to repeat the cycle again. While some historical texts the kids dredge up indicate this has simply been the way of life in Derry going back to pre-Columbian times, the Losers' Club resolve that this time, *they* are going to be the winner.

Watching *It* was something of a bittersweet experience for me. Andy Muschietti's retooling of the classic '90s TV miniseries becomes a loving ode to the dying years of the Reagan Age in which so many of today's Xennials and younger Gen-Xers came of age, and, with its more austere and melancholy tone, it serves as much more of a heartfelt nostalgia piece about the bonds we form at a very important time in our lives. I remember when my own world looked the way Derry's does under Muschietti and his

set designers' keen eyes and how I was very much once a Ben Hanscom—artistically inclined, horribly introverted, morbidly obese, and very, very alone. Although I had "friends" throughout my adolescence, they were few, usually casual, and the kind of group rituals and activities that typify many people's formative years were few and far between. For someone who came of age on media like *Star Trek: The Next Generation, Ninja Turtles, Cheers,* and other programs that emphasized the joy of being an individual personality who was a welcome and beloved component of an effective team, a yearning to belong was a key component of my personality from a young age. My efforts to belong to something were more often than not unsuccessful, just as much a result of high school aesthetics and prejudices—body positivity was *not* a phrase with much cache in late-'90s/early-2000s rural Oklahoma, and I'm not even going to get into the whole "being Jewish" thing—or the eccentricities and lack of social skills arising from the autism I wouldn't be diagnosed with until my twenties. So it was that I was more likely to be spending my adolescent free time alone in my bedroom than out doing "normal" adolescent things.

The sad irony, as it remained moving into college and eventually the workplace, is that I've always generally been happy with myself in terms of who I am, my interests, and personality, and while I've gone to therapy as needed to address issues ranging from obsessive compulsive disorder to coping mechanisms, I've never felt the need or desire to change to appease other people. No matter how I tried, though, belonging was never something that seemed to come. In seeking to be a part of something, I've never managed to really be a part of anything, and seeing all those

abilities that set them apart as individuals: Ben is mechanically and architecturally gifted, Eddie is naturally resourceful and a talented organizer, Beverly is empathic and extremely emotionally intelligent, Stan is intensely logical, Mike possesses a naturally scholarly mind, Richie is funny and able to perform various voices, and Bill has natural leadership skills. All of them are unique, gifted individuals, but none of them alone can face down Pennywise.

That Pennywise attacks its victims in the form of their darkest fears and deepest insecurities is key to understanding both the creature's metaphor and the important role that both individuality and group dynamics play in the story. While it's easy to remember sequences of the creature transforming into various ghoulish apparitions or summoning up heinous tableaux (such as the blood-soaked bathroom that terrorizes Beverly), there are more subtle elements at play in its machinations: The homophobic hate crime that opens *It: Chapter 2* is implied both to help summon Pennywise out of slumber *and* be a consequence of its return while it similarly appears to be both drawn to and to psychically drive homicidal bully Henry Bowers. Pennywise, then, isn't simply a monstrous, extradimensional entity but a walking embodiment of the mundane struggles and great evils of the world, from sickness and insecurity to racism, antisemitism, and familial abuse—struggles that even the most taciturn and strong-willed among us would rather not face alone.

One of the unique narrative dynamics of *It* finds the core group of characters—often referred to as "the expendable meat" in other horror films for their traditionally high body count—form *during*

the events of the movie rather than before it. From *The Texas Chainsaw Massacre* to various *Friday the 13th* movies, *My Bloody Valentine*, the *Scream* franchise, and myriad other popular horror flicks, the protagonists/central group of victims usually begin the film as an extant friend group or collection of employees.

At the outset of *It*, none of the members of the Losers' Club have any established relationships beyond superficial recognition as classmates at the same school in the small, isolated town of Derry. It's through their various encounters with both Pennywise itself and the evil it drives that the members of the group find one another and begin forming their own tribe, both due to their shared trauma and their ability to recognize in one another the talents and gifts the rest of society has ignored.

Excepting certain *Nightmare on Elm Street* movies (as discussed elsewhere in this book), *It* is unique in that it demonstrates how people can be brought together by a shared threat and bond as a result; further, it's through this bond of community that the various members of the group begin to understand and exploit their individual talents. Bill organizes the group's campaign against Pennywise; Ben builds them a clubhouse to be used as the base or HQ; perhaps most touchingly, Beverly demonstrates to Ben and Eddie some of their first experiences with empathy, comforting Ben after he's attacked by a group of bullies and redrawing the cruel "loser" written onto the cast of Eddie's broken arm so that it now reads "lover." Rather than losing their own individual identities to the collective of the Losers' Club, each member instead finds themselves tapping into even greater personal depths, discovering new strengths, and amplifying them not only for the greater good but their own self-actualization.

The message is clear: As talented and resourceful as each individual member may be on their own, none of them can stand against Pennywise alone. Conversely, the more the group comes together and the closer they grow, the more opportunity they have not only for defeating Pennywise but becoming stronger individuals.

This is evident in scenes in which the characters work together versus when they choose or are forced to deal with Pennywise individually. Consider the sequence in which the Losers explore the abandoned house on Neibolt Street, which houses the well leading to Pennywise's lair. Initially entering the house as a unified force, the group splinters when confronted by Pennywise, allowing the monster to get the upper hand and corner Bill, taunting him about his brother's death and placing him in a vulnerable position to potentially meet his own demise. It's only when the rest of the Losers regroup and decide to return for Bill that Beverly is able to get the upper hand by stabbing the clown, both confirming its ability to be harmed and allowing the Losers to escape.

Shortly thereafter, traumatized by their encounter on Neibolt Street, the Losers decide to abandon their efforts, convinced that—in spite of their minor success in wounding Pennywise—they cannot ultimately succeed, each withdrawing into their own private lives: its own form of toxic individualism. The folly of this decision quickly becomes apparent when, now isolated from her friends and made even further vulnerable by her father's continued sexual assaults, Beverly is abducted by Pennywise and taken to its subterranean lair. Beverly's abduction serves as the catalyst to reunite the group in very much the same way that a war or

natural disaster draws together countries and communities for the common good.

It's of special note that it's Beverly who's targeted by It and whose abduction reunites the Losers. She has become the emotional core of the group, their pillar of kindness and empathy, and one of the few people not entirely shaken by the experience at Neibolt Street (only she and Bill suggest keeping the group together). Pennywise believed, perhaps not incorrectly, that taking Beverly could be the final blow the group needed to permanently separate them; indeed, this could have been the case. Instead, the abduction forces them to find their resolve and reunite for the common good, allowing them to drive Pennywise into hibernation for the next twenty-seven years.

Although the group makes an oath to fight Pennywise again should the entity ever return, they eventually splinter once again, this time due to life circumstances: Beverly is immediately sent away to live with family members following the revelation of her father's abuse, and the remainder of the group simply drift apart and move away as they enter adulthood, as happens with many childhood friend groups, with only Mike choosing to stay behind.

Though they can't be faulted for wishing to escape their stifling small town and embark on their own lives, it's the disbanding of the Losers' Club that allows Pennywise an initial foothold back in Derry once it resurrects, necessitating the now-adult members to return to their hometown for a second battle with the creature. *It: Chapter 2* almost takes the form of a video game quest narrative, necessitating the group to first reunite in Derry and then set off on their own separate journeys through the town, seeking

childhood totems that will be sacrificed in a ritual key to actually killing—rather than simply wounding—Pennywise. Each of these totems is revealed to be tied to painful memories from the Losers' childhoods: for Bill, the paper sailboat Georgie was playing with when he was murdered; for Beverly, the love note she received from Ben; for Mike, a rock thrown in a partially racially motivated attack; and so on. Retrieving each totem encourages them to at last face unresolved issues, necessitating further personal growth for both their own benefit and the benefit of the team.

It's through the performing of the ritual—conducted as a group—that the Losers are able to accomplish something rare in a horror film: Although Stanley and Eddie die over the course of the film, Pennywise, too, is definitively killed, once and for all, with no tease of a sequel or return. Unlike Jason or Freddy, whose demises are always framed as temporary defeats that allow one protagonist to escape an immediate threat, the audience sees the final elimination of Pennywise at the climax of *Chapter 2*, with no hint that the creature will return. Indeed, too, unlike with many horror films, we're permitted to spend some time with our conquering heroes and see them enjoy their victory, with Ben and Beverly getting married, Mike finally leaving Derry, and Richie able to accept his homosexuality and love for Eddie.

Though they once again go their separate ways, pointedly, the film ends with one last act uniting them together, as each member receives a posthumous note from Stanley, affectionately reminding them that they will always be "losers"—always members of the same, united tribe, one that has demonstrated strength comes not only in numbers but in the individual contributions of each member of the group.

All of us need to feel like we're a part of something; all of us need to be secure in our own individual identities. One of the great feats in life is fusing those two; while, for many, that may simply be a part of adulting, for many more, subsuming our identities to a group risks the loss of our own identity. And, for a few more, it means the ongoing quest to find our own Losers' Club.

Oh, the Humanity!

In the early to mid-1990s there was an obscure, short-lived emo/hardcore band called Ashes, whose 1994 album *Hiding Places* begins with an audio from Stephen King's *It* in which the members of the Losers' Club frightfully discuss the film's protagonist, Pennywise the clown:

Bev: Who's gonna be next?

Bill: B-Bev's right. We've gotta do something.

Ben: We've gotta tell somebody.

Bev: They don't see what we see.

Eddie: Why?

Bill: When you grow up, you stop believing.

Richie: They'd just laugh their heads off and put us in a nut hatch.

Ben: It kills kids, damn it.

Bev: We've gotta do something.

Bill: Help me.

The implications this quote embodies—confusion, anger, fear, despair—resonated on a deep level with my sixteen-year-old self. It summed up much of what I was experiencing during

that time in my life and was also a part of what drew me to the punk/hardcore/underground hip-hop world in the first place—the sense of otherness and disillusionment that united many of us who followed this scene. We were uniquely individual beings but also similar in many of the aforementioned ways.

To feel other than at such an already confusing time in our lives only adds to the difficult, stressful, and confusing experience of being a preteen/teenager. Our bodies are changing. Our interests and friend groups may be changing. The consequences for our actions and misbehaviors typically steepen (I'm looking at you, detentions and suspensions). To find some semblance of acceptance and fitting in—even if that means fitting in with others who don't fit in—means a hell of a lot. That's why punk/hardcore meant so much to me. It was okay to be myself and to be confused and scared and jaded and, most important, to feel welcomed. Nineties punk/hardcore was a golden era for things that on paper shouldn't have worked and yet . . . they did—well, at least most of the time. On any given day you'd find shows consisting of virtually every genre of band sharing the stage—punk, hardcore, metal, indie rock, doom, drone, industrial, black metal, emo, death, math-core, noise-core, experimental . . . even rap and hip-hop. Nothing was off the table, and the diversity was a beautiful thing.

Bands respected one another (mostly), shared equipment, toured together on barely enough money to get from venue to venue. Strangers would let bands crash on their apartment floors or sneak them into their parent's basement, and overall, it was done in a very supportive and familial way. Fans and band members alike were outcasts who cared about one another—and we were very much like the outcasts in *It*'s the Losers' Club.

Even the punk/hardcore scene had its own sort of cool kids' club, and while I was accepted and even played in some bands that garnered attention and respect, I still wasn't cool in the scene at all. I often felt like Ben Hanscom of the Losers' Club. Like Ben, I was a highly sensitive individual, a hopeless romantic, husky in size, and bullied (in high school, not the punk/hardcore scene). Sadly, it's easy for kids to poke fun at other kids who are different from them in even the slightest ways, which, in turn, typically carries into our teenage years, high school experience, and in many cases, adulthood as well. As I've hopefully made clear by now, being a skateboarding, punk-rock/hardcore/alternative teen in a rural Connecticut town during the early to mid-'90s wasn't easy. My entire grade consisted of maybe sixty kids, and if you weren't an athlete or member of the high school band, or didn't have stellar grades, you were basically viewed as lesser than and a waste of time.

Taking into consideration not having things like the constant threat of school shootings as a concern like it is nowadays, I can still say my high school experience was a pretty hellacious four years. On one occasion I was smacked exceptionally hard on the back of the head by my biology teacher—to the extent it sent my glasses flying off my head and onto the floor in front of me—because I was whispering to a friend of mine during a film being shown. On another occasion, I was jacked up against my locker by my history teacher because I stood up for myself after being accused of doing something I hadn't. Luckily, one of my friends was there and tackled him off me onto the floor. And it wasn't just

that sort of physical abuse, but rather, the mental and emotional abuse that was the worst. Constantly having it hammered into one's head by faculty (and many of the students) that you're no good, not going to amount to anything, and are worthless can definitely take its toll, and it did on me.

I did, however, have a very healing and cathartic experience with high school after my second book, *Everything Mind*, was published. I was invited by the town's youth and family service program to give a talk at an all-school assembly, proceeded by speaking to the creative writing classes. When I first received the invitation I remember thinking, "There's no way that's going to happen," but then I saw what they were going to pay me and thought, "Okay, so this is going to happen. The least they could do is pay me for some of my suffering through those four years, which included addiction, weight issues, trauma, suicidal ideations, and thoughts of self-harm."

As I walked through my old high school's front doors, I was greeted by the same receptionist who worked there when I was a student. She pulled me aside, and I was completely shocked by what happened next. She apologized. And not just for her own treatment of my friends and me, but on behalf of all the faculty at the time of which she was now the only one remaining. She told me they didn't understand the piercings, the punk/skateboarding aesthetic. Their fear of the unknown, she said, resulted in what she imagined was a difficult high school experience for us.

I was speechless. My eyes teared up, and before I could muster any words to respond with, I gave her a hug. I told her how much that meant for me to hear, and that yes, it was a very difficult time

in my life that contributed to some of the struggles I've faced since. Both the assembly and creative writing class talks went really well, and the day resulted in a very therapeutic experience.

I still have my struggles in life—but with the help of my Losers' Club, which consists of a few very dear friends and my family, I'm still here. I'm still alive. And not only have I endured 100 percent of the difficulties I've faced in my life, but often, I've even thrived. I'm learning to love myself (albeit sometimes slowly) on a deeper level each day, and with the help of others, I'm cultivating a legitimate sense of self-worth and love.

A practice I've recently undertaken is one in which every morning, after getting out of the shower, I look in the mirror and verbally thank my guru, Maharajji, followed by my teacher, Ram Dass. Lastly, I look myself in the eyes, thank myself for showing up that day to do the work that's necessary to live a better life, a life that I deserve, and then give myself a hug and say, "I love you." This might sound corny or hokey to some readers (believe me, I get it), but the weirdest part to me is that I actually find myself meaning those self-loving affirmations most of the time. It's true that it's up to each of us to show up and do the actual work, but with the love and support of others, it makes the process that much easier.

So, my advice—if I may be so brazen—is that if you don't have your own Losers' Club, get one: find your tribe and hold them close to your heart.

PRACTICE: Make a New Friend

I recently moved from the East Coast to California. Through social media, I knew a few people there virtually, but that was

it. Before I made the move, I became aware of my introversion kicking in and anxiety rising at the thought of potentially meeting new people and making some new friends. It was in that moment, however, I made a promise to myself that when I arrived, I'd get out of my comfort zone and make at least one or two new friends. Some of my fellow introverts may cringe upon reading that at first, which is completely understandable, *but* let's not forget we live in the era of apps, which includes those that help us to connect with others.

Even most "dating" apps these days have the option to choose what you're looking for—be it a long-term relationship, short-term relationship, *friendship*, and more. I mean, hell, Tinder isn't even just strictly for hooking up anymore. With that, I can honestly say I have zero shame in my "dating" app game because it's actually resulted in meeting a couple of very cool people who I now hang out with here in San Diego.

A few apps that I've personally found beneficial are Bumble, Fam, Tinder, Yubo, Wink, and the Facebook "dating" app. While all of these are free, there are limits to how much interaction you have each day, but if you don't mind spending a little money, each app (except for Facebook's, which is entirely free) offers options for unlimited communication among other features as well.

If introversion isn't an issue for you, there's of course always the tried and true organic, old-school way of simply introducing yourself to someone else out in the world if they seem like you might vibe with them—just don't make it weird and creepy, ya know? *Or* make it *extra* weird and creepy and if they're not scared away, you'll know you've definitely found a member of your tribe.

The Power of Christ Compels Us to Explore Spirituality and Religion

Reagan MacNeil from *The Exorcist*

"She's acting like she's fucking out of her mind, psychotic."

—Chris (*The Exorcist*, 1973 version)

Oh, the Horror!

"I'm spiritual, not religious." It's a mantra we hear more and more often lately, to the point it's even become one of the stock choices on many dating apps and social media platforms. It's an

understandable sentiment: In an age when Christian-flavored fascism is threatening to roll back decades of civil rights in America, the Islamic extremist government of Afghanistan is banning women from public education, Israel continues its apartheid state against Palestine, and the Buddhists of Myanmar attempt to ethnically cleanse the Muslim Rohingya people, religion as a social force and pseudo-government entity seems to be putting infinitely more evil into the world than the ostensible good for which they stand. At the same time, though, a desire for a connection to something bigger, deeper, more meaningful, and dare I even say cosmic is something inherent to the human condition. Whether it be a quest to convene with a god or gods as understood in a deistic sense as a sentient, supreme entity, or a connection to nature and the natural world as a manifestation of divine wonder, humanity wants—*needs*—there to be something greater than ourselves with which we can connect.

It's long been religion's role to serve as a mediating force through which we can engage with this desire. Yet as religion has often become intertwined with politics, both domestic and geopolitical, the lines between spirituality and dogmas have become starker rather than fusing into one entity—individuals want to hold onto their faiths and beliefs but also no longer want to adhere to the rigid laws and rituals.

Does religion necessarily inhibit the exploration of the spiritual, though, or can it still fulfill its purpose as a tool for spiritual exploration and fulfillment? Is religion itself evil or simply a convenient tool for humans to exercise evils they'd find other excuses for given its absence? And what of the "spiritual" component of

that aforementioned "spiritual, not religious" label? Isn't spirituality a component of most religions? And if so, how do we separate one from the other, the positive from the negative, the dark from the light? *Can* we? These are questions that humanity has been asking itself for millennia, ever since primitive rites evolved into the first organized religions. While the answers, if there are any, are too complex to tackle in a single chapter of one book, we can perhaps at least explore and dialogue with these ideas through the lens of one of the best films ever made about the complicated relationship humans have with belief, *The Exorcist.*

There's something terribly wrong with sweet, twelve-year-old Regan MacNeil. Formerly a bubbly, chipper little girl, the beloved daughter of famed Hollywood actress Chris MacNeil has begun acting strange lately. Sure, every pubescent child going through the cycles of life starts to act out a little bit, but Regan's transition into adolescence has been a little . . . off. There's the weird, withdrawn spells, sure, and the sudden, unnerving staring into space. But then there's the sudden intrusion into Chris's dinner parties to inform guests that they're going to die and random, public urination. Sure, Regan's been spending an awful lot of time with a Ouija board lately, and maybe twelve is a little too old to have an imaginary friend named Captain Howdy who tells Regan awful things, but kids are kids, right?

After a battery of scientific tests (including a gruesome spinal tap that's gone down in horror history as one of the most unsettling scenes ever committed to celluloid) indicate Regan's perfectly fine—and especially after Chris's director, Burke Dennings, is found dead outside the MacNeil home with his head rotated

180 degrees—the distraught mother finally breaks down and decides to consult the Catholic Church to investigate whether Regan's become possessed. Problem is, the best man the Church has on hand for the job is sad, sexy, conflicted priest Father Karras, a licensed psychiatrist struggling with his own faith in the face of personal turmoil. His vow of poverty means there's not enough money to help keep his increasingly senile mother out of anything other than a nightmarish state-run facility that's only one step up from camping out at the Port Authority Bus Terminal. Her ignominious death there, coupled with his loss of comfort in Catholic ritual, have left him in an existential crisis, and he's wondering whether the God to whom he's devoted his entire life even exists—and, if He does, whether He even gives a damn about His creation.

While Karras's initial encounter with Regan—or, rather, Pazuzu, a demon revered by ancient Mesopotamians as a wind deity who's taken up residence in Regan's body—leaves him insistent the girl is simply in need of psychiatric help, subsequent encounters finally convince him more drastic measures need to be taken. Enter Father Merrin, an aging Church archeologist who's already had a showdown with Pazuzu in the past and whom the demon seems to have been actively trying to summon for a second showdown. As the stalwart Merrin prepares for a final encounter with the anarchic Pazuzu, battle lines are drawn for the fate of Regan MacNeil's soul, with her ultimate fate dependent on the answer to a pivotal question: Does Father Karras truly believe? Or, more cogently for our purposes, is he spiritual or merely religious?

Like many of us in times of trouble, Karras attempts to find some safety in the rote prayers and rituals of the Church to which he's devoted himself, but the lack of a concrete end result only pushes him further into despair. It's one of the pitfalls of reliance on religion not as a source of enlightenment but as a life crutch and one of my own personal gripes with the stripe of spiritually and intellectually dishonest "faith and family" films like *Facing the Giants* or the *God's Not Dead* franchise, which posit that as long as we believe enough in a divine power (or, rather, the *right* divine power, as defined and understood by American-flavored evangelical Christianity), our lives will instantly improve, all hurdles will be removed, and the good guys will always win. Despite his faith, Father Karras finds himself both at loggerheads with the Catholic Church as a religious entity and struggling with his own spirituality. It's against this backdrop that the main action of the movie kicks off with Regan MacNeil coming under the influence of the demonic entity Pazuzu, ultimately necessitating the intervention of both Father Karras and experienced exorcist Father Merrin. Yet, as we shall see, it's ultimately not the religious ritual of the exorcism that frees Regan from Pazuzu's clutches, but Father Karras's restoration of faith.

Notably, the titular character of Father Merrin doesn't arrive to the MacNeil household until 94 minutes into a 121-minute-long movie, turning up dead at the 112-minute mark after Father Karras returns to Regan's room following a brief detour when he becomes rattled by the demon's taunts. In the 18 minutes between his first appearance at the house and his demise, only a fraction of the screen time is dedicated to the actual exorcism, which goes

comically wrong: In the brief expanse of time Merrin and Kar-
ras attempt to drive the demon out through liturgy and ritual,
they succeed only, it seems, in pissing Pazuzu off, resulting in a lot
of profanities, some levitation, and the utter exhaustion of both
men involved. Though they quote scripture and command the
demon out through "the power of Christ," it would appear that
Karras's own lack of conviction renders the words meaningless:
like a Christmas-and-Easter Christian who attends services out
of a sense of devotion rather than true faith. For Karras, the exor-
cism is an empty gesture, a rote recitation of what's been taught.
It's religion, not spirituality.

Only Merrin has any conviction at this point, as explored
through a deleted scene. Sitting on the stairs of the MacNeil home
in the middle of the exorcism, they ponder the practical reasons
for what they're experiencing; Karras, still unsure in his faith, is
flabbergasted. Merrin, meanwhile, steadfast in his faith and un-
derstanding the situation, explains to his colleague: "The point is
to make us despair. To see ourselves as animal and ugly. To make
us reject the possibility that God could love us." In touch with his
spirituality, Merrin's use of the exorcism ritual isn't hollow and
repetitive; it has meaning to him, a meaning he can understand,
engage with, and explain to others because of its profoundly held
meaning for him. The ritual is a tool of expression, not an ineffec-
tive cudgel, as it has become in Karras's hands. *Exorcist* novelist
William Peter Blatty was particularly incensed that this scene was
cut from the film, as he saw it as expressing the thesis of the story:
that *faith* is a counterbalance to evil. To put it into biblical terms,
if faith without works is dead, so, too, are works without faith.

Karras recovers that faith, though—or, perhaps, we should say, he realizes that he's spiritual but not religious. Returning to Regan's room to find Merrin dead and the demon staring in bemusement—even *it* seems surprised to have come out on top so quickly—Karras decides to take matters into his own hands. Rather than continue with the exorcism—rather than rely on ritual and religion—Karras instead, in an act that should absolutely *not* be repeated by anyone anywhere regardless of their spiritual struggles, begins beating the crap out of a little girl. Though it initially seems as though the priest has cracked under the pressure of everything he's seen and experienced, his demand of Pazuzu—"Take *me!*" demonstrates that something else altogether is happening. Perhaps recalling his Gospel of John, "Greater love hath no man than this, that a man lay down his life for his friends," Karras implores the demon to destroy him, instead, throwing himself through the upstairs window and to his death at the moment of possession. Though one might anticipate that, now robbed of its new host, the immortal Pazuzu may return to repossess Regan, Blatty's point has been made: Karras's rediscovery of his own belief and faith have overridden its power, and it no longer has any place in the MacNeil home.

What's the lesson, then? Although they can go hand in hand, religion and spirituality are not the same; while spirituality can thrive without religion, religion without spirituality is dead and ineffective for all but the most superficial and aesthetic of purposes. Nonetheless, with a true devotion and curiosity, for some individuals, religion can be a useful tool for the expression and exploration of their own spirituality. For Father Karras, the

rediscovery of his faith—his spirituality—is a final act, but, for the vast majority of us who aren't facing down infernal entities intent on claiming the souls of small children, it can be the beginning rather than end of a fulfilling period of our lives. Living free from the rigors and confines of an organized religion that places bridles on our spirituality can be an emancipating experience that allows us to commune with something greater on our own terms and through our own personal vocabulary and understanding. Using religion in a measured, thoughtful way as a tool to enhance that process can be equally rewarding. The important thing to remember is to not allow external powers or parameters to define for us what spirituality is and means—that, and, please, for the love of God, don't go around beating up little kids, or I'll have to sic Jason Voorhees on you.

Oh, the Humanity!

Arguably, the most controversial scene in *The Exorcist* is when Captain Howdy possesses Regan in her bedroom and she proceeds to violently shove a blood-soaked crucifix into her vagina shouting, "Let Jesus fuck you," repeatedly. Add to that she then grabs her mother Chris by the back of the head and shoves her face down into the, er, um . . . blood-soaked area. Chris pulls away and recoils in horror—Reagan's blood covering her face. Reagan's childhood toys are also violently flying throughout her room crashing into walls, which leaves her mother to quite literally witness her daughter's loss of innocence in what I'd have to imagine is the most terrifying way possible. It was also a big

F-U to her mother's cherished religious faith as exemplified by the churchgoing company she keeps, including one of the fathers from her church.

While nowhere close to the disdain of Captain Howdy possessing Reagan's body, I've met a lot of people throughout my life that recoil at the word *God* or idea of organized religion. The general consensus of most individuals that hold this feeling is that they had religion forced upon them during their childhood and teenage years, leaving a very unpleasant taste in their mouths toward it. If you're reading this and can relate, I'm sorry about whatever experiences you've had throughout your life that have left you turned off or jaded by the idea of religion and spirituality. I hope this chapter helps in expanding what your ideas of religion and spirituality are and possibly make it feel a little more accessible.

I was raised in a household that believed in God but wasn't religious. My church was whatever abandoned parking lots I could find to skateboard in. My bibles were *Thrasher* magazine and *Fangoria* magazine. My sermons came in the form of Powell-Peralta skateboard videos such as *Animal Chin* and *Public Domain* as well as whatever Saturday afternoon "Spine Tingler" horror movies basic cable afforded me.

During my teenage years, however, I was an atheist to the core, and part of that aesthetic to me was all things "dark." Not goth, but *dark*. I hated the idea of religion and had no idea there was a difference between that and spirituality, nor did I care. This attraction to all things dark undoubtedly lent itself to my love affair with *The Exorcist* from the very first time I saw it, because

indeed, that film is dark. And while I had little interest in traditional religion, I always appreciated the religious-themed horror films, as well as iconography from the world's different religious traditions, especially the various depictions of the crucifix.

My first deep dive into spirituality didn't happen until I was in college as I sat in my professor/academic advisor's office. While waiting for her, I looked around her office and noticed a corkboard that included pictures of religious figures such as Buddha, Ganesh, Mother Mary, Krishna, and Jesus. Once she arrived, and in a most confused way, I pointed at her corkboard and ignorantly asked, "What's going on here?" to which she replied, "What do you mean?" I said, "I thought you just pick one of those guys or gals or whatever-the-fucks and just go with it." She playfully laughed and, in a nutshell, explained that no one but yourself can ever truly tell you what spirituality is or isn't. It's always subjective. For some people it's a mix of various religious figures, saints, sages, yogis, and rishis. For others, it's simply nature. Some people experience it in prayer and meditation. Some people experience it in the use of sacred plant medicines. Some do yoga. Some do all of the above. Some do none of the above but are still highly spiritual beings because again, it's inside you.

My professor also explained that spirituality is internal/subjective whereas religion is external/objective, neither being more right or wrong than the other. Twenty-plus years later, I still find that explanation she gave me to resonate as true. There are pros and cons to both spirituality and religion, of course. I mean, just turn on Netflix, and you're inundated with tons of scandalous documentaries about both spiritual teachers and religious leaders.

While my introduction to spirituality happened in my college professor's office, my practice, I realized, had already begun in bands and music scenes. The raw passion of the vocalist's screams, or the pained words of the hip-hop artist's life experiences, the driving guitars, deep bass, and grimy beats—it all ripped my heart center wide open and made me feel deeply connected to something greater than myself. The very same way that years later, kirtan music (Hindu devotionals) would also identically rip my heart center wide open—just like the most common images of Hanuman (also from the Hindu tradition) usually depict—and feel connected to something greater. They were essentially the same exact experience elicited from two seemingly opposite ends of the spectrum.

No one but yourself will ever know what truly does and does not resonate as spiritual for you because no one else will ever be within your body, heart, and mind. So be curious. Be open. And most important, be discerning. There's a lot of snake oil salesmen out there who prey on people new to religious or spiritual paths. One tip, if anyone ever tells you they have "*the* way," run like hell in the other direction. There are many different paths to take to the mountaintop, none of them more correct than the other. It's like my teacher Ram Dass said, "The spiritual journey is individual, highly personal. It can't be organized or regulated. It isn't true that everyone should follow one path. Listen to your own truth."

Those words resonate deeply as I'd always celebrated individuality and reading that the path was highly individual afforded me a sense of freedom in my exploration, which I very much

needed. It also inspired me to start a website called the Indie Spiritualist, which explored the intersection of spirituality and indie culture through interviews with various spiritual teachers, actors, musicians, authors, neuroscientists, and more.

The Indie Spiritualist website became the foundation upon which my first book of the same name, *Indie Spiritualist*, was written. In *Indie Spiritualist*, while paying homage to my punk/hardcore roots, and my interest of spirituality, I wrote, "A friend of a friend described the punk/hardcore scene as a 'last ditch effort for authenticity in a world increasingly devoid of it.'" I still believe that.

Aside from its raw passion, I think some of the things I was—and still am—most fond of about the punk/hardcore scene (especially the '90s) were its eclectic-ness, diversity, and inclusivity. There were Jewish bands and Hindu bands and Christian bands and satanic bands and atheist bands and "whatever the hell else you cared to identify yourself as bands."

While I was fond of at least one or two bands from most of those genres, my penchant was always for the darker, chaotic, sludgy, noisy bands such as EYEHATEGOD, Today Is the Day, Coalesce, and Overcast. The same went for rap/hip-hop. While I loved the positive vibes of groups such as A Tribe Called Quest, Souls of Mischief, The Pharcyde, and so on, my penchant there, again, was for the darker sounds of acts such as Onyx, Mobb Deep, Gravediggaz, and Jeru the Damaja. These were, and still are, a gateway for me to tap into all aspects of spirituality that can be found in both the light and dark areas of life. As Carl Jung said, "One does not become enlightened by imagining figures of light, but by making the darkness conscious."

I'm still not one for organized religion, or much of any organization to be honest, but I'd be doing myself and this chapter a disservice if I didn't at least mention transparently that based on my own direct experiences through meditation, plant medicines, nature mysticism, reading, skateboarding, making love, and more, I have no shadow of a doubt that there is something greater at play in both the micro and the macro of the cosmos.

To bring a little science to the matter, in 1944, while giving a speech just three years before his death, German theoretical physicist Max Planck said:

> As a man who has devoted his whole life to the most clear-headed science, to the study of matter, I can tell you as a result of my research about atoms this much: There is no matter as such. All matter originates and exists only by virtue of a force which brings the particle of an atom to vibration and holds this most minute solar system of an atom together. We must assume behind this force the existence of a conscious and intelligent mind. This mind is the matrix of all matter.[1]

My hope is that you come to know this "mind of the matrix" in whatever way feels real to you in your life. Don't forget, you're the only one who can know what resonates as undeniably true for yourself—the only catch is your ability to take a rigorously honest look at what that means for you in your life, even if it questions all you thought that you knew. It is my intention that the following practice and list of books help you to do just that. Godspeed, my friends.

PRACTICE: Recommended Reading (Books That Make Ya Go Hmmm)

Reading holy texts isn't just for priests expelling demons as exemplified in *The Exorcist*. When done in a slow and reflective manner, reading can become a spiritual practice in and of itself. It opens our minds to different ideas, opinions, beliefs, cultures, and can increase our general understanding of the world we live in. Reading can also help connect us to others and help us get to know ourselves better. The following is a short list I curated for those interested in exploring spiritually themed books drawn from all the world's great wisdom traditions. May they be a source of growth, depth, peace, and compassion in your spiritual life.

Be Here Now—Ram Dass

A Brief History of Everything—Ken Wilber

Waking Up—Sam Harris

High Magick—Damien Echols

Radical Acceptance—Tara Brach

The Enlightenment Trilogy—Jed McKenna

Awakening Shakti—Sally Kempton

Spiritual Graffiti—Jeff Brown

When Things Fall Apart—Pema Chodron

Cutting Through Spiritual Materialism—Chogyam Trungpa Rinpoche

There Is No God and He Is Always with You—Brad Warner

I Wanna Be Well—Miguel Chen

You Are Here—Thich Nhat Hanh

A Heart as Wide as the World—Sharon Salzberg

I Am That—Nisargadatta Maharaj

The Mission of Art—Alex Grey

The Book—Alan Watts

Be as You Are—Sri Ramana Maharshi

The World's Religions—Huston Smith

Conscious—Annaka Harris

Living Untethered—Michael A. Singer

The Four Agreements—Don Miguel Ruiz

Self-Compassion—Dr. Kristin Neff

The Gnostic Gospels—Elaine Pagels

The Tibetan Book of Living and Dying—Sogyal Rinpoche

The Yoga of Jesus—Paramahansa Yogananda

The Tao of Physics—Fritjof Capra

Faitheist—Chris Steadman

Tao Te Ching—Lao Tzu

The Red Book—Carl Jung

Healing Trees—Ben Page

The Doors of Perception—Aldous Huxley

A Gradual Awakening—Stephen Levine

Chapter 5

BRAINS!...
and Mindfulness
Tarman from
Return of the Living Dead

"You think this is a fuckin' costume?
This is a way of life."

—Suicide (*Return of the Living Dead*)

Oh, the Horror!

"Brains!"

First growled by the gargantuan Tarman, played by Allan Trautman in a costume that adds a few more inches to his already six-foot-two frame, the simultaneously inquisitive and demanding word becomes something of the mantra of *Return of the Living Dead* as wave after wave of the recently reanimated dead converge upon the hapless punks and squarejohns who've found

themselves pinned down between a crematorium and medical supply warehouse. Today hailed as a horror-comedy classic that manages to be both simultaneously scary and funny, the film also served to codify certain tropes that have today become part of the monsters' canon but that at the time had rarely or never been explored. Of particular importance in horror history is that the film contains one of the earliest depictions of aggressive, running zombies as opposed to the heretofore ostensibly slow, shuffling threats who only became dangerous in large numbers or when cornered. Even more important, it introduced the concept of zombies as specifically connoisseurs of human gray matter—a unique conceit that, when looked at through a psychological lens, allows us to view the film not just as a really, really fun zombie flick but a meditation on the nature of addiction and compulsion and how our own individual quests for fulfillment can destroy not only us but those we cherish most.

It's July 3, 1984, and young twenty-something Freddy Hanscom has got it made. The obvious dorky kid back in high school, he's managed to land himself a vivacious, attractive girl-friend in the form of punk princess Tina, who brings along with her devotion a ready-made friend group for the hapless schlub, including nihilist bruisers Scuz and Suicide, new-wave rocker girl Casey, some guy named Chuck (a clueless suit-and-tie-clad prep-pie whom the group seem to treat more like a pet than a compan-ion), Spider (the requisite one black friend from every '80s horror flick because genre cinema had finally gotten the affirmative ac-tion memo), and Trash, an apparent sexual compulsive given to performing impromptu strip routines for her pals at the drop of

a hat. Freddy doesn't just have cool new friends, though: Freddy's got a job at the Uneeda Medical Supply Warehouse, the place in town for every young person to make their career. In addition to routine warehouse tasks such as filling orders for forceps and formaldehyde, though, Freddy will also have another, much more unusual role: guarding the oil drum containing Tarman, the sole surviving zombie from the real-life fiasco that *Night of the Living Dead* was based on.

See, as Freddy's boss, Frank, explains, back in the '60s, the military was experimenting with a chemical weapon called Trioxin, and when it was accidentally unleashed, it resurrected the dead in a small rural town, an incident that became the basis for the famed Romero movie. While the Army was able to finally clean up its mess and confine the last zombie to its current state, they accidentally delivered the drum to Uneeda instead of its intended destination, and it's just sort of been sitting there ever since. There's no need to worry, though—a poorly maintained, rust-caked, twenty-year-old steel drum has got to have incredible structural integrity, right? Well, of course not, otherwise there wouldn't be a movie. Before long, both Tarman and the vestiges of Trioxin sealed in the container with him have been released, unleashing the massive ghoul in addition to reanimating an anatomical cadaver kept on hand in the warehouse. In a panic, Freddy, Frank, and warehouse owner Burt manage to wrangle the cadaver next door to the town mortuary, operated by Ernie, Burt's BFF, and definitely not an escaped Nazi doctor in hiding. Although the quartet manage to incinerate the cadaver in Ernie's crematorium, there are a few dangling threads. The first, obviously, is Tarman,

who's still in the Uneeda basement and who quickly avails himself of Suicide's brains when he and Freddy's buddies arrive to pick him up from work. The second is that while the crematorium may have destroyed the cadaver, fire doesn't eradicate Trioxin gas, and the escaping fumes enter a passing storm system. The third and biggest problem is that the storm system opens up on the very heavily populated neighboring cemetery, unleashing a literal army of the undead. Oh, and there's a fourth problem, too: After their exposure to Trioxin gas, Freddy and Frank have begun to act strangely. They're getting pale, cold, and their muscles are stiffening—and they're slowly getting it into their heads that a healthy heaping of brains just might be the answer to their problems.

While in the past the undead had simply been content with eating their prey in toto, *Return* writer Dan O'Bannon decided to up the ante on the zombie mythos and explore their psychology. In a memorably surreal sequence, our heroes manage to capture and interrogate one of the creatures, who helpfully explains that zombies are in constant pain due to being able to feel their own decomposition, and brains act as a narcotic to stave off their suffering. For an overtly comic movie, it's an unsettling moment of real dread. The thought of living with crippling, constant pain is a fear many of us have, and a reality for many—not just physical pain, but the pain of anxiety, depression, obsessive compulsive disorder, or even just overwhelming life stress that prevents us from living a joyous life. Indeed, while we may not be rotting corpses with an appetite for cerebellum and a penchant for one-liners (in a more lighthearted moment in keeping with the

film's overall tone, a quick-learning zombie hops on a dead po-
lice officer's radio and contacts central dispatch with the request
"send more cops!"), many—if not most of us—spend our days
behaving much like the zombies of the film.

How many of us respond to physical or emotional pain by
throwing endless quantities of drugs, alcohol, or other distrac-
tions at the problem, only numbing it for a moment, never attack-
ing the source cause of the problem? How many of us lash out
and hurt others, either out of a misplaced sense of blame for our
own issues or unintentionally in the throes of an emotional mael-
strom? By engaging in this negative behavior, we may temporar-
ily numb the pain we're feeling, but it's only a temporary—and
negative—solution that lets us feel slightly better in the moment
while doing lasting harm to others. Indeed, the zombies' raven-
ous hunger to temporarily lessen their agony is hardly a long-
term solution—there are finitely many humans on whose brains
to feast, and their mindless, ravenous, constant, and animalistic
attacks make it hard to believe they could ever arrange a Day-
breakers[v] scenario. Ultimately, left to their devices, Tarman and
his cohorts would devour the world—and then spend the remain-
der of their existence still in crippling agony without any potential
source of respite.

Writing about *Return of the Living Dead*, and its intensely
punk aesthetic and ethos, never fails to remind me of a dear friend,
Jacob, for whom this was a favorite flick when he, my brother, an-
other guy named Aaron, and I were inseparable weirdos in rural

v An inventive but uninspiring 2009 vampire film in which, after taking over the
world, vampires keep a select number of humans alive in "farms" as a constant
source of blood—hey, at least it's got Sam Neil in it.

Oklahoma at the turn of the 2000s. As I was the only one of the group to own a big-screen TV and, later, the first to get a DVD player, my house tended to be ground zero for our invariable hair-brained plots and schemes, the bulk of which revolved around using my brother's eBay-purchased, '90s-era camcorder to make intentionally bad, black-and-white horror movies of our own. A not uncommon summer afternoon involved my mother making us sandwiches and our camping in front of the television and watching something from my sizable library of horror and exploitation movies before disembarking, camera in hand, to make the world of homegrown cinema a worse place.

Return of the Living Dead was a regular fixture in our sandwich-time viewing, and while I enjoyed the film, Jacob in particular was inspired by it. For him, punk life represented something aspirational. The eldest child of a type-A engineer with a military background, Jacob had been tapped from a young age to carry on his family's legacy of excellence, and with the right unhealthy amount of parental pressure and unrealistic expectations, he was president of various clubs, a polyglot, straight-A student, and consistent honor roll fixture throughout his high school career; when he graduated a year ahead of us, my brother and I could hardly be surprised, nor were we shocked when he landed a five-figure job straight out of school and moved into his own place. Off the bat, it seemed, Jacob was going to make his dreams—or, rather, his parents' dreams for him—come true and continue excelling beyond any of us.

Turns out, Jacob *was* going to make *his* dreams come true—little did any of us realize that those dreams involved living in

the world of *Return of the Living Dead*, zombies included. Before long, Jacob had sought out and enmeshed himself in the Tulsa punk underground; his blond crew cut became a bottle-black mop, and he traded in polo shirts and button-downs for shredded jeans and safety-pin T-shirts. While my brother, Aaron, and I may still have been a part of his friend circle, we were no longer the nexus of it, slowly replaced by a cavalcade of dead-eyed, perpetually narcoticized punk musicians (and punk "musicians," who were invariably all planning shows or working on albums that never materialized). Minus the brain eating, there was a genuine zombie movie vibe to Jacob's place, now filled to the brim with bodily fluids, excrement, and rotting (animal) flesh from weeks' worth of half-eaten hamburgers.

Though, like their cinematic analogues, Jacob's punk-zombies were often too high to be more than monosyllabic, if you could get them talking, they sounded a bit like them, too: They all wanted to make the pain go away. There were runaways who'd been kicked out of the home for coming out as gay or bisexual; victims of childhood molestation by clergymen—survivors who'd subsequently lost their faith; and there were children of broken homes whose parents had weaponized them in the divorce. There was Jacob, who was going to night college for a degree he didn't want but that his parents insisted he obtain, working a full-time job he hated at eighteen just for that whiff of freedom financial independence offered. Dig deeply enough with any of them, too, and you began to get some darkly consistent answers about their aspirations for the future: gay, Latino, atheist, *punk*, they didn't *see* futures for themselves in rural Oklahoma, or a way to escape it.

Like the zombies of *Return* who will inevitably rot into nothingness, they were just biding their time before they expired. They weren't exactly *okay* with it, but there was a certain stoic acceptance that this was inevitable. You can't reverse the process of decay, they reasoned.

Just like *Return*'s unfortunate Trash, transformed into a zombie after they converge on and devour her, proximity spelled doom for Jacob, and he, too, became one of the undead. With his ersatz "roommates" eating through his finances (he was supporting many of them), he finally demanded they begin contributing to the household, which they did by offering him some of the morphine one of them had obtained through some shady connection at a local hospital. Now with access to an even greater escape than he'd ever known before, it wasn't long before Jacob had joined many of his "friends" in full-blown addiction; like Freddy, who sets his sights on Tina's chewy caramel brain after he achieves full zombification, so, too, did Jacob begin preying on those closest to him, hitting up friends for cash after he lost his job following one too many days spent shooting up. If Jacob didn't realize it, my brother and I did: It can be dangerous to spend too much time around zombies. After nearly getting pummeled by a Tarman wannabe—in our case, a giant guy with a pink swastika tattoo on the side of his head—at one of Jacob's "parties," my brother and I stopped coming around.

Evicted and ultimately arrested for burglary, Jacob finally got his wake-up call when he *literally* woke up in the hospital with no memory of why he was there. It later transpired he'd been jumped in a dive bar men's room, violently mugged, and had his head

split open with a pipe. By either some cosmic twist of fate, divine intervention, or a really big coincidence, he'd been found by one of his old punk friends, who himself was going into the bathroom to shoot up; recognizing Jacob, he loaded him into his car and dumped him at the entrance to the nearest ER, fearful of getting picked up on a number of outstanding warrants.

If Jacob had become a metaphorical zombie, just like in brain-muncher fiction, it was a literal head shot that took him out—or, in this case, snapped him out of things. Kicking morphine, he eventually got steady employment as an AV tech for a school system, a job that, by all accounts, he enjoyed. He was certainly happy when I saw him in 2009, during a visit back to Oklahoma to stay with my brother in between semesters of college. Jacob and I hadn't seen each other for five years by that time, and my brother and I were delighted when we ran into him leaving the barcade where I'd spent the afternoon trying and spectacularly failing to secure a Ms. Pac-Man world record. It was a golden Tulsa summer sunset that cast all the world in a purifying sepia light, and we were all delighted to see one another again. We talked about old times and what we were doing now, and it seemed that, for all that had transpired, nothing had changed, and we were teenage kids plotting our B-movies again, *Return of the Living Dead* reliably playing in the background.

It was the last time I ever saw Jacob.

Sitting in a parking lot in August 2020, still in the depths of the COVID-19 quarantine, I got the text from my brother that Jacob had died the night before, in the hospital where he'd been admitted a week prior for ruptured esophageal veins, the result of

undiagnosed end-stage cirrhosis, a lingering effect from his time among the zombies. As in *Return*, and similar to most zombie media, the virus was ultimately fatal.

What's the solution, then? When things seem overwhelmingly awful, when we're drowning in our pain and sorrow, how do we cope? The answer, though seemingly obvious, is equally difficult. *Stop*. Stop running, stop attacking, stop mindlessly devouring what's only destroying us. The zombies encounter, over the course of the film, a mortician, multiple medical professionals, and indirectly come into contact with the US government; had they stopped for a moment, grounded themselves, realized they had another shot at life, might they have been able to explain themselves to a sympathetic audience? Might they have gotten the help they needed? It might seem like the least effective alternative in the moment, but grounding ourselves, taking a moment of peace for ourselves, finding a way to exist in the *now* is the great long-term solution. It allows us to calm our anxiety, clear our minds, and determine better, more effective solutions for the future. At the risk of denigrating other steps of the healing process, being able to place ourselves mindfully in the moment is perhaps the most important of them all; without it, the rest are impossible.

The zombies of *Return* are never in the moment, though, as they lose themselves wholly to their endless quest for brains; as the zombies of Jacob's apartment lost themselves to their endless quest for self-destruction; as Jacob, himself, was sadly finally lost to another sort of awful virus that'd gotten into him long before it took him. My brother and I were seventeen when Jacob made his descent into punk squat zombie annihilation; I'd like to think

that, if I were older and wiser, I could have maybe taken him aside, told him to breathe, and asked him to talk. Maybe it would've helped; maybe not. Unlike the ghouls of the film he loved so much, though, he did have a chance, and I wish that I or someone else had been able to make him see that. Since that isn't the case, though, it's my hope that this portion of the book may serve of some use to the millions of other Jacobs out there who can learn something from it; I'm sure that somewhere out there, Jacob himself is deeply pleased that one of his favorite movies is being used for a bit of good. To the summer of '04, Jacob—*BRAINS!*

Oh, the Humanity!

Aside from 1978's *Dawn of the Dead*, 1985's *Return of the Living Dead* is easily my favorite zombie flick. A big part of this is because it changed zombie rules in many ways—they were faster and more aggressive, they talked (even comically at times), they problem-solved, they were the first zombies to specifically lust after *eating brains,* and they weren't mindless carcasses aimlessly meandering around.

While obviously not a carcass, I can still relate to the aimlessly meandering around tendency of zombies—especially through years of substance abuse that left me feeling like a shell of a being and, at times, carcass-esque (if that's a thing?). After living several years of my life dependent on substances, which landed me in my first detox at twenty-four and provided some semblance of clearheadedness, I became aware of a yearning within. It was faint, but it was there and wanted more out of life than barely

existing.

After detox and a residential program, later I began learning about mindfulness and meditation, quickly realizing that what I thought meditation was—the practice of stopping one's thoughts—was incorrect. Instead, it's the practice of nonjudgmentally observing our thoughts as they arise, hang out for a bit, and then fade away.

Buddhist teacher Pema Chodron uses a friendly metaphor of our thoughts as the passing clouds in the sky whereas the sky itself is our ever-present mind—or our true self. A similar example is that of a stream that represents our ever-present minds, and either bubbles or leaves floating down the stream serve as representations of our thoughts.

Years later, after working with meditation practices for some time, I was watching *Return of the Living Dead* (for like the millionth time). Out of nowhere this silly idea popped into my mind to, while in meditation, replace all the pretty clouds, and skies, and streams, and bubbles, with graveyards and zombies. More specifically—I began picturing the wet, eerie, dark, and sludgy graveyard from *Return* as my mind and the decrepit walking and crawling zombies as my thoughts that passed by, and holy hell—it worked! That is, until the infamous scene of punk goddess Trash (played by Linnea Quigly) dancing fully naked on a tombstone entered my mind. Ugh.

In Buddhist cosmology there is a malignant antagonist named Mara whose main goal was to try to distract Siddhārtha Gautama (the yet to be Buddha) as he sat meditating under a bodhi tree, vowing to not get up until he reached enlightenment. Mara's most

potent distraction was in the form of trying to seduce Siddhārtha with visions of beautiful women. Siddhārtha endured the temptations and did reach enlightenment. I, however, did not.

The irony of Trash's amazing striptease was the dialogue she shared with her friends just before she began getting naked. She said, "Do you ever wonder about all the different ways of dying? You know, violently? And wonder, like, what would be the most horrible way to die? Well, for me, the worst way would be for a bunch of old men to get around me and start biting and eating me alive." And that's exactly what happened to poor Trash. Still, it's the sexiest damn zombie death I ever have seen, and while she is certainly a distraction in my meditation practice, I'd be lying if I said I didn't take a second or two to note her presence with a slightly crooked grin. I mean, I am a human, ya know?

When using the *ROTLD*-themed meditation practice, I started likening Trash's appearance to that of Mara's seductresses trying to tempt Siddhārtha. So, when Trash occasionally makes her way into my meditation, I try to immediately think of Tarman—*ROTLD*'s gnarliest, grotesquely dripping black tar-like substance everywhere saying his infamous line, "Brains!" and then returning to mindfully watching the various zombies (thoughts) crawl their way through the swampy recesses of my mind (self).

Does that always work? Hell no! I'm human, and this is Linnea Quigly we're talking about. So if I do find my mind locked in a battle between Tarman and Trash, I know who the victor will usually be (I'm looking at you, Trash) and simply go back to some more traditional sky and stream visionary meditative practices. As they say in the twelve-step fellowships, "progress, not perfection."

PRACTICE: 5-4-3-2-1 Grounding and Body Scan Meditation

Although it may not always feel like it, life is a gift, and if noth-
ing else, we're lucky to experience our brains evolve to the point
that they have. Rather than being mindless brain-eating zombies,
we can use our brains to enjoy watching mindless brain-eating
zombies as a form of entertainment. We can also use our brains
to practice various forms of mindfulness and meditation that help
us become more aware of just who exactly we are in this often
confusing and frightening world.

As mentioned earlier in the Freddy Krueger chapter, mind-
fulness can be practiced literally anywhere at virtually any time as
it's simply the process of acknowledging what's going on around
you and within you in that moment as you engage as many of
your senses as possible. Try not to linger on any guilt or shame
that may arise over the past nor any anxiety about your future—
rather, just be here now, fully engaged with the present moment.
The following are two practices that can help assist you in accom-
plishing this.

5-4-3-2-1 Grounding

A very simple and effective practice I like to use is called 5-4-
3-2-1 and goes as such:

Begin by taking three to five slow and intentional breaths to
help anchor you into the moment. Then, acknowledge five things
you can see around you, four things you can touch, three things

you can hear, two things you can smell, and one thing you can taste. Yup, it really is that simple, and it really does work.

Body Scan Meditation

While mindfulness is something that can be practiced at almost any time, meditation is a practice that is better done at specific times—which are up to you—and in a quiet place with no distractions. While the breath is generally the main focus of meditation, an alternative meditative practice I enjoy using is the body scan method. This can be done in as little as three to five minutes or as long as thirty to forty-five and consists of scanning our bodies from head to toe looking for any areas of tension we may be unknowingly holding. This can be done lying down, sitting in a chair, or in other various postures. Body scan meditation has been shown to help our nervous system's response to our body, manage anxiety, and help with sleep. A win all-around. Here's a quick and easy walk-through of how it's done:

1. Take three to five long and slow intentional breaths.

2. Now bring your awareness to the top (crown) of your head. The key word here is *awareness* as we don't want to be thinking about the various parts of our bodies but rather, simply noticing them without judgment.

3. Next, slowly move your awareness down through your body while looking for any areas of tension you may be holding. Start at your forehead and work your way down through the eyes, cheeks, mouth, jaw, neck, shoulders, arms and hands, chest, back, abdomen, lower back, pelvic area, legs, ankles, feet, and toes.

4. Next, repeat this scan slowly in reverse from your toes back through your feet, ankles, legs, pelvic area, lower back, abdomen, back, chest, arms and hands, shoulders, neck, jaw, mouth, cheeks, eyes, up to the crown of your head—again, seeing if there are any areas of tensions you missed or possibly released but came back.

5. Finally, see if you can feel your entire body united as one interconnected entity—which, in actuality, it is. Nothing to worry about if you're not quite able to do this yet. We spend the majority of our lives focusing on things external to us, so becoming more aware of our inner selves can take some time. It is pretty cool to feel fully embodied as one interconnected being, though, so try to stick with this practice until you get to that point. I don't think you'll be disappointed.

Chapter 6

Sinking Our Teeth into Life's Problems One Bite at a Time
Bruce the Shark from *Jaws*

"Ha ha, they're all gonna die."

—Hooper (*Jaws*)

Oh, the Horror!

Though most of us would hate to admit it, any hunting expedition —be it for food or survival—is something of a game of wits. Humanity may have developed the spear, the bow and arrow, the knife, and the gun over the course of our long evolution, but we're merely a blip on the radar in the great history of Mother Earth. Many animals have been around far longer than we can even comprehend, and what they lack in verbal intelligence or social graces they more than make up for in pure, brutal, instinctual

cunning. From pack-hunting wolves who strategize attacks to snow leopards who utilize camouflage for ambushing prey, Mother Nature has spent millennia honing wild animals into perfect killing machines who survive and thrive not solely by brute force but through an unsettling degree of intelligence most of us would rather not acknowledge. The frightening, implacable intelligence of the animal kingdom and our insistence that we're still the apex predator because we have the guns and flashy cars and smart watches to prove it is the perfect metaphor for every situation in which we find ourselves in over our heads. The solution? Admit that vulnerability, accept the intelligence of the beast/insurmountability of the situation, and move forward accordingly.

That's a lesson we can learn from Steven Spielberg's fantastic *Jaws*, a movie that shows a group of characters forced to admit their helplessness before animal intelligence and gives us something of a dark object lesson in approaching life's struggles. If you're reading this book, you're likely familiar with *Jaws*, a film that, adjusted for inflation, is the most financially successful horror movie of all time.[vi] But, for the uninitiated few, here's the rundown. In the cozy seaside resort of Amity Island, vivacious young skinny dipper Chrissie Watkins turns up dead, hideously mutilated. That would be a tragedy under any circumstances, but for glad-handing mayor Larry Vaughn, it's especially terrible because Chrissie's brutal demise just so happens to coincide with the beginning of tourist season.

Although Vaughn is able to pressure tough-but-fair police chief Martin Brody into agreeing that Chrissie's cause of death

vi Its 1975 gross of $470,653,000 translates to about $2.6 billion in 2023 dollars.

was a boating accident, the subsequent, undeniably shark-related death of young swimmer Alex Kinter forces Brody and Vaughn to acknowledge there's an unusually aggressive man-eater in the bay—although that *still* doesn't convince the mayor that it's time to close the beaches, a potential death knell to the tourist money on which Amity relies. Now taking the case even more seriously, Brody recruits oceanographer Matt Hooper to the case, learning that, far from your average shark, the culprit they're after is a massive great white—and they're going to be in for a hell of a fight if they want to locate and kill it.

After the shark stages a seemingly precision-strike attack on a crowded beach during Fourth of July celebrations, a guilt-ridden Vaughn finally agrees to close the beaches. Further, he gives Brody the go-ahead to obtain the services of Quint, Amity Island's requisite creepy alcoholic. Quint's not your run-of-the-mill Jimmy Buffet–loving, turquoise-bracelet-selling beach bum, though: He's a World War II veteran who survived the infamous sinking of the USS *Indianapolis*,[vii] a number of whose crew were subsequently munched on by sharks. Ever since, Quint's weaponized his trauma into becoming a professional shark hunter of the highest caliber, and he's set on making Jaws the kill of his career. Setting a course for the waters of the Atlantic Ocean, the trio soon learn that the shark isn't just bigger than they could have anticipated, it's *smarter*, and an unusual battle of wits, wills, and resources is about to unfold between man and beast.

vii The cruiser that delivered the uranium and parts used to make the Little Boy atomic bomb dropped on Hiroshima. The ship was torpedoed by the Japanese Imperial Navy en route to training maneuvers in the Philippines.

For much of the first half of *Jaws*, the villain isn't so much the titular killer, which remains largely off-screen,[viii] but Mayor Vaughn and his stubborn refusal to admit that a shark may be terrorizing his idyllic Atlantic paradise and cutting into tourism profits. Obnoxiously clad in a series of go-to-hell suits that only a certain stripe of individual can *really* pull off (see author photo), Vaughn's hucksterism at first glance seems to be the cold-blooded result of capitalism run amok, a profits-over-people approach to life that'd fit in nicely in any given 1980s corporate cutthroat flick.

As the film progresses, though, an undercurrent develops that there's something a little more human at play in Vaughn's insistence that the shark deaths must be related to something else: fear that he's up against something he's woefully ill-equipped to handle. One gets the impression that Vaughn's been consistently reelected mayor of Amity Island precisely for many of the reasons the viewer comes to hate him: all ostentatious cheerfulness, Vaughn is a 1930s carny reincarnated into the body of a 1970s-era politician, a personality type that, under normal circumstances, makes him the perfect candidate to rule over a town whose primary business is tourism and whose biggest issues are probably public intoxication and keeping the beaches clean. He's the right man for the job as long as there isn't a man-eating abomination of nature on the loose, but when he comes up against that, rather than admit he's in over his head, Vaughn—like many of us—refuses to admit defeat or, rather, not even defeat but that he is simply ill-equipped to handle the threat facing him. Even after being forced to acknowledge that there is, in fact, a shark terrorizing

viii A happy accident due to frequent breakdowns in Bruce, the mechanical shark built to "play" the role.

the town, he's quick to accept that the threat is less grave than the larger creature suggested by Hooper, instead readily accepting that the culprit was the smaller, less deadly, and more easily hunted tiger shark brought in by local fishermen.

Only when he's reached his rock bottom—when the shark stages a bold midday attack on the beach—is Vaughn forced to confront the fact that the threat is real and that he's *not* the man to confront it. Similarly, too often in life, we allow ourselves to reach similar rock bottoms before we're able to admit we need help, be it in a professional setting when we struggle to complete on time a task we're unequipped for, or personally when facing a life challenge we need external support to overcome.

Once the threat of the shark is placed in the hands of men capable of tackling it—Brody, Hooper, and Quint—even they're reticent to admit the true extent of what they're up against. As illuminated by Brody in the now immortal line, "You're gonna need a bigger boat," they've not truly considered how powerful and cunning their threat is. Time and again, the men underestimate the shark, each of them assured for various reasons that they're the superior hunter to this primal foe.

Both Quint, who's faced down sharks in the past after surviving the sinking of the USS *Indianapolis*, and Hooper, an expert oceanographer, *fail* to anticipate the true power of the shark on multiple occasions. First, when Quint tries to use his boat to drag it to shore, he underestimates the strength of the creature, despite having seen its total size, resulting in him ruining the engines and potentially stranding the men. Later, Hooper attempts to inject the shark with poison from the "safety" of a shark cage,

again underestimating that this is no typical shark and trusting in the power of human engineering over animal strength; again, human's hubris falls before the superior killing abilities of Mother Nature, and the shark nearly consumes him. In the resultant fray, Quint neglects to exercise caution against the now frenzied shark or engage in any defensive maneuvers, convinced that, as the experienced seaman, he's got the upper hand in the situation; as a consequence, he's killed when the shark stages an unexpected ambush on the boat, taking advantage of Brody's rescue of Hooper. Having witnessed firsthand the shark's attacks multiple times, the men never stop to reevaluate their plan, return to shore for better supplies, or strategize against a foe that's far more cunning than they give it credit for.

While we naturally never get a portion of the film told from the shark's point of view, its behavior indicates that it's far from a mindless killing machine. Consider the shark's MO: The first time we see it attack, it's an isolated swimmer under cover of darkness. Later, when eating Alex Kinter, it engages in what the FBI would characterize in a human serial killer as a blitz attack: the sudden, aggressive use of extreme force on a target with the goal of immediately killing or immobilizing them before quickly fleeing the scene. It later seems to taunt its prey, appearing to terrorize them for a moment before Quint harpoons it and then almost spitefully pulling his floatation barrel underwater. This is an intelligent creature, perhaps even one capable of some degree of what we might call executive functions in a human, but the men fail to recognize that they're not up against "just" an unusually big animal. It's an underestimation that kills Quint and nearly claims the lives

of the other two men.[ix] So, acknowledging its superior hunting prowess, what can we learn from the beast?

In a word: strategy, or rather, formulating our own calculated plans of attack to approach the problems in our life one bite at a time. After all, as we get to see in gruesome detail when Quint meets his end, in the wild, the great white shark does not chew its food, despite possessing 300 teeth. Instead, the animal uses those teeth to tear apart its prey into easily digested, bite-size chunks. Indeed, if Jaws were a person, it'd be a very well-organized, put-together one: It never goes after problems bigger than it can handle (tending to attack individuals), strategizes the best time and place for action (targeted attacks), and when it must face large problems head-on, it breaks them down piece by piece instead of trying to tackle the big picture at once (pinpointing individuals in a crowd versus going after everyone/literally taking chunks out of people). Put that brain in a human body and wheedle out the killer instinct, and you'd have a hell of an event manager or life coach on your hands.

None of us likes to admit when challenges may be beyond us or when we come up against an obstacle or challenge that's bigger than us. This is an inevitable part of life, though, and the better part of wisdom is to be prepared to acknowledge there will always be certain issues we can't tackle and people who are maybe more skilled or talented than us when it comes to a particular aspect of our lives. Acknowledging this and then both seeking help and

ix Notably, in the source novel, Hooper is killed and eaten when the shark breaches the cage, and his character was meant to meet the same demise on-screen. He was spared only when a second unit happened to capture footage of a real great white shark attacking an empty cage. Spielberg—struck by the power of the footage—opted to include it in the film, sparing Hooper.

learning from the individual or challenge are parts of developing as happy human beings and enjoying our best lives. This is what makes Brody the ultimate hero of the film and allows him to come out on top: For all the screen time he spends chugging down booze, from the get-go he's the one who recognizes both the threat of the shark and the need for outside help. This makes him perhaps one of the only competent—if not borderline alcoholic—local cops in horror history and a generally well-rounded individual. He identifies the problem, knows that he can't solve it on his own, seeks the professional assistance of Hooper and Quint, realizes that an initial plan may have flaws (the bigger boat line), and never underestimates the shark, allowing him to finally get the upper hand in the end by taking advantage of circumstance and improvising a plan to kill the creature. In a world where we'd all like to think we're brilliant Hoopers or fearless, hard-ass Quints, it's best to remember that it's humble Brody who ultimately comes out on top; and at the end of the day, I think we'd all rather be Roy Scheider in bad glasses than chum.

Oh, the Humanity!

The element of fear the killer shark Bruce induces in *Jaws* is caused more by his absence during the majority of the first half of the film (due to mechanical issues as mentioned in the previous section), which, in my opinion at least, resulted in a very happy accident for both Spielberg and viewers alike. This was because the actual scope of what the residents and visitors of Amityville were facing on their beaches and in the water was left to

our imagination. As humans, when it comes to the unknown, a curious thing happens—many people automatically lean toward worst-case scenarios. Scenarios that rarely happen—unless you're poor little Alex Kitner—but nevertheless, our minds often tend to take us there.

A glaring example of this is when it comes to change. It's such a hell of a thing, change, and when it comes to the thought of actually acting on a change, well, that can be just downright horrifying. As a result of the fear to change I've witnessed countless individuals who've remained in jobs they hate, unfulfilling relationships, living various forms of unhealthy lifestyles—which leads to myriad physical, mental, emotional, and spiritual maladies—and all because "the familiar" is more comfortable . . . even when it isn't.

Herein lies a wonderful opportunity to take a note from our friend Bruce, who, as exemplified by his piece by piece devouring of humans, teaches us that if we break tasks down into manageable (or bite-size, har har) pieces, almost anything is possible. Later, I'm going to share an incredibly simple and effective practice I use that helps make change and reaching our goals more tangible, but first, let's take a quick look at the stages of change.

In the early 1980s researchers James Prochaska and Carlo DiClemente were exploring smoking cessation and as a result created the Stages of Change framework—one of the three components in their transtheoretical model of behavior change (or TTM). The framework officially consists of five stages (though an "unofficial" sixth was added later on), which are as follows:

The first stage of change is *precontemplation*. At this stage, the individual is either in denial or unwilling to admit they have a behavioral problem they need to change. The second stage is *contemplation*. At this stage the individual begins to acknowledge there is a problem but is yet unwilling to put in the necessary effort to make the change. The third stage is *preparation*, in which the individual becomes willing and gets ready to make the change. The fourth stage is *action*, which is to say when the individual actually sets out and puts forth effort to make the change. The fifth stage is *maintenance*, which maintains the changed behavior. The sixth (unofficial) stage is *relapse*. This is the time in someone's (not everyone's) life when they have slipped back into the old self-defeating behavior that they set out to change in the first place. Again, this sixth stage is unofficial but, in my opinion, is helpful if not necessary as I'm an individual who's fallen back into myriad self-defeating behaviors throughout my life. It's of importance to note that a relapse does not equate to failure, nor should one give up if they experience this stage. It's merely a setback and can actually be a positive thing if we're willing to take a look at the what, why, and how of where things started to go wrong so we can hopefully learn from those patterns and avoid them in the future.

Having patience and compassion for ourselves as we embark on changing anything in our lives is of paramount importance. Also, breaking things down into smaller, more achievable goals makes the potential feelings of anxiety and emotional overload lessen dramatically. If only Quint hadn't been so hasty as to set sail as quickly as he did with an ill-equipped boat and instead took a moment to breathe rather than hard charging Bruce the shark, he may have lived.

Bringing ourselves into the present moment, finding acceptance around what is right now, and then committing ourselves to take that first step is a huge win! Keep it simple. One step at a time, one day at a time. You can absolutely do virtually anything you set your mind to. I mean, if Preston and I can write a book about friggin' horror and wellness, try to tell me you can't accomplish whatever it is you've perhaps been intimidated to embark on. As Taoist master Lao Tzu said, "The journey of a thousand miles begins with one step." Try it out and see for yourself.

PRACTICE: SMART Goals

Brody, Hooper, and Quint set out on a mission to kill a magnificent shark, one that they were ill prepared for. While I'm guessing most of you reading this don't have plans to embark on a shark-hunting expedition anytime soon, you can still prepare in a more conducive way to achieve your goals than our friends in *Jaws* did.

SMART is an acronym for goal setting first presented by George T. Doran and now widely used. The cool thing about SMART goals is that they can be used in virtually any area of your life and provide a simplistic, intentional, and specific template to follow. SMART stands for:

Specific—Creating a goal so clear it's impossible to misinterpret.

Measurable—The goal should be created in a way in which it allows you to track your progress.

Attainable—A goal that is realistic.

Relevant—A goal that relates to your integrity, ambition, and makes you excited when you're thinking about it.

Time-bound—A goal with a specific date of completion. This can be anywhere from a week to a month to a year and beyond.

When put together, SMART offers a blueprint that helps direct your actions so every move you make puts you one step closer to your goal in the most productive way possible. Again, these goals can literally be used in any area of your lives from relationships to work to personal development. Literally anything. Using the desire to spend more time outdoors as an example, the following is what a SMART goal could look like:

Specific—I will spend thirty minutes outside every day.

Measurable—I will go for a ten-minute walk and keep the experience fresh by including other activities such as reading and practicing mindfulness to fill the rest of the twenty minutes.

Attainable—I will use a reminder such as Google Calendar so that I don't forget to do this each day.

Relevant—I will spend thirty minutes outside not only to break the monotony of what can sometimes be mundane indoor living but also to put me in touch with the magic of life. (Please know this can be done regardless of whether you live in a rural area or the hood—just please don't get shot or stabbed.)

Time-bound—My goal is to start this week and make it a habitual part of my life within a month of my doing so.

Bam. There ya go. SMART goals really are that simple. I hope you find them as helpful in your life as I have in mine.

Chapter 7

Letting Ourselves (and Others) off the Hook
Daniel Robitaille from *Candyman*

"We shall die together in front of their very eyes and give them something to be haunted by."

—Candyman (*Candyman*, 1992 version)

Oh, the Horror!

Perhaps no other franchise slasher in recent memory has gotten as raw a deal as *Candyman*, both in the movies and in real life. The former point is obvious: Unlike Freddy "I'm a child predator who sold his soul to dream demons" Krueger or Leather "I eat people because the economy bottomed out" Face, Daniel Robitaille has a sympathetic origin story that places him closer to

the Jason end of the slasher spectrum. The son of a slave and a talented Chicago-based artist, Robitaille's gruesome lynching for an affair with a rich white man's daughter (in order, they sever his dominant hand, smear him with honey to attract bees that sting him to death, and then publicly incinerate his corpse as a deterrent to other Black men) is what imbues him with his supernatural powers, transforming him into a hook-handed vengeance wraith who can be summoned Bloody Mary–style by chanting his name in a mirror.

In the real world, the *Candyman* franchise got not quite as brutal but just as fatal treatment as the fictional character: With its themes of the return of the repressed, the still complicated relationship between Black and white America, the lingering legacy of slavery and contemporary life in the inner city, *Candyman* should have been one of *the* horror franchises of the 1990s, holding up a shattered mirror to a country experiencing such immediate strife and developments as the Rodney King beating and subsequent riots, Crown Heights, the Million Man March, and more of what historian Femi Lewis calls "advances and setbacks for Black people." In the way Rod Serling's *Twilight Zone* reminded America it had a long way to go, so, too, could and should *Candyman* have been a hot-button franchise.

Instead, the series was shuffled into direct-to-video purgatory alongside the era's other under-the-radar horror franchises such as *Wishmaster, Leprechaun,* and *Hellraiser* (not terrible company if you can get it), netting only two sequels: 1995's enjoyable but bloated *Candyman: Farewell to the Flesh* and 1999's *Candyman: Day of the Dead,* the less said about, the better. Although the

series got a shot of much needed lifeblood from Nia DaCosta and Jordan Peele with 2021's *Candyman*, as of the writing of this book there are no plans for a sequel, and it appears that the movie is less of a revivification attempt and more of a coda that wraps up plots and ideas from the prior films while reminding America things *haven't* gotten better.

While the franchise's trajectory has been disappointing, it also makes a degree of sense when we consider the character himself, whose very MO throws a certain narrative wrench into things: While, on paper, Candyman should be an imminently sympathetic character, from the second he's revived as an undead force, the vast majority of his victims are innocent souls. Although the film leaves it ambiguous as to whether he or the gang leader who goes by the street name "Candyman" is responsible for the gruesome castration of a young boy, when the ghost himself appears later, he clarifies that he's *definitely* going after "innocent blood"—and for no other reason than to perpetuate his own myth. Further, rather than a source of inspiration for the people of Cabrini–Green or object lesson for those outside it, the Candyman story is a narrative prison, keeping the Black populace of the city in the grip of terror. Rather than use his powers to go after, say, racist cops, drug dealers, or right-wing politicians, Candyman instead puts them to incredibly petty, spiteful use. (Heaven knows if I were butchered by a bunch of Neo-Nazis and got to return from the dead with supernatural powers, the members of my synagogue are the last folks I'd be going after.)

Thus the dilemma: Candyman kills innocent people, but how do you root *against* a franchise slasher who's *also* the victim of a

brutal hate crime? While it's difficult from a marketing perspective, there is a degree of tragic logic at the core of the Candyman character, who becomes the living embodiment of the treatment industry adage "hurt people hurt people." To further explore this idea, let's first give ourselves a recap of the events of the film.

Grad students Helen Lyle and Bernadette Walsh have stumbled onto a find most people in their position would kill for. While working on a semiotics thesis on urban legends, the two young women come across the tale of Candyman, a hook-handed ghoul said to stalk Chicago's rapidly dying Cabrini–Green housing project, violently eviscerating anyone who dares summon him. Though most folks have heard—and spread—their share of urban lore, what's so startling to Helen and Bernadette is the extent to which the people of Cabrini–Green *really* believe in Candyman: They've ascribed a recent spate of particularly brutal killings to the phantom. Like so many cinematic rationalists who've come before her, Helen doesn't know that she's in a horror movie and dismisses the residents' fears as a coping mechanism. The real monsters, she reasons, are gang violence, drug addiction, poverty, and systemic racism, and the way she sees it, Candyman is simply a metaphorical monster concocted by generations of the oppressed to act as a scapegoat for their suffering. Helen's so sure, in fact, that she goes through with the ritual, attempting to summon Candyman herself. When the ghoul doesn't immediately materialize, Helen takes it as a sign that her theory is correct and continues on with her research.

Helen's about to be in for a rude—and bloody—awakening, though. This begins when she learns the origin of the Candyman

legend; an expert on local lore tells her the tale of Daniel Robitaille's tragic fate. When things really ramp up, though, is when Helen is attacked by a local gang leader whom she later fingers to the police, who arrest him and charge him with the string of killings attributed to Candyman. And that's when the entity finally *does* put in an appearance to Helen, not to kill her but rather to read her the riot act.

See, Candyman derives his power from fear, and for the last century or so his restless soul has de facto ruled over Cabrini-Green with an iron . . . hook. Ever since Helen began poking her nose around, though, and *especially* now that the press is attributing his killings to a mere mortal, his "subjects" have begun to lose faith in him. As a result, Helen is going to get a unique punishment: rather than dying, she'll have to live with the knowledge the innocent blood Candyman is about to spill is on *her* hands, now that the ghoul has to resort to drastic measures to restore his people's "faith" in him.

Anger is a powerful emotion, a primal response to pain, displeasure, slights (real or imagined), or any other negative stimuli that elicits hostility. Unjust anger and even righteous anger that's not properly challenged are both dangerous forces, though. Research has demonstrated that trauma—especially formative trauma—can actually reshape the limbic system, the part of our brains responsible for emotional regulation. As a result, traumatized individuals often have difficulty controlling their anger and impulses, struggle to re-center themselves after a provoking event or flashback, and neglect to engage in self-care. Due to this emotional dysregulation, they often also lash out at exactly the wrong

people: those closest to them, including friends and loved ones, not because the individual is *directly* upset at them but by sheer virtue of proximity. How many of us have known someone with traumatic incidents in their background who've snapped at us or lashed out, only for them to later simmer down and apologize with something along the lines of "it's not you, it's the situation" or something similar? Too, the phenomenon is especially prevalent in men who've survived trauma and been socialized to view vulnerability as "weak"; psychology has discovered that unexplained anger is often a marker of depression in men versus crying or uninhibited displays of sadness in women, as Western culture has programmed men to see aggression as an acceptable response to frustration.

Taken from this perspective, Candyman makes a bit more sense: What we're seeing is human trauma response played out on a supernatural level, with the ghost of Daniel Robitaille blindly lashing out in response to his death and resurrection. Perhaps not conducive to a franchise character (it would be much easier to root for and follow the ongoing adventures of a supernatural vigilante, after all), it is at least a tragic psychological portrait of the way trauma and anger can warp the best of us.

What's the proper response to trauma, then? One of the biggies, as I've insinuated above, is channeling our anger in the right directions, toward the right causes, and toward constructive rather than destructive ends. Channeled, righteous anger can be put to powerful use: It's been one of the fuels in the fire of every civil rights struggle in America and abroad, and to say that the protestors marching on Selma or the crowds at the Berlin Wall weren't

angry would be a disservice to their experiences. Malcolm X and Martin Luther King were angry; Gandhi was angry; Elie Wiesel was angry; Gloria Steinem was angry. In each instance, individuals angry about personal and societal injustice harnessed that emotion and synthesized it into something transformative, powerful, and above all, positive. An axe is either a tool or a weapon depending on the hands that wield it; so, too, anger can be a force for positivity rather than destruction if utilized correctly.

We also need to talk about self-care, though. While the term has become something of an overused buzzword in recent discourse and often becomes a crutch for selfish or apathetic individuals to excuse their lack of engagement or shirking of responsibility, a certain level of stepping back, disengaging, and worrying about our own well-being is an important part of being a psychologically and emotionally healthy individual. While, superficially, self-care often takes the form of personal luxuries such as a hot bath, nice meal, or weekend parked in front of the TV, there's also an internal component that many of us neglect and that is equally important: a psychological inventory. How am I feeling? Are the emotions negative? If so, what are they? Anger, frustration, anxiety? *Why* do I have these negative feelings, and, more important, how can I engage with them and either put them to positive use or eliminate them?

For individuals with ongoing external or internal stressors, be it a bad job or unhappy home life or unresolved trauma, external self-care can only accomplish so much. Candyman has worked to keep his legend alive, sure, and that ensures his name and the injustice of his death aren't forgotten and swept into the dustbin

of history as so many atrocities have been. It's the supernatural equivalent of standing under a hot shower at the end of a long day though: Nice, but in the big picture of our ongoing mental health and well-being, what precisely does it accomplish?

A hundred years after his murder, Candyman is thriving, but Daniel Robitaille is still angry, tormented, and not getting any better. If your entire immortal existence consists of waiting around to kill innocent people for the crime of saying your name, how fulfilling can that really be? Unlike Freddy Krueger and Pinhead, who seem to be having a ball living for all eternity with grody powers, Candyman comes across as deeply unhappy with his lot in eternity. Indeed, the hook with which he slays his victims becomes a potent metaphor for his inner life: Just as the world is forever metaphorically "on the hook" for his death and subject to get cut down for dissing his legacy, so, too, is Daniel himself "on the hook" to his own inner torment and inability to address it. He's "hooked" on vengeance against an enemy with no face or name, "hooked" on instilling blind, baseless fear in his own people.

If Candyman could engage in an honest psychological inventory—some real emotional self-care—he might be able to let himself *off* the hook, though. He could realize that his dominion of fear and senseless killing are doing more to carry on the legacy of his murderers than improve the life of the Black community and that the biggest victim of his unbridled anger is himself. Would—could—Candyman harness that anger for good? Might he even let it go and transcend this plane to either Paradise or a blissful nothingness? He'd only find out if he tried.

Similarly, we can only discover anger-free, happy futures if we

engage with the consequences of our own traumatic experiences, stop hurting other people—and ourselves—and both channel negativity and practice both physical and psychological self-care. Candyman may be damned to an eternity of all-consuming rage and lashing out at the wrong people (come on, seriously—how cool would it be to see him go to town on a Neo-Nazi rally?), but he's also a supernatural ghoul. As flesh-and-blood human beings, we've actually got a chance for ourselves.

Oh, the Humanity!

After his death at the hands of a racist lynch mob, artist and slave Daniel Robitaille becomes Candyman, a total badass who will gut anyone from "gullet to groin" that dare speak his name five times. That, in and of itself, is terrifying enough, yet what I personally found almost just as terrifying in the *Candyman* film is the conditions in which the poor, marginalized residents of his stomping ground, Cabrini–Green, find themselves living in. And just like Candyman's severed hand, these low-income housing projects consist of severed families, severed hopes, and severed dreams. Unlike the fictional character Candyman, Cabrini–Green is a very real place in Chicago, Illinois.

I've spent years of my life living in ghettos. From Sisson Avenue in Hartford, Connecticut (it's come up a lot since I lived there in the early 2000s) to 49th Street in City Heights, California, I've seen a lot—pimps, prostitutes, gang violence, guns, knives, fights, excessive homelessness typically coupled with drug and alcohol abuse and severe mental health issues, nightly ghetto birds (aka

police helicopters) looking for various suspects, and all the heart-break, hopelessness, and utter despair you can imagine. These locations and experiences, however, pale in comparison to the reality of Cabrini–Green.

Still, having experienced years of drug and alcohol abuse myself, coupled with major depressive disorder, anxiety, body dysmorphia, and homelessness, I've always felt a deep kinship with marginalized and cast aside populations such as those in Cabrini–Green, as I believe that many of its residents, like me, did not or do not feel okay with who they are, which led to where they have ended up in life. In one of her blogs, meditation teacher Tara Brach speaks to this: "The wounds in our lives are so often related to severed belonging and the ways that we in some way get split off from the feeling that who we are is okay. Through our families and our culture, we get the message that something is wrong with us. We split off because we get hurt or because an-other has not been able to stay with us."[1] I'm not a betting man, but I'd place pretty much any wager that Brach has not seen 1992's *Candyman*, let alone know its protagonist Daniel Robitaille's (aka Candyman) origin story, yet she somehow seems to summarize the overall plot in a single paragraph that's seemingly unrelated.

Whether Brach has seen it or not, her thoughts led me to wonder how residents of places such as Cabrini–Green, people who find themselves in pain due to the various severed and frac-tured components of their objective environments and subjective inner wellness, make it through their day-to-day existence. This query then expands to not just residents of ghettos and subsidized

housing projects but humanity, which deals with the hardships in life.

Returning to the wisdom of Brach's blog, "The beginning of healing is recognizing suffering and asking the question: Where does it hurt? Seeking to understand, offering our interested presence, is the first wing of spiritual re-parenting. Just as the concerned parent, seeing their child upset, angry, withdrawn, would want to know what's going on, we can learn to bring interest to our inner life and gently ask ourselves: *What is going on inside? Where does it hurt?*"[2]

There is a saying, "The only way out is through." This is something I can say from direct experience is true. Sure, it can absolutely suck, but if we want to begin healing from pain and traumas that are detrimental to our overall well-being, it really is necessary. When endeavoring upon this kind of work, kindness and compassion are our friends (see the Loving-Kindness practice in the Leatherface chapter for more). Life's already tough enough, so why not cut yourself, and others, some slack? Can you imagine how much kinder this world would be if we did?

Random acts of kindness are also helpful with this. Not only do we get a nice hit of dopamine when doing something nice for another, we never truly know the reach those ripple effects can have. Something as simple as smiling at a stranger, holding the door for someone, paying the toll for the person after you, or buying a cup of coffee for the stranger standing in line behind you are all very doable, and again, you never know how far a reach that may have. Perhaps it inspires the stranger to in turn perform their own random act of kindness for someone else, and then

that person does it for someone else, and on and on it goes. Once again returning to Brach's wisdom, "If we really want to have a world where we can connect and respond to each other, we must widen the field and attend with the same understanding and care to all humans, all species, all the parts of this living world that are having trouble. We begin with the same question: *Where does it hurt?*"[3]

And we're the only ones who can answer that question for ourselves, "Where does it hurt?" It's typically not easy to take an honest and unflinching look at the reality of what's going on within ourselves—especially when it comes to looking at mentally, emotionally, and spiritually difficult material—but if we want real healing in our lives, this is where that truly begins to take form. Imagine if Daniel Robitaille were to heed Brach's advice and looked at the tragic pain he carried within and worked skillfully toward tending to the hurt inside rather than lashing out in murderous sprees to deal with it—then again, we wouldn't have such a fantastic film as *Candyman* that we do, so I guess there's a time and place for everything.

Now, if only there was a way to say Tara Brach's name five times and conjure a presence of infinite care, compassion, understanding, and loving-kindness. Hey, a guy can dream, right?

PRACTICE: Five Steps Toward Forgiveness

Author Toni Bernhard's favorite definition of forgiveness is "to forgive is to stop feeling angry or resentful toward yourself or others for some perceived offense, flaw, or mistake."[4] Realistically, if we lived in a world without forgiveness, it would be virtually

impossible for people to live together in even the minimal harmony that we see today. Forgiveness is also vitally important to our psychological well-being, physical health, relationships, and again, the world as a whole. It's also helpful in the reduction of anxiety and depression. Taking this into consideration, it becomes clear that the benefits of forgiving ourselves and others far outweigh the cons. But is it really that easy? Absolutely not! Still, is it doable? Um, yes? I think? Maybe? Truthfully, I really don't know, but I do believe it's entirely worth giving our best efforts when we're ready and the time feels right.

According to the Mayo Clinic, "Forgiveness can be hard, especially if the person who hurt you doesn't admit wrongdoing." If you find yourself stuck, here's a helpful list they provide:[5]

1. Practice empathy. Try seeing the situation from the other person's point of view.
2. Ask yourself about the circumstances that may have led the other person to behave in such a way. Perhaps you would have reacted similarly if you faced the same situation.
3. Reflect on times when others have forgiven you.
4. Write in a journal, pray, or use guided meditation. Or talk with a person you've found to be wise and compassionate, such as a spiritual leader, a mental health provider, or an impartial loved one or friend.
5. Be aware that forgiveness is a process. Even small hurts may need to be revisited and forgiven again and again.

My sincerest hope is that with the forgiveness practice provided here, as well as the other practices offered throughout the

Chapter 8

The Guts of What Really Going with the Flow Looks Like

The Thing from *The Thing*

"I don't know what the hell's in there, but it's weird and pissed off, whatever it is."

—Clark (*The Thing*, 1982 version)

Oh, the Horror!

A culture of suspicion and paranoia. A deadly biological threat, traceable only through blood tests and often undetected until it's already too late. Men turning on one another with accusations of ulterior motives and infection. A sense that the world is coming to an end. All these things describe the atmosphere and ambiance of John Carpenter's seminal 1982 classic *The Thing*, the early

1980s alien invasion flick that served as the feel-bad answer to *E.T. The Thing* initially bombed at the box office for its pitch-black tone and heinously visceral creature special effects before gaining cult status and eventual recognition as one of the greatest sci-fi and horror films ever made. All those same things *also* describe the state of America when the film debuted at the height of an epidemic of unprecedented proportions, one whose legacy we're still grappling with today: the HIV/AIDS epidemic, which ravaged the country's LGBT population and launched a wave of homophobic paranoia unchecked by the Regan administration, leaving those affected to fend for themselves and learn a very valuable lesson, one popularized decades later by the 2011 awards-bait sports drama *Moneyball:* "Adapt or die."

Rewatching John Carpenter's *The Thing* recently in the wake of the COVID-19 epidemic, it's startling how in addition to being an amazing horror film and fantastic SFX showcase it's also a mordant time capsule of a time in American history when AIDS specifically and homosexuals broadly were a cultural boogeyman, and how the LGBT community had to figure out for itself how to survive in the face of a careless world. And damn if we can't learn a *lot* from their perseverance and adaptability. HIV is a retrovirus that infects a host and rewrites their DNA, corrupting it to progressively degrade their immune systems, just as the Thing rewrites an individual's DNA to corrupt their identity and "rewrite" them into copies of the entity. HIV is considered a "smart" virus, which is why we're still struggling to tackle it forty-plus years later.

A recent conversation with a pair of good friends, Dan and Bradley, a married couple who've been together for over a quarter

century now and who survived the 1980s intact while watching numerous friends and loved ones succumb to the ravages of AIDS, revealed how startled they were by the lack of awareness in contemporary LGBT+ youth, particularly Zoomers, of the exact extent of the AIDS crisis in the 1980s, the stigma around it, and the atmosphere of panic the virus created.

For these younger generations, a world has never existed where RuPaul isn't one of the most recognized and beloved celebrities on Earth and *Drag Race* a zeitgeist-capturing phenomenon, or where a celebrity coming out as LGBT+ barely registers as a blip on the media radar. They've grown up in a world where AIDS *isn't* a death sentence and where pills to keep the virus in check are casually advertised during Hulu commercial breaks. For Dan, Bradley, and me, though, AIDS was once a viral grim reaper that stalked our nation broadly and its LGBT+ population especially, decimating 40 million people between 1981 and 2023 and impacting the public perception of queer individuals. There was a time when understanding of AIDS was so primitive it was believed by some that it could be transmitted through saliva or even airborne, engendering a culture of stigmatization so intense that even some medical professionals were afraid to so much as touch an AIDS patient's hand, let alone even be in the same room with them. While prominent public figures such as Jerry Falwell and Pat Robertson lauded the virus as a divine punishment, a seemingly simpatico Reagan administration remained silent for a crippling four years, leaving desperate victims and equally distraught medical professionals to handle the situation on their own, adapting as best as possible against a silent threat that could seemingly strike at any time.

While its source material, the 1951 alien invasion flick *The Thing from Another World*, served as a metaphor for the senseless paranoia of the Red Scare era and how baseless fear of communist infiltrators was perhaps more destructive than Russian agents themselves, Carpenter's *The Thing* holds up a mirror to 1980s America's fear of homosexuals as the dreaded, literally diseased "other." With its exclusively male cast, fixation on who's been "infected," obsessive talk of blood tests, paranoia over who can be trusted, lack of help from the outside world, and view of the "other" as hideously grotesque and diseased, it's hard not to view *The Thing* as a metaphor of America's panic over the AIDS crisis, especially considering how closely it was released to the virus becoming a major media talking point. Moreover, at the time of the film's release, it was believed that HIV/AIDS exclusively impacted homosexual men. Viewing it in this light, though, we shouldn't see it as a piece of homophobic scare propaganda depicting AIDS victims as monsters, but rather as a sympathetic portrayal of how the LGBT+ community was left on its own to take care of itself and rapidly adapt against the virus and an apathetic world.

Set over the course of a few days at an Antarctic scientific research station, *The Thing* finds a disparate group of men (and, make no mistake, every character is a man—the fact that this is one of the greatest sausage fests in horror history is gonna be important later) facing down the titular entity, an alien abomination that reproduces by consuming other life-forms and creating exact replicas of them, which in turn go on to consume and replicate other humans and animals. Realizing that the creature is capable of completely wiping out the human species, the station staff—led

by Vietnam vet/helicopter pilot/living embodiment of nominal determinism R.J. MacReady—attempt to devise a means not only of destroying the creature but of surviving the winter.

Just as deadly as the alien, though, is the mounting atmosphere of fear and distrust that grips the station as the men begin turning on one another under the suspicion that they've been "thinged," meaning that they might just end up doing the monster's work for it. After MacReady comes to realize that each of the creature's individual cells is a separate, living organism capable of living on its own if severed from the whole, he develops a test to draw the men's blood and expose it to a heated wire to see if it reacts defensively, ultimately leading to a final showdown between those who are still human, those who have been thinged, and those whose identities are yet to be determined.

So, what can we learn from *The Thing*? Again, we return to our mantra: Adapt or die. New situations call for new responses, and we must often look beyond our patterns, habits, and old ways of doing things in order to tackle a problem. Returning to the AIDS parallel, the gay community first became more mindful of safe sex practices, following the anything-goes '70s, during which herpes was the worst that could happen to you and most STDs were easily rectified with a shot of penicillin. Condoms, once derided as a source of inconvenience and hindrance to pleasure, became a sort of armor. Individuals became more mindful of their partners' sexual history as well as their own, getting tested to ensure they weren't infected and also couldn't infect other individuals (as commercials, radio ads, and billboards exhort even to this day, "Know your status"). Individuals at risk of infection via needle sharing

entered rehab or participated in safe needle programs that arose to provide safe paraphernalia for those unable, unwilling, or in the process of quitting. Those who adapted—like my friends Dan and Bradley and other elder queer individuals who are still with us—survived. For those who refused, though, the results were less optimistic. While countless individuals were afflicted through no fault of their own, many people refused to use condoms or keep aware of their status and continued to share needles either with strangers or with other drug users whose sexual history and HIV status they remained unaware of. Unfortunately, those individuals represent a chunk of the 40 million statistic I cited earlier.

Similarly, we see adaptation and change in response to threats in *The Thing*. Throughout the film, MacReady and the Thing adapt to each other's moves to try to gain an upper hand in their struggle: once Fuchs dies and can no longer develop a blood test to identify the creature, MacReady devises another; once the Thing identifies MacReady as its biggest threat, it prioritizes eliminating him before engaging in more assimilations. These are all situations neither one has encountered before, all requiring novel responses. So, too, as new, unfamiliar problems enter our lives must we devise novel solutions. How can we do this?

My good friend and colleague Dr. Erin Chernak pointed out the Change Management Model[x] put forward by social psychologist Kurt Lewin is the perfect schema for how to tackle unexpected and new crises in our lives and is what MacReady is attempting throughout the film.

The first step, unfreezing, refers to acknowledging that a new

x Appropriately, for the purposes of this chapter, also called the Un*freeze*/Change/ Re*freeze* Model.

problem has arisen and that established patterns of problem-solving won't be able to address it: while being "frozen" in our ways has aided us to this point, we must now acknowledge—like MacReady and company must acknowledge the alien threat, like the medical and LGBT+ community had to acknowledge the rise of HIV—that a new problem has arisen for which our old ways of doing things are no longer suited.

Many individuals become stuck at this very early stage of adaptation: We don't like to admit that we're up against something new and challenging; even if we're able to do that, we don't like to acknowledge that perhaps we're unprepared or unequipped to deal with it. Just as in *The Thing*, change is scary, even if the change involved isn't a man transforming into a homicidal spider-snake-monster before our eyes.

Far from simply acknowledging for ourselves that change is necessary, in a group dynamic—as depicted in *The Thing*—a core component of unfreezing is convincing the majority of individuals facing crisis of the need for change and that the status quo can no longer be contained, in the same way MacReady must assert authority over the men of Outpost 31 and the way that the CDC, organizations such as ACT UP (the AIDS Coalition to Unleash Power), and the American medical community had to force the Reagan administration to acknowledge the AIDS crisis needed government funding and attention.

A driving factor behind the unfreezing stage of the process is a compelling message with an emphasis on *why* change is necessary. For an individual, this may be sitting down and making a list of how current coping mechanisms and strategies aren't working,

or taking an honest personal inventory and acknowledging that current methods of problem-solving aren't working. In a group dynamic, this may need to take the form of a speech or presentation that outlines the issues being faced by the collective and how the current cultural climate isn't equipped to tackle them. We can think of this as the real-world equivalent of the dynamite and blood test scenes in *The Thing*: drastic situations calling for drastic demonstrations to convince the whole that change is necessary.

Once unfreezing has been achieved, change can occur. We ourselves, or the group in which we are involved, have acknowledged that change is necessary and are willing to undertake it. In the case of *The Thing*, change occurs slowly but is most completely achieved once we reach the blood test scene, in which MacReady finally begins the process of definitively determining who is still human although here we even witness some resistance from the other men. In order for change to occur, effective communication and new problem-solving systems must be implemented over a period of time; change can't take place at the drop of a hat, and effort (and blood tests against alien shape-shifters) needs to be put in. As the adage goes, "Do the work." During the change process, we workshop and employ new and effective strategies, asking ourselves, "Why was the old way of solving problems ineffective?" and "How can we learn from those failed methods to implement positive change?" This is the most difficult but core part of the process: following the AIDS metaphor, this is when the medical community, having finally convinced the Reagan administration

of the need for resources and the necessity of acknowledging a health crisis, began to learn more and spread awareness of preventative and palliative measures.

Once we've finally made the desired change—once we've adapted to new circumstances—we can at last refreeze—that is, continue to implement what we've learned to solve extant problems and apply that same knowledge to future potential crises, with the knowledge that the time may come when we need to unfreeze again to make future adaptations. Just as important as the ability to adapt, after all, is the acknowledgment that adaptation is necessary.

Ironically, MacReady (and potentially Childs) achieves this at the end of the film, ostensibly freezing to death after having finally defeated the Blair-Thing; if we assume that Childs has been thinged, the creature itself has gone on a similar trajectory, having adapted new modes of "battle" against humans before reaching the same conclusion as its prey. Again, to resurrect the AIDS metaphor, it's the way that we've adapted to the virus's role in American life: No longer carrying the same level of stigma, most people are now routinely made aware of its threat, how to avoid contracting it, and that there are drugs and treatment programs in place for those individuals who do manage to get it. No longer the scourge it once was, AIDS is now a part of daily life as a result of the adaptations and changes made to it and those changes being frozen into place as standard procedure.

Most of us will never confront inhuman creatures from Clive Barker and H. P. Lovecraft's most fevered dreams, but we will likely face health and financial crises, relationship problems, and

all manner of unexpected problems that will make us feel like our own personal worlds are ending. By being able to acknowledge the necessity of change, we can adapt to these challenges and power forward in life, confident in our newfound knowledge and mechanisms of coping, (Mac)Ready to take on whatever gets thrown at us.

Oh, the Humanity!

Sitting in a group therapy session recently, one of the members made me think of the adapt-or-die mindset while at the same time also exemplifying the beauty of what replacing outdated paradigms in a healthy manner can truly look like. This individual is an intelligent Caucasian male in his early thirties. He grew up in a very unhealthy foster care environment, which led to a young, angry, and confused adult by the time he landed himself in prison.

This young man is a tall, skinny individual who isn't only book smart but is street-smart and highly versed in the school of hard knocks as well. Being in prison, however, these things will only get you so far, and out of a fear for his safety and life, he made the very questionable decision of joining up with the Aryan Brotherhood, a white supremacy gang. While in this survival mode, he did some very grimy things that took their toll on him mentally and emotionally. Three years ago, he was released from prison and has shared in various group sessions that a very important part of his reentry into society was looking at long-held beliefs in all areas of his life—especially the ones that were no longer

serving him—and upon his honest examination, it came as no surprise to him that the first thing to be acknowledged were his outdated racist beliefs.

Today, he renounces his past affiliation with the Aryan Brotherhood but still struggles deeply with drug addiction and believing that he can live his life without the use of narcotics. While that may be an extreme example for some, I believe it's apropos. Even on smaller scales, outdated paradigms can pigeonhole us into very limiting viewpoints and close us off from the beauty and diversity that life has to offer.

If in *The Thing* R.J. MacReady had not been willing to throw out what he knew in certain situations and adapt to new ideas and actions accordingly as he faced off against *The Thing*'s alien/ monster, he wouldn't have lasted the entirety of the film, just like the young man from my group therapy sessions may have not survived prison had he not adapted to some horrendous beliefs and actions while there.

Like *The Thing*'s alien/monster that initially hides mostly in the dark, so, too, do our unexamined paradigms. And just like the Thing slowly makes himself more known as the movie proceeds, so can our unexamined paradigms. It's a universal law that the only constant is change, and if we're unwilling to examine our long-held beliefs from time to time, this can (and will) result in making our lives unnecessarily more difficult.

I was recently reading an article titled "The Science of Change: Working with—Not Against—Our Inner Systems" by Hal Williamson and Sharon Eakes,[1] which stated:

> Scientists have found that, as we go through life, we establish neural networks that record all of our sensory experiences. I find it

helpful to think of this mass of neural circuits as our "subconscious system," in which all of our experiences and our thoughts about our experiences are stored in an interconnected manner. These include our attitudes, assumptions, beliefs, stories we tell ourselves, and so on. It is the subconscious system that defines the state of current reality for each of us.

How utterly fascinating and illuminating. What this tells me is that while I like to think I'm operating from a current, present moment awareness (which sometimes I still believe that I am), most of the time my experience is being dictated by my subconscious system based on past experiences. So even if I'm not in an adapt-or-die situation, I'm still functioning in a manner that's rooted in past tense, which, unbeknownst to me, keeps me somewhat closed to new ideas and experiences and adaptability in general. The article then went on to say:

We have said that when our mind creates thoughts that are inconsistent with our experiences, habits, attitudes, and belief, we experience mental pressure. The subconscious system pushes back in an effort to maintain system equilibrium. This response from the subconscious arises without regard to whether we really want to change, or some source of pressure outside us demands that we change. Both inside and external demands for change evoke the same feelings of anxiety and an attendant equilibrium-seeking system pushback.

This made me think about *The Thing*'s alien/monster and how as its reign of terror continues, the characters' hostility toward one another grows, part of which can be attributed to their fear of the unknown. This fear—that of the unknown—is what underlies

many people's hesitation to change and fight against the flow of life.

Enter Taoism, a philosophical/spiritual path circa 500 BCE attributed to philosopher Lao Tzu and his book *Tao Te Ching*. Some of the main principles of Taoism are simplicity, patience, compassion, going with the flow, and letting go. Taoism also rests on the concept of harmonic order in nature and society. In essence, "The sage is to imitate the Tao, which works unseen and does not dominate. By yielding, by not imposing his preconception on nature, he will be able to observe and understand, and so to govern and control."[2]

The deliberate way MacReady adjusted his approach to the ongoing battle with the Thing throughout the film—while albeit inadvertent—could certainly be seen as a form of Taoism in action. He creates an audio recording of the events unfolding to have a record of the madness they're experiencing, lamenting that "nobody trusts anybody." With that recognition MacReady shows awareness of his surroundings and exemplifies the necessity of going with the flow in each interaction with characters throughout the remainder of the film. Regardless of whether we're fighting for our lives against an alien/monster or not, we can all learn to be a little more Taoist in life, hence the following practice to help:

PRACTICE: Practicing Taoism

Part of Taoism is learning to accept ourselves as well as discovering who we are for ourselves. The characters in *The Thing* did this and then some, exemplifying how the only constant in life

is change, which includes our human nature as well. The paradox, however, is that our infinite, absolute selves (some people call this our soul) are always the same, something the human mind typically resists. The practice of Taoism can help us learn how to flow with life and embrace change. Here are some principles for Taoism taken from the Mindful Stoic, a fantastic resource for mindful living:

Practicing Taoism

- With care, aide those who are merely extended expressions of our own nature. We are all fundamentally connected.
- At the same time, be true to yourself. Be authentic. Allow yourself to be vulnerable and imperfect.
- Connect to the world as you wish to be treated. Live the Golden Rule: Do unto others as you would have them do unto you.
- To those unwilling to accept you for who you are, no action is required.

The Silence of Practicing Taoism

- Embrace silence. Take time off for silence. Nothing could be more important. Silence is the soul's break for freedom.
- Let go of perfection. Work at being the best you can at whatever you do in life but also embrace the faults of life and your individual flaws. Imperfections make us individuals. Imperfections make us beautiful. Accept the good and bad or more accurately, blur the distinctions between the unhealthy labels of "good" and "bad."

- Explore your essence. Learn how to trust your own intuition. Listen to your own heart. If something doesn't feel right, then you need to examine why. Let go of judgments that hold you back. Remove conflict and anger from your relationships. If you find yourself in dysfunctional relationships, either set up firm boundaries for yourself or remove yourself from the relationship altogether. Life is too short. Empty your boat while crossing the river of life.

- And finally, and most important, be kind to yourself and pace your life to match your own true essence.[3]

Chapter 9

Strangers in Strange Lands (and Learning to Make Our Way)
Yautja from *Predator*

"El que hace trofeos de los hombres"
means "the demon who makes trophies
of man."

<div align="right">—Anna (Predator)</div>

Oh, the Horror!

You're all alone in a vast terrain, and a threat *is* coming. You can't see or hear it, but you know it's there. Your friends and allies have departed you, your back is against the wall, and if you're going to get out of this with your body and mind intact, it's going to take all the skill, cunning, and resources you have to identify and eliminate this invisible threat. That's the situation US Special Forces

Major Dutch Schaefer finds himself up against in *Predator*, the sci-fi action horror film that's entered the popular consciousness through launching a major franchise, the presence of Arnold Schwarzenegger at the height of his fame, and a certain gnarly clip that's gone viral thanks to its repeated appearances in *Arrested Development*. Sadly, it's also a situation *we* find ourselves facing quite regularly, albeit in a subtler (and less extraterrestrial) way: Too often, a different sort of predator enters our lives, individuals out to use us for their own purposes and exploit our better nature. Just as Dutch must use his intellect and skills as a soldier to identify and eliminate the predator from his life, so, too, must we learn to recognize when we're being preyed upon and remove ourselves from those relationships, be they personal, professional, or even intrafamilial.

Predator illustrates how even the canniest and least gullible of people can be taken advantage of if they're not on guard. At the outset of the film, Dutch is the head of a search and rescue unit within US Special Forces, a crack team who've put aside the skills they honed for killing in a previous life to dedicate themselves to *saving* lives. When Dutch is approached by former comrade-turned-CIA agent Al Dillon about a unique mission he wishes him to undertake, he is skeptical that the objective is altruistic and only agrees to take the assignment when he learns that his goal is to find and rescue a Guatemalan cabinet minister whose plane went down near a Latin American guerilla base. Rising to the occasion, Dutch and his men embark into the jungle, only to learn that they've been lured into two unique but equally deadly traps. The first has been laid by a recognizably human threat: Dillon lied about the cabinet minister and has intentionally lured Dutch and his men to the guerilla base knowing they'd be spotted

and that the trained soldiers would quickly and easily kill the civilian soldiers. As they learn after taking the sole survivor, Anna, hostage, the guerillas are far from rank-and-file rebels and are in fact backed by the Soviet Union in an attempt to get a foothold in Latin America, and Dillon's mission was always an assassination mission.

The second trap in which the men find themselves is far more surreal, and literally out of this world. The jungle is also home to a Yautja: a massive, crustacean-like, extraterrestrial "visitor" who's come to Earth on a hunting trip, intent on using the most dangerous humans it can find as prey in a sci-fi twist on the classic short story "The Most Dangerous Game." The creature had previously been stalking local hunters and the guerillas themselves, but after seeing Dutch and company make short work of their foes, the Yautja sets its sights on the military men, setting the showdown for a battle between the most firepower that Reagan-era America can supply (a memorable sequence features Dutch and his men firing machine guns aimlessly into the jungle nonstop for a full fifty-five seconds) and alien technology that renders the Yautja seemingly invincible.

Predator is one of those 1980s movies that my horror-hating dad should absolutely not have enjoyed but that he still loves to this day. Maybe it was the presence of Arnie in the cast, maybe it appealed to his love of sci-fi, but the guy who has never and will never sit down to watch so much as *The Shining* with me plunked me down next to him when I was probably about four and showed me a movie in which a giant space crab skins people alive and blows a dude's arm off with a laser cannon. It was one of my formative horror-going experiences, and, while Mom turned

out to be the parent with whom I could share a love of horror in adulthood, it was Dad who helped make me fan.

I found myself thinking about *Predator* quite a bit a few years ago, after I'd been laid off from a job vetting scripts for a production company while also serving as an acquisitions editor for their publishing wing and writing a column for the movie magazine they published. They'd acquired my debut novel, *Our Lady of the Inferno*, both for publication and to adapt it into a film, and they felt that an experienced writer rather than an intern or film school graduate was the right person to vet submissions.

For nearly the next four years, it felt as if I was one of the most beloved new faces on the horror scene. High-profile websites wanted to interview me about *Our Lady*, and beloved figures from my childhood were suddenly sliding into my DMs to congratulate me on the success of the book and asking if they could land a copy. Creators I'd long admired wanted to give me blurbs and sing my praises while others wanted to take me out for drinks, catch a movie with me, or just shoot the breeze. True "cool kids," admired and popular figures in the entertainment community, wanted to take me under their wing and usher me into their ranks. It was a dream come true for the formerly 300-pound teenage Jewish boy who had barely a friend in high school and who'd spent his formative years holed up in a bedroom every Friday night of his teen years watching horror movies—many of them made by or starring folks who now wanted to be my friend. I'd *finally* at long last found my tribe (see the *It* chapter).

I met a lot of great people this way: Mark Miller, producer of the beloved *Cabal* cut of *Nightbreed*, who'd go on to form the

publishing company that would print my next two books; screenwriter Jason Alvino, who's become a trusted confidant; Mick Garris, the director of many of the '90s Stephen King TV miniseries and an all-around sweet guy; actress Kelli Maroney, with whom I've collaborated creatively and with whom I still grab lunch whenever one of us is in the other's neck of the woods; and many more.

Then the day came that my coworkers and I got our pink slips—the company was being sold, relocated to another state, the magazine relaunched, and the publishing wing shuttered—and, as I slowly came to realize, I'd met many more *not* so great people.

It's easy to look back in retrospect and spot a pattern in many of my dealings during this time, one I wish I'd recognized and one that would've allowed me to safeguard myself a little bit more. All those folks who'd wanted to wine and dine me, who said my work was so great, how talented I was, and how happy they were for me—well, all those folks *also* had *little favors* to ask. Could I take a look at their script? Could I read their book? Could I maybe, gee, I hate to ask, but recommend their movie for acquisition? Could I speak to my paymasters about securing some financing for their project? Could I introduce them to X person, whom I'd worked with on a project and with whom they'd love to work, too? They were about to make a stand on a major social issue—I may catch some heat, but I was a *voice in the community*, and could I lend them support?

Behind so many friendly faces, plaudits, and "free" dinners was a mercenary expectation: Their admiration and friendship was wholly conditional on my getting them what they wanted.

It was a realization that set in slowly when folks who'd blurbed a book of mine suddenly pretended I didn't exist; when, now unemployed at the height of COVID, folks I'd helped get work and supported in the past wouldn't return phone calls; when people didn't want to just hang out anymore, or catch a movie, or grab a drink. When, at one of my darkest hours, I begged trusted friends for help and was told I just needed to "go away and make things easy" for them. Sure, it sucked that I'd lost my job during a global pandemic, could no longer afford to pay medical bills, was potentially facing eviction, and my career may be over, but *they* had jobs and were doing pretty well, so what was the problem? I went from being a "voice" to the target of snide vague tweets made by folks who just months earlier had been clamoring for my support and offering me their friendship. The cool kids moved on; I was no longer connected, so I was no longer convenient to them. And it all got me thinking about *Predator*, and how Al Dillon is a smiling, friendly face who appeals to Dutch's own talent—military maneuvers versus my writing—for his own purposes, only to leave him high-and-dry in enemy territory when he's no longer useful. And how, even more so, for those nearly four years that I thought I was riding on top of the world I was really no more powerful than Dutch lost in that jungle, invisible predators all around me, hiding not behind interstellar camo but false promises and, more insidiously, the offer of friendship, acceptance, love, admiration; how, like Dutch and his men firing wildly into the jungle and demonstrating their weaknesses to the Yautja, I'd brazenly left myself too emotionally vulnerable for human predators to identify and exploit my desire for belonging.

While my experience involved B-movie actors and 1980s genre icons, it's not a really unique situation. We're all subject to our own personal predators: from the coworker who's always grabbing us a cup of coffee and asking us if we can pick up their slack to the friend who constantly needs a sympathetic ear or a ride but who's never willing to reciprocate, to relatives who emotionally abuse and psychologically manipulate us in the name of "family," we're surrounded every day by folks who want to take, take, *take* from us without giving so much as a friendly "Hey!" once in a while. These emotional leeches can and will take from us until we can give no more, be it providing them with some sort of material gain or acting as their own emotional support system, and once we're dry—or no longer able or willing to give them what they want—they'll move on to the next person, leaving us feeling alone, exploited, and questioning our own value as human beings. After all, we all want to feel useful, wanted, and able to give, but we don't want to be valued *solely* for our usefulness, and the realization that we were involved in an emotionally meaningful relationship that was, in fact, built solely on transaction is uniquely devastating.

So what could I have done differently, and, for the purposes of this book, how can you learn from my—and Dutch and company's—mistakes?

Of utmost importance is listening to our own gut instincts. In many—though not all—instances, we can tell something is up. Thousands of years of evolution have honed in most people an instinct for a dangerous situation or when something or someone "isn't quite right" (the book *The Gift of Fear* by Gavin de Becker is

a fantastic read on this subject). Many times we *don't* get fooled; rather, what tends to happen when we're taken advantage of by emotional predators is that other factors override our own instincts, and we end up *convincing* ourselves that *we're* the ones in the wrong. Be it because of the promise of something we desire such as a job or experience, sympathy for a seemingly vulnerable person, or sentimentality toward someone for whom we feel loyalty or affection, we act against our own best interests.

Take a look at Dutch and Dillon's early interactions. After engaging in a sweaty arm-wrestling battle that doubles as an ostensible matching of wits, Dillon begins his recruitment attempt of Dutch. For the whole duration of the subsequent scene, Dutch audibly and visibly works to convince himself that Dillon isn't lying to him. He *knows* that something is up. He both knows Dillon's personality from their time in the service together and subsequently intuits that he isn't being forthcoming in their discussion, and he knows that the CIA probably isn't sending him around the world on aid missions.

In Dutch's case, it's his loyalty to his old comrade, his desire to feel that he isn't being lied to, and, most important, the appeal to his humanitarian streak—it's the story of the vulnerable, civilian cabinet minister that finally pushes him into taking the job—that cause him to act against his own instinct. Had Dutch trusted himself, he wouldn't have found himself confronting space crabs.

Too, in many instances, I realized that the folks offering me praise or friendship probably had some ulterior motive: The way they'd phrase something would seem insincere, or *too* sincere, or their praise was ostentatious, or they were calling me "brilliant" for a debut novel (sure, a lot of authors write *good* first novels,

but whose debut is really *brilliant*? Like, Donna Tart and Mary Shelley?). I could see the red flags, but the desire to finally be one of the "cool kids"—to feel like I'd finally found my tribe—let me convince myself that I was just being paranoid and mistrustful. If we listen to our own instincts, though, we can cut off exploitation by human predators before it even begins.

What happens once we're in the situation, though? What do we do when we end up subject to a human predator, be it because we ignored our own instincts or, even worse, because we were genuinely fooled into thinking that the relationship was based on goodwill, mutual admiration, and reciprocity? First, we need to be conscious of warning signs. Human predators are both very good at convincing us to give them what they want and very bad at hiding it as time goes on. Just as the Yautja's cloaking technology eventually fails it, and its untreated wound allows Dutch and his men to inspect its green blood, human predators will give us signs. If they're constantly relying on you for emotional support, validation, and empathy, how often are they willing to be emotional safe spaces for us? If they're constantly asking for favors, money, or other material benefits, how do they respond if we want or need something similar? If they ask you to put your neck on the line for them, be it vouching for them professionally or defending them from abuse in the workplace, home, or online environment, are they willing to do the same for you if you need it? If you're constantly there for them, are *they* there for you? Similarly, how do they treat their *other* friends?

Recognizing a series of signs, patterns, and toxic behaviors can be key to realizing that we've become associated with a human

predator. In retrospect, I failed to recognize a handful of occasions when some of the human predators in my orbit turned on or tossed aside supposed friends when those individuals proved no longer useful to them, or when association with them became inconvenient for their image—which is precisely what they did to me in the end.

Once we make that realization, what next? Going back to something I mentioned previously, if we intuit and accept that we're in proximity to a human predator, it's imperative we don't expose vulnerabilities or weaknesses. Dutch and his men do just about everything wrong and show the Yautja how to kill them: Rather than conserve ammo they blindly fire into the jungle, showing the creature that they're heedless about their own resources. When a wild boar gets caught in a trap intended for the alien, the men panic rather than remain calm and rational, allowing the creature to slip into their camp and demonstrating they can be easily frightened and distracted. When the men succeed in briefly capturing the Yautja, only for it to quickly escape, two of the men blindly run off in pursuit of it, separating themselves from the group and allowing themselves to be easily picked off. It's Dutch alone who doesn't demonstrate vulnerability and expose himself, remaining calm in the face of danger. In retrospect, I realized that one of my own biggest mistakes was opening myself up and making myself too vulnerable to people who had ill intent for me, teaching them precisely how they could use offers of friendship and a sense of belonging to bend me to their will, providing them a convenient decoy to throw under the bus when they needed a distraction.

Like Dutch, when we realize that someone in our lives intends to exploit and leech from us, we need to put up barriers and be mindful of exposing ourselves to potential harm. This can be an incredibly difficult skill to acquire as our compulsion as social creatures is to want to trust and give one another the benefit of the doubt; if we acknowledge our own gut instincts, we can next put into place healthy barriers to protect ourselves. This may take the form of only interacting with a toxic coworker as much as is necessary for workplace productivity, limiting interaction with predatory family members during social occasions such as the holidays (or, on the most painful and extreme end of the spectrum, cutting off contact with them entirely if their predation truly threatens our emotional or physical well-being), and not being emotionally forthcoming with friends of friends or acquaintances we can't remove from our lives.

Which brings us to the next step to take: If possible, remove yourself from the situation and/or the person from your life. For a portion of the movie, Dutch and company's goal is to escape rather than kill the creature, and of the two people to survive the film, one of them, Anna, makes it out precisely because she makes it to an exfiltration site, removing herself from the situation and the Yautja from her life entirely. So, too, must we, if possible, remove predatory individuals from our lives. In the case of friends, acquaintances, and people with whom we've willingly entered some sort of professional working relationship, this can be relatively easy, if not painful if we still have affection for that person. It can be hard to acknowledge that someone we care or cared about doesn't and perhaps never did care about us and is only

using us, and it's all right to have positive memories of someone who's turned out to be predatory; the happiness we felt in those moments was still real, and we can either cherish or mourn those times, depending on what's healthiest for us.

Still, it does us no good to remain in relationships with people who will only hurt us in the end. It can be tempting to think that people will change, or that we're wrong about them, but such wishful thinking does us no good. Even as I began to realize how many human predators I'd let into my life, sentimentality for the "good old days," a hope that I was wrong about them, and a desire to keep being one of the cool kids let me keep certain people in my life longer than I needed, and I ended up getting even more hurt for it. I hadn't learned my lesson; I still sought the acceptance and approval of people who'd demonstrated to me time and again that I was expendable to them, but sentimentality kept blinding me. Had Dutch and his men laid down their arms and just beelined for the exfiltration point once they realized the Yautja only hunts for sport, perhaps more of them would have made it out alive.

Just as Dutch and Anna are sure to carry some physical scars from their encounter with the Yautja, I carry my own emotional scars from my human predators, and even writing this years after the last of them departed my life, I'll still catch myself thinking about one of them and how happy they made me at one time and how cruelly they treated me once I could no longer serve as a means to an end for them. The experience has left me a little more jaded but also a little more guarded and a little more mindful of how I need to think and behave to safeguard my own mental health in the future. Had I considered the lessons I'd already

learned from Dutch Schaefer at four, I may have come out a little happier as a result; hopefully you, dear reader, can learn from both of us.

Oh, the Humanity!

Until my thirties, the majority of my relationships with significant others had some semblance of—if not full-on—toxicity. In the spirit of accountability, I own that I was very much a part of the problem (if not more in some cases). I suppose things such as drugs, alcohol, codependency, and lack of self-love and -worth can have that effect on people and relationships.

My first "real" girlfriend was someone who, like me, self-harmed. Unlike me—at least up to that point in my life—she was also very suicidal. We dated for a couple of years, but as the relationship went on, I came to realize that it consisted of more fights and stress than joy and support, thus began the process of my trying to end things. I say "began" because my first attempt resulted in her threatening to kill herself if I left. I was a teenager and didn't know how to talk to anyone about something as serious as this, whether it be a parent, teacher, or even friend. I also didn't want *her* to get in trouble, nor did I want to get in trouble—an entirely unrealistic fear, but one that I didn't know what to do with at the time.

The various breakup attempts I continued to try to make over the next year yielded the same results and ultimatum from my then girlfriend. That is until one day when I decided to stand my ground and end things for good—and, as promised, my now

ex-girlfriend did try to kill herself. Thank God she survived and, as far as I know, is alive to this day, but that was an extremely traumatizing experience for me to have at such a young age—one that left an emotional scar deep within. It wasn't until many years and toxic relationships later that I learned about healthy dynamics in relationships and the difference between codependency and interdependency.

Like Schaefer, Dillon, and their military crew working together to kill the Yautja in *Predator*, my significant others taught me what it meant to work together in a relationship dynamic that supported a healthy and joyous manner, lifting each other up— interdependency rather than codependency, which consists of an unhealthy, clinging, and addictive quality to the other person in order to feel safe and validated in the relationship.

One of the fondest memories I have regarding interdependency occurred during the one time I've been married. It was several years ago on my birthday—a day I historically self-sabotaged in various ways, which included telling people I didn't want any form of celebration or recognition on my day only to be sorely disappointed when they took me at my word. Without fail, this resulted in my shifting to victim mode and spending the rest of the day in "woe is me" mentality.

My ex-wife saw through me and planned a couple of simple and thoughtful things for my birthday. It was incredibly kind of her, but I, not knowing how to handle something so nice, emotionally shut down, got grumpy, and acted like a complete child. We were standing in the kitchen as I sulked when my ex firmly

put her hands on my shoulders, told me to look her in the eyes, and in a very firm yet loving way said, "You're worthy of a good birthday. You're a good person with a good heart and deserve good things." Tears welled up in my eyes as she embraced me. I felt my heart's protective armor begin to quickly melt away, and we then went on to make the best of what remained of the day. I'll forever be grateful to her for that.

What my ex did at the end of our marriage, after my second relapse to alcohol during our marriage, was something I still knew little to nothing about—setting healthy boundaries. Had Dutch Schaefer set healthier boundaries with his longtime friend Al Dillon, perhaps he wouldn't have found himself in the middle of the jungle going toe-to-toe with a Yautja. Then again, some situations just call for Schwarzenegger to save the day, so we'll go ahead and let this one slide.

Non-Yautja related, and old military buddies aside, boundaries are essential to a person's integral wellness, something I say from having had little to no semblance of them for the better part of my life. Healthy boundaries consist of letting others know where our comfort zone begins and where it ends, regarding things such as mental, emotional, and physical support, and sticking to that.

It also means learning to say no, which, as you may have heard, *is* a complete sentence. For people pleasers like me that's easier said than done but doable nevertheless and worth putting into practice. Dr. Leela Magavi, a regional medical director and psychiatrist, notes that "when our emotional boundaries are

respected, we feel valued, honored, and safe. Boundaries can be healing: boundaries can help one not feel taken advantage of." It works in the opposite way as well, as Dr. Carla Marie Manly, a clinical psychologist, points out: "But when our emotional boundaries aren't respected, it may leave us feeling overwhelmed or bullied, or anxious. Not only that, but if our boundaries are chronically disrespected, the ongoing feelings of despair and powerlessness can trigger chronic anxiety, depression, and even trauma."[1]

All this goes hand in hand with people pleasing, which is a behavior that puts others' wants and needs ahead of one's own. People pleasers also have the tendency to avoid conflict at virtually all costs, equating their worth through the eyes of how others see them. They also take the blame for things that aren't their fault, have low self-esteem, and struggle with perfectionism and insecurities. It's borderline eerie how much this sums up the way I've lived the better part of my years, but as I've also learned, it's never too late to change our people-pleasing ways.

Learning to set healthy boundaries is one of the most difficult things I've chosen to do in my life, but with time, I can say the effort has been worth it, resulting in greater peace and equanimity in my life. I still struggle with setting healthy boundaries at times because it's hard to feel like I've let someone down, but I've learned I can also let myself down. We, just as much as anyone else, deserve to have our cups filled with good things, even when that means having to set difficult yet healthy boundaries. The following are some tips that you'll hopefully find helpful if this is an area in which you struggle.

PRACTICE: Setting Healthy Boundaries

Yautja was obviously comfortable in his own weirdo alien skin, so the only boundary he bothered setting was to not hunt any humans without weapons because it wouldn't be worthy enough of his time. As the neurotic, anxiety-ridden humans many of us can often be, however, boundaries are essential and can become our friends. The five major types of boundaries include physical, sexual, intellectual, emotional, and financial. [2]

It's important to take each of these into consideration as you begin setting boundaries in your life. Here are ten approaches to creating healthy boundaries that I found to be incredibly helpful and feel are worth sharing here:

1. Reflect on the reasons for your boundaries.

2. Start with a few boundaries.

3. Consider setting boundaries early on.

4. Try to be consistent with your boundaries.

5. Carve out time for yourself.

6. Don't be afraid to include boundaries.

7. Set healthy boundaries on social media.

8. Communicate when your boundaries are crossed.

9. Practice self-love and engage in activities you enjoy.

10. Gain some perspective on your boundaries. [3]

Lastly, don't forget to respect the boundaries of others, regardless of whether they coincide with yours or not. Use common sense, be open and fluid, and live and let live. Cool? Cool.

Chapter 10

The Hell That Is Life Lived Without Gratitude

Pinhead and the Cenobites from *Hellraiser*

"Demons to some. Angels to others."

—Pinhead (*Hellraiser*, 1987 version)

Oh, the Horror!

"No tears, please. It's a waste of good suffering." Thus speaketh Pinhead, one of the most original and fascinating monsters to come out of the horror genre in the last fifty years, as he torments opponent/ersatz love interest/incredibly lucky valley girl Kirsty Cotton, the spunky displaced American girl in London who consistently defeats the forces of darkness through occasional

cunning and lots of incompetency on the part of her otherworldly adversaries in Clive Barker's *Hellraiser* series. While the line is chilling when taken in context—Pinhead would much rather Kirsty's tears be shed as a result of pain doled out at his hands and not due to silly, human grief—it speaks to a rarely explored aspect of the *Hellraiser* mythos and what it can teach us about our own approach to life. While the series is often examined under the lens of unchecked desire and the need for that nebulous, ephemeral, unattainable "more," what's rarely looked at is the flip side of that desire: a lack of contentment with what we do have and the crippling ingratitude that drives both the characters of the series and real flesh-and-blood human beings to engage in destructive thrill seeking and acts of self-sabotage.

While later entries in the series have taken the cenobites in all sorts of different directions, from demonic inhabitants of a vaguely Abrahamic hell to something approaching infernal vigilantes punishing criminals and doling out bon mots, that wasn't always the case. In their earliest inception in Barker's novella *The Hellbound Heart* and its film adaptation, *Hellraiser*, Pinhead and the cenobites were unlike any other creatures inhabiting the realm of horror fiction or cinema. Neither good nor evil, the cenobites were instead presented as former humans driven by pure hedonism, individuals so dedicated to physical pleasure and sensory experience that they'd sacrificed their humanity at the altar of the Lament Configuration, a mystical puzzle box that could only be solved by those worthy of its secrets. Upon opening it, those "worthy" souls found themselves transformed into members of the Order of the Gash, a warped religious institution

whose adherents—"cenobites," a word meaning "a member of a monastic order"—spend their days engaged in "experiments" to explore, as Pinhead phrases it in the first film, "the further regions of experience." No longer finding any distinction between pain and pleasure, the cenobites exist to experience pure sensation, no matter how gruesome or unpleasant mere mortals might find it. Of course, as *Hellbound Heart* and the first film demonstrate, not all those who solve the puzzle box are necessarily cut out to be cenobites, and they're not content to merely experiment on themselves.

At the outset of *Hellraiser*, globe-trotting pervert and general deviant Frank Cotton has obtained the Lament Configuration for himself from a back-alley dealer in some far-flung hellhole, thanks to a large wad of cash and, as the book insinuates, no small number of petty crimes. A gravel-voiced, constantly sweaty sex fiend with a penchant for switchblades and casual shirtlessness, Frank quickly gives us the impression of a pre-Reddit pickup artist, the kind of guy for whom sex is a mindless animal pursuit and for whom women are merely objects to satisfy his basest desires.

Upon opening the configuration box, though, Frank gets an unwelcome surprise in the form of the cenobites. Though their conversation is absent in the film, as the cenobites inform him in the book, they "understand to its breadth and depth the nature of [his] frenzy" and offer to supply him with "pleasure," albeit "not as you understand it" before going on to lecture him on their abilities regarding nerve endings and how "your most treasured depravity is child's play beside the experiences we offer." Only after *multiple* opportunities to back down—the cenobites take pains to

make sure Frank *really* wants this—the beings oblige his request, which in the film takes the form of stuff involving lots of hooks and chains and pillars (I've never quite figured out what the hell is up with those pillars).

Sometime later, with Frank long MIA, his house falls into the hands of his milquetoast brother Larry, the human Wonderbread yin to Frank's gas station burrito yang. Every bit as retiring and passive as his brother is malicious and aggressive, he has no idea that his apathetic, mullet-headed trophy wife, Julia, not only carried on an affair with Frank before their wedding but has been sexually obsessed with him ever since. If her response to setting foot inside the house—immediately slipping into a flashback to the time they had rough sex on her wedding dress—is any indication, she's spent every waking moment in Larry's company wishing he were his brother.

As luck would have it, she ends up (sort) of getting her wish when Larry accidentally cuts himself and drips blood in the room where Frank summoned the cenobites, which succeeds in allowing him to slip out of their clutches and reenter the land of the living, albeit as an emaciated, skull-faced ghoul as the result of his captors' ministrations. Despite his nightmarish appearance, Julia is so hard up for some of that sweet, sweaty Frank Cotton sex that she more or less immediately agrees to go along with his plan to rejuvenate himself by drinking human blood. Thus begins a campaign of awkwardly seducing day-drinking weirdos at area hotels and bringing them back home to murder so that progressively less disgusting Frank can drain their blood for sustenance. Lest the pair forget, though, they're not just up against London's singles population but also extradimensional sex monsters, and before

long, Frank's niece, Kirsty, has accidentally stumbled across their plot and inadvertently summoned the cenobites herself, setting the stage for a final confrontation between the forces of good, evil, and horny.

It's easy to see *Hellraiser* as a story about unchecked and unbridled desire run amok, and indeed, this was something on the forefront of Barker's mind when he was writing the book. A regular inhabitant of underground S&M clubs in 1980s England, where the aesthetics of leather-clad clubgoers and body-modded punks served as inspiration for the cenobites, Barker was aware of the burgeoning AIDS crisis and fearful that he might find himself falling victim to the disease; worse still, in his mind, he was afraid of what his beloved parents might think of him were he to die and worried of whether he would be reduced in their memory to a sex freak who'd sacrificed his own life at the altar of pleasure.

Thus, Barker began to work out these anxieties through the story of a pair of people who really would give up everything just for the sake of carnal experience. A lot of folks will cheat on their partners or engage in risky sex in the name of fulfillment, but most folks won't become aspiring serial killers engaging in bloody grope sessions with the half dead; it's a cogent reading of the material that Julia and Frank are the ultimate examples of taking things too far and what can happen if we let selfish desire consume our lives. I'd like to take a look at the flip side of that, though, and explore not what Julia and Frank pursue outside themselves but what they lack within: contentment.

Before all the murder, both Frank and Julia are living what could be their best lives. What little we learn about Frank's

backstory paints him as a relatively wealthy trust-fund kid or heir to some family fortune; he's able to travel the world at his leisure, including exotic and far-flung destinations that would be off most folks' itineraries for sheer lack of funds. He lives in a multistory house in a beautiful part of town and, from the collection of photos Julia finds in his bedroom, has no shortage of lady admirers, not only at his beck and call but eager to indulge his amateur pornography hobby. Julia, meanwhile, is married to the equally wealthy Larry, a not-unattractive, doting husband whose widowerhood has compelled him to make her the center of his life: as we learn at the outset of the film, the pair's move to England is so that Julia can be back on her "home turf."

Nonetheless, each party wants *more*. For Julia, that more seems to be passion in her marriage, though it appears she's never made an effort to achieve it: There are no indications that she's ever voiced dissatisfaction with Larry in bed or discussed with him what her physical needs are in the bedroom. The viewer gets the idea that their sex life is consistent, if not regular, and that for all his strengths as a husband, Larry probably isn't the most exciting guy in the bedroom. The viewer also gets the idea that he's a rather accommodating chap and, with his devotion to Julia, probably wouldn't be averse to some exploration and experimentation.

Rather than attempt to communicate these needs, though, Julia instead pines away for what she initially thinks can never be and then does the unthinkable in an ultimately doomed effort to make it real. Frank's desires are more nebulous: As he oh-so-romantically tells Julia after they've finished having sex for the

first time, "It's never enough" (seriously, Julia, *this* is the guy you're becoming a serial killer for?). For Frank, no matter how good the sex, how multitudinous the partners, how beautiful the globe-trotting destination, there's always a sense that there's *got* to be something better (I'm tempted to think that he may have a case of anhedonia, the inability to experience pleasure, although it seems Frank *is* capable of experiencing it—he just doesn't *appreciate* it).

In both cases, Julia's and Frank's great sins aren't their desires but rather their lack of gratitude and inability to feel content with what's right in front of them. How many of us have discovered that a hurdle in a relationship suddenly becomes surmountable once we sit down and communicate our needs to our partner? And conversely, how many of us have ever stood on a beach looking out at a sunset or eaten a finely prepared meal and thought to ourselves, "There's got to be something better"?

Pinhead and his coterie, then, become living embodiments of the futility of this mindset and the logical conclusion of severe ingratitude. In their own quest to experience "more," they've rendered themselves monstrous, walking piles of mutilated flesh and leather that carry out their tasks with a distinct sense of joylessness. Doug Bradley has described his performance as Pinhead as someone "mourning for [my] humanity" while Clive Barker gave Bradley the instruction that he should play Pinhead as the director of a hospital "where there are no wards, only *operating theaters.* As well as the man who wields the knife, he's the man who has to keep the timetable going." Both descriptors speak to a deeply unhappy individual, one whose physical and emotional states have become warped beyond all recognition; Chatterer and

Butterball, meanwhile, are both rendered blind by their mutilations while the female cenobite struggles to speak.

Though they may stand in opposition to one another, Frank/ Julia and Pinhead/the cenobites are rather mirrors of one another: individuals who sought more, only to find that there's no pot of gold at the end of the proverbial pervert's rainbow. Julia perishes at the hands of a carelessly knife-wielding Frank, who callously leaves her to die alone on the stairs in the pursuit of Kirsty. Frank wishes to make her his next conquest—his new, unattainable "more," even though he's ostensibly been working toward a monogamous relationship with Julia, a woman who's killed to be with him. Frank, for his money, ends up back in the clutches of the cenobites, lured by his brazen lust for his own niece. And the cenobites find themselves cast back to their realm, after deciding to renege on their deal to leave Kirsty alone should she help them find Frank. Instead of being content with having their precious "experiment" back in their clutches, Pinhead and company immediately discard Frank and turn their sights on Kirsty rather than simply express gratitude for her assistance and go on their merry way. Each of the cenobites leaves the movie howling or hissing (or, in Chatterer's case, chattering) in defeat as Kirsty banishes them back to their own realm, depicted in split-second flashes as a morose and lonely place of medieval chambers and smoky voids, hardly a sensory paradise.

In sharp contrast, it's the characters who are content that are the happiest, even if they suffer at the hands of those who aren't. Larry and Kirsty, each satisfied with their lots in life, each grateful, are two of the only characters we see consistently smile or

laugh. Larry is all too happy to have moved to England to start life over there, happily settling into Frank's home and beginning anew. Kirsty, meanwhile, is quick to make the best and most of her new situation, finding a place of her own, a job she can tolerate, and a boy she likes. That both of them wind up targets of Frank, Julia, and the cenobites at various points is an object lesson that our lack of contentment and gratitude can not only harm us but also those close to us—and for those of us who *are* content, to be mindful of those who aren't and how we can become targets of jealousy and disdain.

Frank could have lived out his days carousing with beautiful women in exotic locales; Julia could've had a life of luxury in London; the cenobites each could have lived their own lives. Instead, by film's end, they're all dead or in sex hell, victims of their own ingratitude and inability to feel contentment. The lesson for us is clear: While ambition can be a positive trait, there are also certain aspects of our lives where contentment is the greater virtue. Sometimes the grass isn't greener, and sometimes the mystical portal leads to a realm of unimaginable suffering. Must we always consume, consume, consume, buying the next bigger and "better" car or piece of tech or luxury good? Must we always think that our house could be bigger, our partners more beautiful, our lives more exciting? Or can we just stop a moment, take a deep breath, and be grateful for the good things in our lives? Happiness and a healthy mind lie in taking the latter route. As *Hellraiser* demonstrates, gratitude and contentment are the better paths to wisdom. Don't be like Frank, Julia, and the cenobites. Don't be ungrateful. Don't end up in sex hell.

Oh, the Humanity!

In 1928, American humorist and journalist Robert Quillen defined "Americanism" as "using money you haven't earned to buy things you don't need to impress people you don't like." All one need do is look around to see the truth of these words in action. Hell, I still fall victim to it at times myself. Just recently I bought an Abominable Electronics "Hail Satan" guitar distortion pedal because it was a new epic artwork variant that I loved and "had" to have. Did I need it? No, not at all. Did I still buy it? Of course! I mean, I knew it'd look super rad on my pedalboard and would catch the eye of other guitarists, possibly making them a little jealous because, hey, I was buying something I didn't need with money I didn't have to impress people I didn't know. Soon after purchasing the pedal my financially sounder mind prevailed, and I sold it because I couldn't justify keeping it. Truth be told, the egotistical/materialistic part of me still very much misses that pedal, but when taking a rigorously honest look at why that is, I know a significant part of it is rooted in my serious lack of self-worth.

About fifteen years ago I had a deeply insightful albeit slightly disturbing realization while in a therapy session. The topic of my heavily tattooed and pierced body came up, which resulted in the long overdue epiphany that while, yes, a part of me *did* appreciate the aesthetic, a larger part of me was getting the tattoos and piercings as a feeble attempt to divert people's attention from me, the real Chris, to my piercings and tattoos instead.

It also dawned on me that while I hadn't self-harmed since I started getting tattooed, that played a part of the role in it, too.

I felt that I needed some sort of penance in my life because of faulty beliefs about being a bad human. Tattoos and piercings became a sort of "legitimate" way of self-harming rather than carving my body up with razors and broken glass. This recognition was a real eye-opener for me, so I decided to stop getting any tattoos or piercings for a while and instead spent time becoming vulnerable with myself and exploring who the hell I was. It's an exploration that continues to this day and one that I'm grateful for. With diligence and perseverance, I've uncovered numerous parts of myself that I've been able to re-own and reintegrate. This has also helped shift my relationship with tattoos and piercings from being a means of evasion and subtle self-harm to one of love for the art and the craft.

And just like my love for the art and craft of tattoos and piercings, *Hellraiser*'s cenobites also have a love for an art and a craft, one that far surpasses any extremities of tattoos and piercings. The cenobites have undergone various forms with differing motives over the years, but one consistent form has remained—they're supernatural hedonists who enjoy sensory pleasure to a point of painful overload as well as enjoying excruciating pain and torture. And while not displaying a tendency toward any semblance of morality or immorality, one thing is clear: the cenobites *are* dedicated to their craft, which, regardless of what end of the spectrum it falls on, pleasure or pain, it's *always* to extreme excess.

Something I appreciate about Clive Barker's monsters in *Hellraiser* is that he wanted them to be able to talk about their condition. In 1988 Barker told *Crimson Celluloid*:

In stalk and slash films I feel that half the story is missing. These creatures simply become, in a very boring way, abstractions of evil. Evil is never abstract. It is always concrete, always particular and always vested in individuals. To deny the creatures as individuals the right to speak, to actually state their case, is perverse—because I want to hear the Devil speak. I think that's a British attitude. I like the idea that a point of view can be made by the dark side.[1]

Part of my tendency toward self-harm was because I wasn't letting my "dark side," as Barker called it, speak or express its point of view, going to great lengths to keep that part of myself stifled—empty sex, overspending, excessive exercise, excessive meditation (because yes, even meditation can become a means of evasion), and, of course, drugs and alcohol—*all* the drugs and alcohol. Like the cenobites, whether extreme pain or extreme pleasure, I, too—albeit on a significantly smaller scale—went to great, irresponsibly dangerous lengths to feel excessive pain and excessive pleasure. If it kept me from being fully present and embodied in myself, you could count me in.

Self-harm, drug and alcohol abuse, depression and anxiety, suicidal ideations and/or attempts—all of which I've experienced in my life—are obviously extremely serious conditions that first and foremost need professional, and in some cases, medical attention. Depending on what self-defeating behaviors you struggle with, therapy, detox, rehab, medication, emergency rooms, primary care physicians, any professional help may be necessary and your first point of action. Stabilizing oneself always needs to come first before moving on to most, if not all, of the various practices and techniques in this book.

Once I got myself into a stable condition, a therapist recommended practicing gratitude. I remember scoffing at the recommendation. I may have been in "stable" condition, but this world was still a fucked-up shithole of a place in my eyes. I did, however, have a bit of willingness, so I decided to give this gratitude thing a shot, which resulted in primarily crickets—radio silence, nada. I was still utterly jaded, angry, and disillusioned with life and the world as a whole. What was there to be grateful for?

My therapist then recommended what she called "intentional gratitude" and gave me the following practice to work with a few times a week. At first, it felt corny to do, but with time it truly has helped me in cultivating a greater sense of gratitude more days than not, which feels a lot better than constantly being jaded and angry at the world.

PRACTICE: Gratitude Alphabet

Today, I'm grateful to live in a world where the *Hellraiser* franchise exists (some entries for better or worse) and the ability to dedicate a chapter in this book to Pinhead and the cenobites. When gratitude practices are generally taught, imagery such as sunshine, rainbows, nature, and the like often come to mind. And those things are cool. I love nature and hiking, but I also love horror movies and blood and guts and all that good stuff.

Keeping that in mind, the name of this practice pretty much sums it up. You simply go through each letter of the alphabet and think of something that brings you joy and gratitude that begins with the corresponding letter. It can be anything—a band, movie, person, book, food, animal, nature—*anything*, no matter how

silly or insignificant it may seem. If it brings you a sense of joy and happiness, it's applicable. One suggestion is that if this is a practice you decide to do for a while, try to think of something different for each letter every time. This, of course, will prove to be difficult with certain letters such as "x," for example. Just do your best, and most important, have fun.

Here's an example of what one of my past lists has looked like:

A—A Tribe Called Quest

B—Bhagavad Gita

C—Compassion

D—Deadguy

E—Empathy

F—Fall

G—Gnostic Gospels

H—Halloween

I—Iceland

J—Jason Voorhees

K—Ken Wilber

L—Legend of Zelda

M—Michael Myers

N—Nature

O—Open-mindedness

P—Pinhead

Q—Quiet

R—Ram Dass

S—Sigur Ros

T—Therapists

U—Universe

V—Viktor Vaughn

W—Waterfalls

X—X-rays

Y—YOB

Z—Zombies

Chapter 11

Hatchets, Sleeping Bags, and Childhood Trauma

Jason Voorhees from *Friday the 13th*

> *"You kids keep your noses clean, you understand? You'll be hearing from me if you don't. We ain't gonna stand for any weirdness out here."*
>
> —Officer Dorf (*Friday the 13th*)

Oh, the Horror!

As you've no doubt noticed, I've interwoven summaries into every chapter in the book up to this point in order to refresh the reader on movies they may not have seen for a while or provide

them with some context for films with which they're less familiar. As we segue into discussing my own personal favorite horror franchise, *Friday the 13th*, though, I'm going to do something a little different, simply because—for as much as I love these movies—their canon, sometimes even within a single film, is a bit, well, *lazy*. Masked killer Jason Voorhees has gone through so many iterations and evolutions as a slasher icon that he's almost become laughable. From an overalls-clad hillbilly killer to a hypertrophic ghoul, from undead to dead to undead again, from a demon worm to a denizen of Hell to a futuristic cyborg, it's difficult to see from the perspective of 2023 how the character ever inspired fear or dread. He's become domesticated, his ability to inspire fear diluted through ubiquity and familiarity. Meanwhile, the series' narrative has made so many confounding leaps in logic and backstory that it's difficult to remember exactly how the character began: as an abused child. It's from this perspective that I plan on assessing the character and franchise below.

To the extent I can summarize things concisely, here goes: Back in the 1950s, an intellectually disabled boy named Jason Voorhees drowned at Crystal Lake, the summer camp where his mom, Pamela, worked as a cook. The very next summer, a pair of counselors were brutally butchered by a knife-wielding maniac who was never caught, and, following a series of other bizarre tragedies, the camp was shuttered for decades until a poor, mustachioed, jorts-loving son of a bitch by the name of Mr. Christie decided to reopen it against the good advice of everyone in his orbit, vaguely psychic town kook Crazy Ralph included. He never gets the opportunity, though.

News of the camp's impending return spurs Mrs. Voorhees (who killed those counselors back in the day) to resume her blood feud with Crystal Lake, and in short order she's butchered Christie and all his counselors save for one lucky (and now deeply traumatized) girl by the name of Alice, who manages to chop Pamela's head off with a machete. Then, lo and behold, zombie child Jason Voorhees emerges from the depths of the lake to attack the girl who killed his mama.

Or does he? When Alice wakes up in the hospital with no memory of how she got there, the cops tell her it was all a dream. She insists otherwise. Her suspicions are *kinda* confirmed when Jason—now inexplicably an average-built, adult man—shows up in her apartment sometime later and stabs her with an ice pick.

From here on out, Jason Voorhees will terrorize anyone who enters his territory, all while the series tosses a string of inconsistent backstories at us: He didn't actually drown but grew up as a feral child; he *did* drown and has always been an undead wraith; he *did* drown but he was possessed by a demonic worm placed there by Mrs. Voorhees in the furtherance of a Satanic ritual and . . . well, you get the point. These movies printed their own money at the box office back in the 1980s—Paramount was more concerned with churning out another entry quickly and cheaply, porno-style, than y'know, artistic merit. They're still all damn fun.

It's doubtful that the myriad creative minds behind the franchise (virtually every entry has a different writer and/or director) ever intended the character or series to explore the deep, psychological implications of child abuse. If we keep in mind, though, that Jason Voorhees is, in fact, an adult (or semi-adult) survivor

of childhood trauma, the series takes on some fascinating impli-
cations. We may substitute "neglect" here to account for the fact
that the series never makes it explicit that Jason suffered actual
physical abuse from an adult authority figure (although Freddy
vs. Jason at least implies that he was bullied by fellow children),
but the end result is still the same: the deep psychological trauma
and scars that come from being made to feel unsafe in childhood.

Assuming that Jason did, in fact, drown as a child, and that
he's undead as early as Part 2—a supposition I'm going to go with
because it requires the least mental gymnastics and because it's
my preferred interpretation—his appearance and behavior make
a great deal of sense. As a living child, Jason was small and weak.
As an undead monster, he's big, strong, and unstoppable. As a
human child, he was fearful and the target of taunting. Undead,
he becomes the figure of fear. The monster we know as Jason
Voorhees is, in many ways, the ideal self of many abused chil-
dren: More powerful than his victimizers, he's the one who calls
the shots; he's the one who *they* are afraid of; he will never be hurt
by anyone again. He's a burlesque of a little boy's understanding
of what it means to be a man—a big, tough guy whom no one
ever pushes around. Even the outfits he steals throughout the
series are composed of totems of traditional, rugged, American
masculinity: work shirts, combat boots, farming clothes, and, of
course, a hockey mask, an icon of a sport particularly associated
with macho swagger, brute force, and violence that are practically
encouraged during gameplay.

If we are to understand Jason as a child trapped in a fantasy
form of a grown man, the question then arises: Why does he kill?

With the exception of a few characters who seek to directly harm others (such as Dr. Crews in Part VII or McCulloch in Part VIII), all Jason's kills are seemingly unprovoked attacks. Is he all mindless rage, as some actors have interpreted the character? Or is he blindly territorial and protecting his turf, the motivation that Tom McLoughlin provided him for Part VI?

While I do feel that rage is a major component of Jason's motivation, I don't think it's necessarily blind. Rather, we can understand the character's motivation as jealousy. He may have returned from the dead as an unstoppable monster, but he's still undead, and, despite the advantages afforded to him by his new body, he is still, ultimately, a twelve-year-old boy—one who'll never grow up. He'll never be afforded the traditional hallmarks of passing into adulthood: never go cruising with his friends; never have his first beer; never kiss a pretty girl; never fall in love; never have sex. In other words, he'll never do exactly what it is the counselors, partygoers, and interlopers have come to Crystal Lake for.

From Jason's perspective, the counselors' carefree hedonism is almost a form of mockery. Consider, especially, that many of Jason's killings occur during or immediately following some sex act or have some sort of sexual undertone (such as Andy's death by castration in Part III, or the numerous victims who die in a state of undress). At twelve, it's likely he was on the cusp of puberty at the time of his death and that he had begun to experience his first sexual feelings (and here I am at a point in my life talking about the erotic awakening of Jason Voorhees). It's not beyond the pale to assume that Jason has a concept of sex, albeit a diminished, childlike concept, and that he fully understands that,

as a decaying zombie, he'll likely never enjoy it. Yet some young, attractive kids, who are not much older than he would have been, have come *to the site of his death* to engage in the very activities and pleasures forever denied to him. It's perhaps understandable, if not forgivable, that he reacts poorly—especially with a bullied child's concept of conflict resolution.

This brings us to the cycle of abuse and how Jason's presentation of a victim of that cycle differs so greatly from other pop cultural depictions of it. Crime procedurals in particular are quick to point out that many victims of childhood abuse go on to become abusers themselves—be that abuse physical, sexual, emotional, or some combination of the three. They're also quick to depict the abusers—particularly sexual predators—in an aesthetically unflattering light. Bald or balding, either emaciated or comically overweight, with bad facial hair, glasses, and an air of sniveling menace, the abusers of primetime crime shows are so blatantly guilty from their appearance alone that episodes could be resolved with the police arresting whatever suspect looks the creepiest.

Jason, though, hardly fits the creeper aesthetic. Decaying flesh aside, Jason is *cool*-looking. He looms large, menacing, and badass above his victims. When he steps on-screen, he's often framed in such a way as to emphasize his stature and power and give him an air of glamorous menace. In other words, we're *meant* to *identify* with him. Even if only briefly, even if guiltily, we're asked to look at an abused kid going after his tormentors and think, "Good for him. Go, giant zombie killing machine."

As any fan who's attended a live screening of a *Friday* movie can attest, it's not uncommon for at least part—if not all—of the

audience to cheer Jason on. Yet, our ultimate sympathies remain with his victims—they always rally in the end, and we're always invited to finally side with them as they improvise ways to beat this seemingly unstoppable threat. Uniquely, then, while the series encourages us to be on the side of good, we're invited—if only briefly—to empathize with Jason; to sympathize with him; to understand him if not necessarily forgive him. In asking audiences to place themselves in a victim's shoes and understand why he or she may react in inappropriately hostile, broken ways, *Friday the 13th* is bizarrely light-years ahead of a popular culture that would rather place victims of abuse in the back of a closet, only to bring them out as clichéd villains of the week.

It's a sympathy that was particularly revelatory for me and, in a way, instrumental in my own development and personal growth. Between the ages of seven and nine, I was routinely sexually abused by a female teacher at a private school whose code of silence guaranteed she would never suffer any repercussions for her actions and enjoy the protection of her fellow educators. As of the writing of this book she has never been held accountable and most likely never will. Although later in life I attempted to open up about my experiences to others, the gender dynamics involved left many people to whom I turned at a loss as to how to respond. Male-on-female sexual violence made sense to them; so, too, did male-on-male. Learning that my abuser was female, many people otherwise sympathetic to me clammed up, panicked, even, at a challenge to their preconceived notions of the nature of sexual abuse. Even my attempts to discuss the situation with crisis hotline workers and therapists reached brick walls. I

was fortunate enough to choose to open up to a friend in college who had worked in childcare herself, and who was open-minded and empathetic enough to give me the understanding and encouragement I needed to begin healing. Although my discussions with her were emotionally cathartic, I was still left with a sense of rage—a rage at the woman who'd done these things to me, a rage at the people who'd let her get away with it, a rage at the people to whom I turned for help, only for them to turn their backs on me. A rage at the fact that, in so many ways, my childhood had been taken from me and I had been denied the opportunity to grow up normally.

So it is that I find a certain degree of identification with Jason, a monster who also wasn't permitted to grow up normal; a monster who was also let down by the people he was supposed to trust. A monster who watched the world go by while everyone else enjoyed the rites of youth denied to him. I found catharsis through Jason; I could project onto him the anger and desire for vengeance denied to me in life. He could become an avatar for all my own suppressed suffering. It's highly unlikely—almost 100 percent so—that anyone involved in the making of *Friday the 13th* intended to make a serious statement on child abuse or provide survivors with their own iconic monster. Yet, in many ways, that's exactly what they've done, and I, at least, will be forever grateful for it.

Oh, the Humanity!

Childhood trauma can be one of the most scarring experiences an individual goes through, and it can have long-lasting

implications for healthy growth and development and a happy life. That said, it's never too late, or early, for us to begin working through those traumas. There's a number of deeply impactful ways in which individuals can approach these practices. Before going further, however, it's strongly recommended that you seek out a therapist (trauma-based approaches such as Eye Movement Desensitization and Reprocessing, also known as EMDR, or Accelerated Resolution Therapy, also known as ART, can be exceptionally helpful), a support group, or whatever other form of help that resonates so you're not doing the work alone.

Unlike our friend Jason Voorhees, whose mental cognition ceased to grow upon his childhood drowning, we process things through the frontal lobe part of our brain (this is the most evolved part of the brain and controls our cognitive skills including emotional expression, memory, problem-solving, judgment, language, and sexual behaviors). Basically, it's the "control panel" of our personality and becomes the lens through which we experience life, including how we process childhood experiences.

For example, several years ago I was sitting in meditation when an unpleasant memory, one I don't believe I'd really thought about since it happened at roughly eight or nine years old, came to mind. I was on a little league team at practice, and our jerseys had just come in. The team was incredibly excited as the coaches passed them out, immediately putting them on and showing them off to one another. When I was given mine, I immediately put it on only to realize it was a size too small, and as a chubby kid, that makes a noticeable difference. My coach noticed this and proceeded to make a joke in front of everyone saying, "Looking

good, Crisco" (instead of using my real name, Chris), which left me embarrassed and feeling deeply hurt as the other coaches and players laughed at his joke.

That was the first time I became self-conscious of my bodily image, something that has stuck with me ever since. It's also a large part of the reason that, as mentioned in the previous section, Jason's "burlesque of a little boy's understanding of what it means to be a man," and how "he calls the shots" resonated so deeply with me from the very first time I watched the *Friday the 13th* franchise.

Continuing with the meditation/baseball memory example, here's what we can learn about processing childhood experiences from an integral, more embodied place—honoring *both* our experience of those memories as an adult in the here and now and any residual childhood pain that's left unresolved.

Remembering that we process experiences through the frontal lobe part of our adult brain, that baseball experience could easily be rationalized by thinking something like "Yes, it was a not cool thing to say, but he probably didn't mean it maliciously." And while that may be entirely true, it offers our childhood self no sense of healing or validation. (If only Jason had experienced some of these basic insights, many lives may have been saved.)

Continuing with the meditation/baseball example, here's my personal account of exactly how I learned to recognize, listen to, and honor my childhood self. I was in an EMDR therapy session, exploring a web of interconnected events with my therapist when we landed back at this baseball memory. I shared the experience with him from my adult lens, again expressing that while it was a

crummy thing to say, perhaps it wasn't meant to be malicious. My therapist stopped me immediately. He said he understood that's what my adult self-thought but asked, "What about your eight- or nine-year-old self?" He could tell I was confused by the look on my face and explained that as adults, we process things through our filtered adult lenses, but we still carry our childhood selves—with his or her emotions and experiences—within.

The therapist encouraged me to close my eyes and go back to that memory as vividly as possible, laying my adult thoughts and emotions aside and instead embodying the experience as fully as possible as my childhood self. It sounded rather weird, but after a moment or two of quieting the discursive thoughts through some mindful breaths, there he was, my childhood self—red-faced, embarrassed, deeply hurt, holding back tears, trying to stretch the nylon material that the jersey was made of away from his belly area, remembering the seemingly deafening laughter of his coaches and teammates. My childhood self was still very much hurting over this experience, whereas my adult self had written it off simply as some shitty thing that happened when he was a kid.

I'm now forty-one and have had body, weight, and self-image issues ever since that day. The EMDR session allowed me to trace the source back to its origins and begin re-owning and reintegrating that suppressed/separated part of myself, which was a very cathartic and healing experience. It's not that I don't still struggle with body image issues from time to time, but it's noticeably less (and less consuming) when it does come up. You don't need to wait to see a therapist to begin working with your inner child, though. Yup, you guessed it—practice time!

PRACTICE: Reconnecting with Your Inner Child

Your inner child consists of the carefree, curious, and explorative parts of yourself that were experienced as a child before growing into your teenage and adulthood years and facing the utter shit show that life can so often be. It's the part of you that jumped for joy when school was closed for a snow day or while watching your favorite Saturday morning cartoons (remember when that was a thing?). However, we grow up, and while we may no longer feel connected to that earlier part of ourselves, the inner child is still indeed there, and it plays a big role when it comes to informing our decisions and behaviors.

Before going any further, I do want to take a moment and address the fact that for many people, childhood consisted of traumatic events and may not be very relatable to the joyous picture painted in the previous paragraph. If that is the case, my heart is truly with you. I would just ask that you give yourself the opportunity to explore some of the following suggestions as they may (or may not) provide some healing. While deep trauma work should of course always be done with a trained professional, the following simple suggestions may help start that process.

Whether you've experienced a traumatic childhood or not, we all still carry fears and worries from our childhood and to that extent all have some semblance of a wounded inner child. Some examples would include avoiding conflict, being a people pleaser, expressing little to no boundaries with others, masking emotions, basing your sense of self on how you think others perceive you, and so on.

That said, regardless of the depth to which one experiences the aforementioned examples in their life, we all have the potential to benefit from working with our inner child. There are numerous ways to reconnect with the inner child part of ourselves, a small sample of which is as follows:

1. **Reminisce:** Whether it's TV shows, movies, toys, books, or other things you enjoyed when you were younger, go back into those feelings of your childhood self and embody them to the best of your ability as if you were actually back there in the experience itself. Better yet, why not reread one of your favorite books from childhood, or watch a cartoon or movie you used to be over the moon for?

2. **Journal:** At least two to three times a month, I anchor back into my childhood self and journal as if it were "little Chris" at the helm. This has been an exceptionally cathartic experience for me as it allows for the repressed parts of my inner child to be more vocal about what they've been holding onto all this time. To be clear, it's not all negative. Often, joyous things from childhood come up, and a feeling of elation follows them. My suggestion is to try to be as open to the process as possible and not force it. Your inner child is there, and all they need is a little space to be heard and open up.

3. **Coloring:** I'm not talking about the adult coloring books that are incredibly intricate and helpful with stress, anxiety, cultivating mindfulness, and a sense of calm—though they certainly have their place, too—but rather, those old-school, big bold line coloring books. You can usually find

them in pharmacies or of course on Amazon. And you better believe that they make horror-themed coloring books, so now you've really got no excuse not to give it a try.

4. **Buy a toy or something fun:** This past Christmas I asked Santa (aka my parents) for a container of silly putty. That was it and, boy, did they—eh hem, I mean Santa—come through; as of writing this, it's three months after Christmas, and the silly putty is still sitting next to me on the dresser and gets played with at least a couple times a week. Aside from that, for my horror nerds out there, Fright Rags, Super7, Cavity Colors, Graveyard Goods, NECA Toys, and Nightmare Toys are all incredible places to visit/shop online (and social media). But do be mindful of your pocketbooks and wallets as they have the "shut up and take my money" tendency on a person. You've been warned.

5. **Get messy:** That's right, make a big old mess. Buy some Play-Doh and create something weird and amazing. Bake something fun and make a mess on the counter. Jump in puddles. Anything that allows you to throw "adulting" out the window, if even for just a short time.

6. **Spend time in nature:** If you're a child of the 1980s or before, you probably remember a time before this thing called the Internet. A time when we actually went outside and had to play rather than stare at screens all day. We played tag, rode bikes, made forts, climbed trees, and got into various kinds of no good (I'm looking at you, mischief/devil's night especially). There was no such thing as "likes" or "followers" or "influencers" or whatever else, and

it was wonderful. Even if you're reading this and you were brought up in the age of the Internet, I still highly recommend you give laying off social media, gaming, and other screen-related things, if even for just a few hours a week, and connect with life out in the world. It can actually be pretty damn rad.

7. **Spend time with children:** I don't have any kids myself, but I do have the two best nieces a human could ask for (I love you, Addie and Ellie). Spending time with them is nothing short of magic as I get to rekindle my own sense of inner child vicariously through their innocence and wonder at life. It's the absolute best. If you don't have any semblance of children (whether they're your own, or nieces, nephews, etc.), you can always look into volunteering at elementary schools, libraries, things of that nature where you can connect with kiddos in a non-creeper way and have some legit fun.

8. **Have a sleepover:** Who ever said you're too old to have a sleepover? Get some pizza, ice cream, some horror flicks (or whatever genre you enjoy), build a couch fort with blankets and sheets, whatever it was you may have done back in the day. Age is only a number.

9. **Enjoy your favorite food(s) from childhood:** Pizza, ice cream, cookies, cake, hamburgers (or veggie burgers), anything that used to bring your palette joy (but in moderation, of course).

10. **Reconnect with an old friend:** Social media definitely isn't all bad. If nothing else, it can be useful for connecting

with old friends you may have lost touch with over the years. Within the past few years, thanks to Facebook, I reconnected with my childhood friends Adam Carmen and Brian Rizzo. These are the dudes with whom, as a kid, I fell in love with horror and skateboarding, and even simply by messaging with them or commenting on their posts periodically provides me with a really enjoyable, nostalgic feeling that I'm super grateful for.

I may be in my forties and haven't killed anyone, unlike Jason—perhaps one of cinema's most iconic survivors (sort of) of childhood trauma—but who's to say what might have happened had I not begun investigating and healing the parts of my inner child such as I have? Ki ki ki ma ma ma . . .

Chapter 12

The Blackest Eyes, the Devil's Eyes, and Carl Jung's Shadow Self

Michael Myers from *Halloween*

"Death has come to your little town, Sheriff."

—Dr. Loomis (*Halloween*, 1978 version)

Oh, the Horror!

At a pivotal moment in John Carpenter's 1978 film *Halloween*, one of the film's protagonists, Dr. Samuel Loomis, delivers what's become an iconic speech offering his psychological assessment of Michael Myers, the implacable, seemingly motiveless[xi]

xi We're ignoring the sequels here, folks.

175

psychopath who cuts a swath of terror through the idyllic town of Haddonfield, Illinois: "I was told there was nothing left; no reason, no conscience, no understanding in even the most rudimentary sense of life or death, of good or evil, right or wrong. I met this . . . six-year-old child with this blank, pale, emotionless face, and . . . the blackest eyes—the Devil's eyes." Completely blank, driven purely by dark desires that only he can understand, unable to be bargained or reasoned with, Michael Myers is arguably the most frightening of the slasher villains that dominated the 1970s and 1980s. After all, there's no such thing as dream wraiths (Freddy Krueger), seven-foot-tall murder zombies (Jason Voorhees), extradimensional sex demons (Pinhead), or killer dolls (Chucky), and, quite honestly, Leatherface is just a burly dude you could easily take out with a firearm (or, as the first film demonstrates, a well-delivered pipe wrench blow).

While Myers has the *trappings* of the supernatural about him—Loomis's insistence of some malign, possibly inhuman nature, coupled with his ambiguous vulnerability to gunfire—the movie comes down on the side of him being nothing more than a seriously disturbed, exceptionally strong human being. Loomis's opinions are simply his own, after all, not backed up by any scientific data or even any evidence of the supernatural, and there are plenty of documented cases of individuals who've suffered severe gunshots (most notably in recent memory activist Malala Yousafzai and Congresswoman Gabby Giffords) and gone on to live productive lives. Michael Myers isn't a creature from beyond the grave or eldritch abomination; the character represents his id or shadow self—unconscious and unacknowledged energy.

Set during the days leading up to and concluding on the eve of the eponymous holiday, *Halloween* follows three parallel storylines all on a collision course with one another. One of those is of Dr. Samuel Loomis, an aging, troubled, and one might say mildly unhinged psychiatrist who has spent the last decade and change of his career studying and attempting to treat mental patient Michael Myers, who—for reasons known only to him—without provocation stabbed his teenage sister and her boyfriend to death at the age of six before lapsing into selective mutism.

Having come to the conclusion that Myers is both beyond help and a danger to society at large, Loomis is anticipating that he'll be able to convince the law of the same at an upcoming competency hearing. It's Loomis's *hope* that this will result in the now twenty-something Myers being relocated from the middle-American psychiatric hospital where he's spent the bulk of his life to a maximum-security prison facility where he'll spend the rest of his days in presumably Hannibal Lecter–esque conditions. As Arthur Miller wrote in *After the Fall*, though, "It's a mistake to ever look for hope outside of one's self," and Loomis's aspirations that society will soon be safe from Myers turn out to be short-lived: Myers orchestrates a prison break, stealing Loomis's car for good measure. Loomis is determined, van Helsing–like, to track and subdue—or, if he has his way, judging from the high-caliber revolver he's fond of swinging around like a drunken lunatic—kill his former patient.

This segues into our second storyline of the film, that of un-assuming high school student Laurie Strode. We don't get terribly much on Laurie by way of backstory, but she emerges as a smart,

quiet, type-A personality. The one single girl among her friend group (though not for lack of trying: Her would-be love interest Ben Tramer turns out to be an unintended victim of the evening's carnage), Laurie's focused on school, family, and work, work in this case being a string of babysitting gigs that are helping her build a nest egg before graduation. On Halloween night, Laurie will be babysitting Tommy Doyle, who, like me at his age, is both easily frightened and *loves* horror cinema. Which brings us to our third, most ambiguous storyline of the movie.

See, while we can never—probably *will* never and probably *don't want to*—know what's going on in his head, Michael is out there making a series of moves that make perfect sense to him to fulfill a goal only he understands. The first step in this is breaking into a convenience store to steal a distinctive-looking Halloween mask; the next is stealing his sister's tombstone. We'll never quite be certain where this is all going, but after he happens to catch sight of Laurie, he becomes obsessed with incorporating her into whatever it is he has going on in his sick head, leading to a final confrontation between all parties involved.

Sigmund Freud famously postulated the theory of the human psyche being divided into the ego, superego, and id, which my intro to psych and childhood psychology professor Dr. Karen Buckman simplified by having us picture a television show where a character faces temptation and a cartoon angel and devil appear on their shoulders. We are the ego, the self who wants to do the right thing in a given situation but who's prone to weakness and temptation. The superego is our higher, rational, moral mind, urging us toward the ethical, legal, and righteous. Then there's the

id. It doesn't matter if it's wrong, unethical, immoral, or if it could potentially even harm ourselves and others—the id's motto is "If it feels good, do it."

Life, the way Freud saw it, was a balancing act. Neither the ego nor id are inherently good or bad, and each contains valuable aspects of the human personality. According to Freud, in his 1923 text *The Ego and the Id,* "The ego represents what we call reason . . . in contrast to the id which contains the passions." He compared it to the relationship between horse and rider, writing in his 1933 book *New Introductory Lectures on Psychoanalysis,* "The ego's relation to the id might be compared with that of a rider to his horse. The horse supplies the locomotive energy, while the rider has the privilege of deciding on the goal and of guiding the powerful animal's movement. But only too often there arises between the ego and the id the not precisely ideal situation of the rider being obliged to guide the horse along the path by which it itself wants to go." In other words, doing the right thing and not harming others while *also* not denying certain base pleasures or living a life of unfulfilling asceticism. Giving over too much to either extreme, he thought, would result in different types of unhappiness: Indulge the superego too much and one could become joyless and puritanical, denying oneself all pleasures, following rules to a fault, and generally being the sort of person who calls the cops to report jaywalkers. Give into the id, though, and one's life becomes a meaningless, dangerous, bottomless pit of sleazy excess, totally lost to sex, drugs, alcohol, and chasing the next high, taking from rather than giving to the world in the short time you're here before the inevitable young and probably ugly

death. That's ego/superego/id in a nutshell, but dig a little deeper, and things get more complex and shed some light on the complex interplay and balance between these aspects of ourselves, particularly that pesky id.

It's now that we return to our old friend Carl Jung (see the *Leatherface* chapter) and his own perspective on the id. As part of his far more esoteric, spiritual approach to psychology,[xii] Jung conceptualized something he called the shadow, which veers close to Freud's concept of the id. Jung took things a little further, though: As opposed to simply a primal drive toward pleasure, Jung's shadow is a subconscious force—the hidden sum of our desires, fears, animal aggression, primal instincts, and sexual urges. Most people deny the existence of this shadow self; who, after all, wants to admit certain dark thoughts that might come to us throughout the day, such as loathing for a coworker or feeling that someone else got something we wanted, like a promotion or winning lotto ticket? Who wants to admit lusting after a friend's partner or envy for someone else's lifestyle? If the id is the devil on the shoulder, then the shadow is Mr. Hyde from Robert Louis Stevenson's *The Strange Case of Dr. Jekyll and Mr. Hyde*, in which gentlemanly Victorian scientist Dr. Jekyll concocts a serum that transforms him into Mr. Hyde, a bestial hedonist who indulges in all the shameful vices that Jekyll desired but repressed. Put another way for horror fans, the shadow is our *Purge*[xiii] selves: what

xii Jung veers more toward the shamanistic than the scientific, a reason that I like fusing his ideas with those of other more grounded psychologists when applying psychological principles to my writing and assessment of everyday life.
xiii The dystopian horror franchise in which, for twenty-four hours every year, all US laws are suspended, and individuals are free to engage in any activity they desire free from consequences.

we would do and who we would be given complete dispensation by the law and human morality. The shadow is what must be kept in check to allow for conformity to social norms and to allow us to live in a peaceful, law-abiding society.

While we might assume that Jung saw the shadow as a negative or inherently destructive thing, though, like many psychological concepts, the shadow in and of itself isn't necessarily bad—it's what we *do* with it. As Jung wrote in his 1938 text *Psychology and Religion*:

> There can be no doubt that man is, on the whole, less good than he imagines himself or wants to be. Everyone carries a shadow, and the less it is embodied in the individual's conscious life, the blacker and denser it is. If an inferiority is conscious, one always has a chance to correct it. Furthermore, it is constantly in contact with other interests, so that it is continually subjected to modifications. But if it is repressed and isolated from consciousness, it never gets corrected.

As is the case with Dr. Jekyll, Jung felt that the attempt to fully repress the shadow could lead to destruction. Unacknowledged and pushed down into some dark corner of ourselves, Jung believed, the shadow would find a way to express itself, and it would do so unconsciously, leading individuals to engage in self-destructive behavior as a means of expression. It would tap into our jealousy or lust or death drive and cause us to act in ways that we don't even realize are destructive until it's already too late.

Rather, Jung believed the shadow had to be acknowledged, accepted, and, for lack of a better word, harnessed. After all, again, the shadow isn't necessarily entirely destructive. Consider: The

shadow is the seed from whence antiauthoritarian and noncon-
formist sentiment flourishes. It's what lets some people march to
the beat of a different drummer, to get that tattoo or piercing that
society may look at askance, to live outside the norm; again, while
rebellion against *just* authority is never desirable, it was a very vir-
ulent antiauthoritarianism that led to MLK's march on Selma, the
Warsaw Ghetto uprising, the fall of the Berlin Wall, and so many
other battles against *un*just authority. Without tapping into this
antiauthoritarianism—without engaging with the shadow, this
willingness to go against societal convention and norm—none of
these things would have been possible.

Furthermore, because of its boundless nature and willingness
and ability to engage with socially unacceptable thoughts and de-
sires, the shadow is, according to Dr. Carolyn Kaufman, a clini-
cal psychologist and creative writing tutor, "the seat of creativity."
Boundless in nature, the shadow is where all our most vibrant
ideas—dark and light—foment, unchecked by fear, shame, or
hesitancy; it's where any idea of any sort can grow and take shape
into story, poetry, play, or musical score.

This is something I know well: In my work as a fiction writer,
I've always looked inward toward my shadow self when crafting
my villains or morally compromised protagonists, looking to im-
bue them with a spark of life and verisimilitude culled from my
own fears and anxieties. My brother, who had been my best friend
growing up, had just moved out of the house; I'd just enrolled
in college after leaving behind my childhood town; I was strug-
gling to make new friends; I'd just gone through an amicable but
still painful breakup; and worst of all, my mother had just been

diagnosed with acute myeloid leukemia and placed in hospital quarantine where I could only interact with her via a telephone beside a glass pane, prison waiting room style. In order to help my family financially, I'd begun taking extra shifts at the movie theater where I worked as a projectionist and usher. What time I didn't spend at school or work was spent at home watching the horror and exploitation movies that had become my only friends and refuge in an increasingly dark life.

One night I came home at one in the morning after the last show of the evening and after having a garbage bag split open on me while helping some other ushers take out the trash. Standing dazed in the spare bedroom of our house, I found myself staring zombielike at the bookshelves where I kept my VHSs and DVDs, row after row of horror flicks and grimy '70s exploitation staples in which I found great entertainment and artistic merit but whose place of primacy in my life was proving to be a barrier to relationships. In my few attempts at making new friends in school, my love of horror had often become a stumbling block; even more so, it'd been a major point of contention in my relationship with my Jane Austen–loving girlfriend, who was a bit concerned about what it said about me that one of my favorite pastimes involved watching people get butchered on-screen. Alone, friendless, hopeless, I gazed at those movies and asked, "What's going to become of me?" And it was in that moment I birthed Andy Lew—a middle-aged, friendless, death-obsessed projectionist whose search for the ultimate horror movie belies a genuine appreciation for art and deep capacity for creativity. He became my first fully formed, realized "adult" character.

It was a meeting with my own shadow self: All the broiling darkness I saw inside myself coupled with my desire to reach out and connect with humanity to achieve something more. It was through this connection with my shadow that I was not only able to write Andy but begin crafting other more nuanced characters as well, and the process through which I was able to fully examine my own love of horror cinema and what it said about me, coming to a place of peace regarding my love of a genre so often reliant on pain and violence against women. My conclusion: Consuming horror and exploitation cinema is perfectly fine, but it can't be done unquestioningly or consumed blindly; we need to remain aware of what we're watching, why we like it, and remain in dialogue with it. So it was through this acceptance and engagement with my own shadow that I was able to evolve into the writer I am today.

Instead of denying or repressing the shadow, we must acknowledge and integrate it into our personalities—like the id, knowing when to indulge and when to pull back. Think of it like a well-trained but still dangerous dog: Sometimes you need to keep it on the leash for the safety of others; sometimes, it's okay to let it go but always with an eye on keeping it under control, ready and able to put the leash back on. What happens when we don't, though? What happens when the shadow is completely untethered, left to dominate? We discussed earlier in this book Jung's idea of becoming the persona; what happens when we become the shadow?

Why, Michael Myers.

From a Jungian perspective it's easy to see the moment that Michael kills his sister and her boyfriend—or perhaps the

moment he *resolves* to do it—that whatever personality existed there before becomes totally sublimated and he *becomes* his own shadow. Everything we see Michael do throughout the course of the film comes from a place of either practical survival (murdering a trucker for a change of clothes and new vehicle to throw the cops off his trail; killing a stray dog to eat for nourishment) or in furtherance of whatever's going on inside his head.

One of the more unsettling aspects of the movie is that we get vague hints of *some* kind of concrete narrative going on inside Michael's head as to why he's doing what he's doing, even if it only makes sense to him. Need a mask and supplies? Michael doesn't buy it, he steals it. Guard dog in the way? Just strangle it. Michael wants to kill, so he kills; Michael wants to create freaky tableaux out of human corpses, so Michael creates freaky tableaux out of human corpses. Piggybacking onto the shadow being the seat of creativity, far from simply killing his prey, Michael turns the unfortunate teens of Haddonfield into components in weirdo art installations, moving and posing his victims for reasons that only make sense to him. While the cenobites may veer more toward personifications of pure id, acting wholly according to the pleasure principle, we can see in Michael Myers the shadow made flesh, a being given over totally to the miasma of dark desires, creative inspiration, and antiauthoritarian sentiment that lives in the depths of each of us.

That Michael Myers's nemesis is a psychiatrist, Dr. Loomis, rather than a more conventional authority figure like a police officer, lends further psychological underpinnings to the character. As the pure shadow, Michael is a psychological construct come to

life, requiring a mental health professional to go toe-to-toe with him. This is typified in one of the film's subtler yet most powerful moments when, in their final struggle, Laurie manages to yank Michael's mask off, revealing a relatively handsome but otherwise average twenty-something man. Rather than continue his attack, Michael panics and snatches the mask back, urgently tugging it on, providing the distraction necessary for Loomis to ambush and shoot him: Michael is so subsumed to the trappings of his shadow self that anything that serves to expose his conscious, human self stops him in his tracks.

In contrast to killers such as Jason who hide their identity behind masks for protection or to intimidate their prey, the mask *is* Michael's real face. This facet of the character is even acknowledged in the film's official credits: only Will Sandlin and Tony Moran, the actors who portray the unmasked Michael as a child and adult, respectively, are credited as "Michael Myers." Nick Castle, who portrays the masked version of the character seen on-screen for the bulk of the film, is rather credited as "The Shape." One can just as easily see him being called "The Shadow."

All of us have our own inner darkness with which to reckon, impulses best left checked and desires best left unfulfilled. Just because something is dark doesn't necessarily mean it's evil, though, and we can look to our shadow selves as sources of creative inspiration, individuality, and a source of strength against injustice and oppression. The trick is in always being the one in charge of and dictating the actions of the shadow, and not the other way around, lest we turn into our own personal versions of Michael Myers. Who *wants* to be the bogeyman?

Oh, the Humanity!

In 1978, John Carpenter wrote a little film you may have heard of called *Halloween*. The final scene in this groundbreaking film shows Dr. Loomis shoot Michael Myers five times before Michael falls off a balcony to what should be his ultimate demise. The camera then shows a cowering, deeply distraught, and teary-eyed Laurie Strode ask Dr. Loomis, "Was it the bogeyman?" to which he replies, "As a matter of fact, it was." The scene ends with Dr. Loomis looking over the balcony at the ground below, seeing that Michael's body is gone. His reaction was a mixture of mild surprise but also one that suggests he somewhat expected it. Laurie then proceeds to cower further, cry more intensely, and the ominous *Halloween* theme song plays while Michael, unseen, can be heard subtlety breathing through his mask in the background.

Halloween, and this scene specifically, had a deep impact on my life when I saw it for the first time at eight years old. I was too young to understand why, but I felt it to the core of my bones. The *Halloween* franchise also began my love affair with all genres of horror, but to this day, my penchant is still for masked killers.

It wasn't until I started studying psychology and human behavior that I began putting the pieces together of my penchant toward these faceless villains. As my studies went deeper, I became acutely aware that to see ourselves, let alone others, for who we truly are can be an exceptionally visceral and unnerving experience. When I say, "who we truly are," I'm not talking about our names, jobs, relationships status, and all the other material things we typically identify ourselves by. Rather, I'm talking about the

self that we are beyond and beneath those things, which for most is kept hidden and suppressed at virtually any cost.

Want to experience real horror? Try taking a moment to explore what it means to accept yourself fully in all your perfect imperfections; to take an honest, fearless look at your true self and stay there, acknowledging both the frailty and the glory in the same glance. This is something I've been working on for twenty years and still feel as though I've only begun to scratch the surface. Perhaps that's part of what lent itself to why Myers was so obsessed with his mask and always having it on—his complete disconnect with himself and any semblance of humanity that remained within him.

Seeing 1978's *Halloween* for the first time when I was younger was a visceral experience (in the best possible way). I wasn't watching the movie so much as I was having it happen to me. Michael Myers. His mask. His walk. His breathing. The bloodshed. That it took place on my favorite holiday, Halloween—it had everything I could ask for, not to mention the undeniable gold standard that cowriter, composer, and director John Carpenter set for future horror/slasher filmmakers (and all on a mere $300,000 budget, which even by late '70s standards was a shoestring moviemaking budget).

My experience with Michael Myers grew into the thing nightmares are made of, literally. For years I had recurring and unrelenting dreams about Michael trying to kill me. Truth be told, as terrifying as they were at times, it was pretty damn cool to have a starring role alongside my favorite horror villain in my very own *Halloween* franchise. Granted, these "films" left their mental and

emotional mark on me over time, but what horror movie worth its weight in blood and terror wouldn't?

I also saw Michael as the epitome of punk rock. He did what he wanted, when he wanted. Sure, this mainly consisted of killing people (and dogs), but he did it on *his* terms. Michael answered to no one and was unapologetically himself. And just like Carpenter became the golden standard for slasher filmmakers, Myers was equally a golden standard for the DIY (do it yourself) ethos that punk and hardcore prides itself on (or at least did at one point). Michael *made* shit happen. He didn't ask permission. He couldn't care less what anyone else thought. He was Michael effin' Myers, and he was *not* to be messed with.

Part of the beauty, or frustration, of *Halloween*—depending on how you look at it—is how much of the story and Michael Myers's motives are left unknown and unexplained. He is an evil, psychotic killer, and on Halloween, he sets his murderous sights on Haddonfield, Illinois (which just as easily could have been called "Anytown, USA"). And that's basically it. That's all we as viewers—or experiencers—have to work with.

What lurked under that emotionless mask was unknown and exceptionally scary. I found resonance in this on a personal level because during my formative years, just like I didn't know who or what was under Michael's mask, I also didn't know what was under the metaphoric masks I wore or who I was inside. The confused, scared, angsty, and anxious part of myself was mirrored in everything I experienced Michael Myers as. Seven years later, while taking an abnormal psychology course in college, I learned about Swiss psychologist Carl Jung and what he called the shadow self, or inner shadow, which I mentioned earlier.

The importance of beginning to recognize the various shadow aspects we embody—whether they are negative traits, behavioral patterns, or both—is because they have the strong potential to sabotage our lives. It's like Jung said, "Until you make the subconscious conscious, it will lead your life and you will call it fate." The shadow is often synonymous with our subconscious mind because it is difficult to see clearly, making it hard to be aware of. Denying these hidden, shadow aspects of ourselves does not make them disappear, but rather, they fade from our conscious awareness into our subconscious, resulting in repeated unhealthy patterns and behaviors in our lives.

Three very helpful ways we can become more aware of our shadow selves is by paying attention to projections, triggers, and patterns. Projection is when we project the parts of ourselves we dislike onto others. As mentioned earlier in this chapter, anger, guilt, and shame would be examples of things we project. (A quick note to say that we do also project positive attributes and qualities onto others, which can be a good thing, but for the purpose of this chapter, we're honing our focus on the things that don't serve our well-being.) Triggers are not just surface events that cause conflict in our lives but can also be experienced as invitations to become more aware of the hidden aspects of ourselves buried within our subconscious. Patterns are repeated behaviors in our lives and, when it comes to the shadow specifically, are usually an attempt by our shadow to be acknowledged and seen. The shadow wants to make itself known; that way, it can be seen and reintegrated in a healthier way into our being to break whatever disruptive cycle it's causing in our lives. Learning to re-own and reintegrate

our shadow is essential to living our most integrally healthy lives. Every time we suppress or act on it, the shadow grows stronger, which does no one, including ourselves, any good. That's why Michael Myers is so apropos here—he's the archetypal bogeyman shadow figure showing us how unsavory impulses and behaviors can manifest when we're cut off from ourselves and that which lies hidden within.

The following practices will help guide you in beginning to work with your own inner shadow. May they be helpful and healing.

PRACTICE: Shadow Journaling and 3-2-1 Shadow Process

Like Michael Myers, shadow work is intimidating, and while it can be mentally and emotionally taxing at times, it primarily just consists of becoming aware of what's hidden within and gradually healing those aspects of ourselves. While it's not necessary to do shadow work with a therapist, I personally would highly recommend doing so if it's at all within your means.

Perhaps the most conducive way to ease into shadow work is by journaling—particularly by using shadow-specific journal prompts because they give us some tangible direction in which to work. The following are twenty prompts to get you started. If none of these resonate or if you'd like more prompts after finishing the following, simply google "Shadow Work Journal Prompts," and you'll find no shortage of free ones to choose from.

Twenty Shadow Work Journal Prompts

1. Is there a specific emotion you try to avoid more than others? What is your reaction when experiencing this emotion?

2. What sort of things does your inner voice usually say to you? Is it kind or critical?

3. Is this inner voice actually yours, or could it be the result of other people in your life, like parents/family, friends, or teachers?

4. How do you handle disappointment?

5. What kinds of situations make you anxious, panicked, or stressed? How do you handle them?

6. What situations make you withdraw, feel depressed, or despair? What (if any) techniques do you use to manage them?

7. Can you acknowledge your role in these dynamics? Can you apologize when you're in the wrong and your actions have negatively impacted another?

8. What traits tend to show up when you're stressed?

9. What traits do you find most annoying/repulsive in others? In what ways do you also have these traits?

10. Are there particular emotions you experience as more challenging than others, and if so, why?

11. Are there truths in your life you tend to ignore?

12. What problem(s) did you face in your childhood, and how do they affect you today?

13. What have you not forgiven yourself for?

14. What have you not forgiven someone else for?

15. What kind of self-destructive behaviors and habits do you exhibit?

16. What are your core values, and are you living in alignment with them? If not, which values aren't being respected?

17. Imagine your life is coming to an end. What regret(s) do you fear having the most?

18. Do you ever feel empty inside? If so, how do you fill this void? If the means and methods are unhealthy, are there healthier alternatives you could learn, practice, and use?

19. Do you feel valued? If so, what makes you feel that way? Alternatively, if not, what makes you feel *that* way.

20. If you were to live the rest of your life as you have thus far, how would that make you feel? Is there anything you'd like to do differently? If so, what's stopping you?

3-2-1 Shadow Process

The following process, which I've used for several years and found to be very effective, was written by friend and integral spiritual teacher Diane Musho Hamilton. Hamilton describes how the 3-2-1 process "uses shifts in perspective as a way of identifying and integrating shadow material. '3-2-1' refers to 3rd person, 2nd person, and 1st person—the perspective." Hamilton then shares the process in both a long-form and short-form version, which are included below. [1]

Long-Form Version

First choose a "difficult person" to whom you are attracted or by whom you are repelled (e.g., romantic partner, boss, parent),

or pick a dream image or a body sensation (like tightening in your chest or tension in your face) that creates a disturbance in your awareness. Keep in mind the disturbance may be a positive or negative one. Then follow the three steps of the process described below. For the short form, spend about five minutes on each perspective. For the long form, you can spend ten to fifteen minutes or longer.

You can either talk through the process or use a journal to write it out. If talking, imagine the person or thing sitting across from you. If using a journal, simply write out each of the following steps.

3—**Face It:** Describe the person, image, or sensation in vivid detail using third-person pronouns (e.g., he, him, she, her, they, their, it, its). This is your opportunity to explore your experience fully, particularly what it is that bothers you. Don't minimize the disturbance—take the opportunity to describe it as fully as possible.

2—**Talk to It:** Enter into a dialogue with this object of awareness using second-person pronouns (you and yours). This is your opportunity to enter into a relationship with the disturbance, so talk directly to the person, image, or sensation. You may ask questions such as "Who/what are you? Where do you come from? What do you want from me? What do you need to tell me? What gift are you bringing me?" Then allow the disturbance to respond back to you. Allow yourself to be surprised by what emerges in the dialogue.

1—**Be It:** Now, writing or speaking in first person, become the person, image, or sensation you have been exploring. Use the

first-person pronouns (I, me, mine). See the world, including yourself, entirely from the perspective of that disturbance, and allow yourself to discover not only your commonalities but also how you really are one and the same. Finally, make a statement of identification: "I am _____" or "_____ is me." Now integrate this perspective into a larger you, feeling it as an integral part of your being.

Short-Form Version

You can do the 3-2-1 process anytime you need it. Two particularly useful times are right when you wake up in the morning and just before going to bed at night. Once you know 3-2-1, it only takes a minute to use it for anything that might be disturbing you.

- First thing in the morning (before getting out of bed), review your dreams and identify any person or object with an emotional charge. *Face* that person or object by holding it in mind. Then *talk* to that person or object, or simply feel into it. Finally, *be* that person or object by taking its perspective. For the sake of this exercise, there is no need to write anything out—you can go through the whole process right in your own mind.

- Last thing before going to bed, choose a person who either disturbed or attracted you during the day. *Face* him or her, *talk* to him or her, and then *be* him or her (as previously described).

Chapter 13

A Blood-Soaked Exploration of Guilt and Shame

Carrie White from *Carrie*

*"It has nothing to do with Satan,
Mama. It's me."*

—Carrie (*Carrie*, 1976 version)

Oh, the Horror!

Shame. It's a powerful emotion, perhaps one of the most primal and motivating things that we humans can feel. It makes sense: As social creatures, we crave companionship, a sense of belonging, and love, and many of us are willing to go to incredible, oftentimes ludicrous (and, let's be honest, often stupid and quite frankly dangerous) lengths to feel like we have acceptance. Shame—the sense that we've displeased another person, or, worse, a large group,

entire community, or some divine force—is precisely the oppo-
site of those positive feelings, the sense that we're alone, disliked,
despised, unloved, and perhaps even unlovable.

Like almost every emotion, under certain circumstances,
shame can be put to positive use: Positive social pressure to be-
have in acceptable and constructive ways can prevent us from do-
ing such potentially harmful, or at least embarrassing, things such
as eating that entire cake in one sitting or behaving rudely in pub-
lic. Conversely, it can also be put to destructive uses: Throughout
history, shame has been one of the primary tools of totalitarian
and theocratic regimes, used to stigmatize individuals or groups
whose behavior falls outside the accepted norms of society as a
means of domination and social control. From the stocks and
pillories of the Middle Ages and Renaissance to Plymouth and
Salem's scarlet letters and the yellow stars and pink triangles
of the Holocaust, visibly calling or marking out someone as an
object of ridicule and scorn—and inflicting shame upon those
individuals—has been a powerful form of authoritarian domina-
tion. It's something we're seeing quite a bit of today, for better
and for worse, with the rise of Twitter mobs and the use of social
media as an arbiter of justice.

On one hand, call-out culture has proven to be an effective
tool for shaming powerful public figures and institutions into
reassessing bad behavior or pressuring law enforcement into in-
vestigating cases or individuals who'd used their influence to slip
under the radar. On the other hand, though . . . well, has "mob"
usually had a positive connotation?

While it may be highly undesirable to *feel* shame, it can feel
incredibly empowering to *inflict* it, the reason it's been such a

powerful tool for abusive regimes. Inflicting shame brings people together, granting them the very sense of belonging and together- ness that shame strips away. It allows us to come together against a uniting enemy; if someone *else* is meant to feel shame for some- thing, and we're the ones pointing it out, it necessarily places *us* in the right, moral guardians who've found ourselves in the posi- tion of being able to *tut-tut* those who've done wrong—or, rather, whom we'd like to *think* or *say* have done wrong.

For every sexual predator shamed out of the entertainment industry and every corporation pressured out of an endorsement deal, social media abounds with countless instances of petty pile-on mobs as the "main character of the day" finds themselves the target of harassment and public shaming for social infractions no worse than questionable takes in cinema or bad fashion ad- vice. One could say that shame is a tool: Used properly, it can be restorative, repairing, and constructive. Wielded like a blunt ob- ject, though, like most tools, it becomes something else entirely: a weapon. It's a lesson presented in visceral detail in Brian de Palma's 1976 film *Carrie,* a Stephen King adaptation that demon- strates the destructive power of unchecked and unjust public shaming and shows us on a grand and fiery scale the potential consequences.

Captivatingly played by Sissy Spacek, Carrie White is, perhaps, one of the most unfortunate teenage girls in the history of West- ern cinema, which, considering the way Western cinema usually treats teenage girls, is saying a hell of a lot. She's the only daughter of Margaret White, a single mom laundress whose brand of fire- and-brimstone Christianity is considered terrifying and radical

even by the standards of their ostensibly conservative, small New England town. This may be the 1970s, but one gets the impression these are still churchgoing folk although *their* churches most certainly don't include the gruesomely realistic, blood-soaked St. Sebastian statue that's a fixture of the White household, or regular beatings and enforced trips to claustrophobic "prayer closets."

Quiet, retiring, and passive, the angelic Carrie exists in a state of near-constant angst, fearful of the world and unable to relate to it due to her restrictive upbringing, which has kept her essentially isolated from other people except to go to school. Between her unworldliness, nervous demeanor, withdrawn nature, and constant aura of anxiety, Carrie is the designated Weird Chick at Castle Rock High, making her the prime target for Queen Bee Chris Hargensen and her coterie of mean girls.

While teenagers have always practiced social ostracizing and othering as a means of bullying, this is also the dark ages of 1970s American high schools, a savage wasteland of borderline lawlessness, which means that Hargensen and company don't just stop at letting Carrie know with every waking moment they despise the very air she breathes. Their abuse ranges from verbal taunts and constant insults at best to outright physical assault, as demonstrated in the film's opening moments. Showering after gym class, Carrie experiences her first period, a life event for which her mother has left her woefully unprepared: According to Margaret's cracked theology, only spiritually unclean women experience menstruation, and she'd hoped her daughter might remain "pure" and never have to deal with it. Bleeding and screaming, Carrie reaches out to her classmates for help, prompting Chris and

company to rain down a barrage of sanitary napkins and tampons on the poor girl. While school administration eventually steps in, we get the impression this is more or less business as usual for Carrie White: sympathetic gym teacher Ms. Desjardin and school staff treat the incident not so much as a particularly cruel one-off incident but rather the culminating incident in years of verbal and physical bullying.

It becomes clear that Carrie's otherness has made her *the* shame target at Castle Rock High, the unwilling sin eater designated by her peers to serve as the object of their scorn and ridicule for being socially maladapted, awkward, and strange— in other words, a teenager—so they can feel better about their own shortcomings. Even the *boys* don't want to have anything to do with Margaret White's daughter, as evinced when one of her classmates, Sue Snell—feeling guilty for her participation in the shower incident—pressures her reluctant boyfriend Tommy to take Carrie to prom in her stead as a show of remorse.

Although he ultimately relents, Tommy initially balks, not so much out of loyalty to his girlfriend but his aversion to Carrie (an instance of Hollywood casting getting in the way of the story; while in the source novel the character has poor hygiene, is covered in pimples, and is frequently likened to a toad, as played by Sissy Spacek, Carrie White is undeniably *cute*, and there isn't a hormonally charged teenage boy alive who'd let some weird staring and social awkwardness stand in his way). This is a horror movie, though, and few good deeds go unpunished. Chris Hargensen isn't just your run-of-the-mill pissy teenager but a budding psychopath in the flower of her youth, and since she's been

banned from the prom for her role in the shower incident, she's going to make sure it's a night Carrie won't ever forget. Chris goes to insane lengths to both rig the election for prom queen to make sure Carrie wins *and* rig up a bucket of pig's blood to drop on her nemesis at what the poor girl will think is her crowning moment of acceptance.

Again, though, this is a horror movie, and while Chris's plan may come off, there's two things she hasn't anticipated. The first is that—hopeful teenager that she is—Carrie's fallen in love with Tommy over the course of the night, feelings he just may have been beginning to reciprocate when that bucket hit him at just the right angle to fatally snap his neck. The second is that in addition to being the maladjusted daughter of a religious cook, Carrie White is also telekinetic. And pyrokinetic. And she's been pissed off for a very, *very* long time. And that bucket was the straw that broke the homicidal psychic's back.

While, in the wake of school violence in recent years, Stephen King has distanced himself from the character and likened her to a mass shooter, I find it hard to watch *Carrie* and not walk away wanting to give its protagonist a great big hug. For nearly two hours, we watch the poor girl go through a veritable assembly line of humiliation and degradation, all in the name of empowering her tormentors and allowing them to feel both a sense of community in their group shaming of her and a sense of personal empowerment at being the ones doing the shaming rather than receiving it.

Carrie is awkward and strange and comes from a weird family and is clueless about many of the social niceties and shibboleths

of being a "normal" teenager (indeed, absent her maladaptive upbringing, as played by Sissy Spacek, the character—probably unintentionally—demonstrates multiple signs of high-functioning autism, including a flattened affect, awkward manner of speech, misunderstanding of social norms, and occasionally strange posture and comportment; the last comes from Spacek's modeling Carrie's body language in certain scenes on depictions of medieval martyrs about to be stoned). Should she feel shame for any of these things? Of course not. Shame has been misapplied here not for social benefit but for social control.

The dark irony is that, just as in real life, the individuals who *should* feel shame—Chris and company—are the ones doing the shaming themselves, weaponizing the emotion for malign purposes. Worse still, they further take advantage of the positive feelings that group shaming can create—that sense of togetherness against the other—and draw others into their ostracizing of Carrie, even those, like Sue Snell, who would normally act more gracefully, a powerful reminder not to automatically engage in "pile ons" or readily follow "dragon slayers" who may not have the best intentions at heart when engaging in shaming, be it in a workplace, classroom, or community context, or in an online setting. It's easy to knee-jerk join a crowd or hit that retweet button, but it's the better part of wisdom, beforehand, to consider if the individual or entity in question is worthy of this shaming or if—like Carrie White—they've found themselves the undeserving target of a malign strike.

It's important to remember, too, that, while we may feel positively for shaming the individual, even what we perceive as minor

embarrassment or inconvenience for whom we see as a deserving target can, to the impacted individual—especially the undeserving individual—*seem* much more severe, amplifying the experience beyond even what may be intended. While many first-time viewers miss it, in the film's infamous "They're all going to laugh at you" sequence—when Carrie finds herself covered in pig's blood and recalling her mother's hysterical admonition that the night will inevitably end with her classmates scorning her—*Carrie is only imagining her classmates laughing.* The film subtly switches between objective "real world" sequences showing a nominally horrified crowd and the more bombastic, kaleidoscopic sequences shown from Carrie's perspective, in which even her teachers are pointing and cackling at her.

When asking ourselves if another individual is worthy of shaming, we shouldn't just first pause to consider the justification of it, but if we *do* decide that shaming is necessary, we should also consider the degree and what the real impact will be for the target. Chris and her friends "just" had a good laugh while their classmates looked on in horror; to Carrie, the entire world had just turned on her. Similarly, to us, we may just be hitting a retweet button; to the person on the other end, it may be the end of their world.

One final consideration: What happens when we find *ourselves* on the receiving end of a shaming, be it in a private or public capacity? While it may be tempting to take the Carrie route and lash back out, it's vital to remember that it's rarely the better part of wisdom. First, consider: Is the shame deserved? We all like to view ourselves as the heroes of our own narratives and

put-upon victims like Carrie, but an honest self-assessment and inventory of our words and actions are necessary. *Have* you honestly caused harm through word or deed, even if unthinkingly or thoughtlessly? Even if the harmed party has taken drastic action, such as publicly shaming you for a minor personal slight, accept your guilt and make a sincere apology. Take accountability for whatever harm you've caused and offer to make amends in whatever way the injured party requests, as long as it's reasonable (and legal).

If, after an honest self-assessment, you find that the shaming party is behaving unreasonably and being a bad actor to gain clout/sympathy, for attention, or other malign reasons, lashing out still isn't the way to go. We all want to defend ourselves when confronted unreasonably, but going on the attack only serves to potentially escalate a situation. Consider: What's the context, and what potential harm do you face? Is the shaming being done in a capacity that could cause actual material harm to yourself, such as a coworker shaming you in front of an employer or influential co-workers, or a social media presence with a large following? Or is it something more akin to being laughed at by a few people in the high school gym? If it's the latter, a complete lack of response may be the better part of wisdom: Remember, the majority of Carrie's classmates were horrified at what *Chris* had done, and had Carrie not wigged out and indulged her inner pyromaniac, she would have been the object of sympathy, not scorn. If it's the former, offer a simple response, and then disengage. Take strength in the knowledge you've done no wrong, and then wait things out.

Successful shaming requires you to actively feel that shame; and, as I'm reminded by one of my favorite lines from the fantastically insightful Netflix dramedy *Bojack Horseman*, "People have short memories. It's the best and worst thing about people." If you've truly done no wrong, folks will either see through that initially or forget it over time as the next main character of the day takes the dreaded limelight. Had Carrie White walked out of prom, lived her best life, and attended her twenty-year reunion, folks would be talking about what a jackass Chris Hargensen was, not yukking up over that time poor Carrie got blood dumped on her.

Shame can be a necessary and powerful emotion, useful for both our own protection and, when necessary and called for, the protection of a larger society. Like all powerful things, though, it must be used with responsibility, and if we as human beings are going to make another person feel shame, it should both be justified and a final course of action. Sometimes, people who use anonymity, ghosting, and gaslighting to try to cover up malign behavior have to be shamed as a last resort when attempts to address that behavior privately have failed.

Consider, too, that shame is a key component in the intervention process as addicts are confronted with how their behavior has hurt their friends and loved ones, with shame acting as a driving force to seek help and not repeat their past actions. We're capable of feeling shame because sometimes it's necessary. In the wrong hands and under the wrong circumstances, though, shame can do infinitely more harm than good and succeed only in making us feel good about ourselves at the expense of others' mental health

and well-being. Most people who are publicly shamed (hopefully) won't turn out to be killer super psychics with pent-up rage and enough mommy issues to make Freud salivate; if, like Chris Hargensen, though, we target those unworthy of shame, we're still contributing to the destruction of the world.

It doesn't make the world a better place to induce suffering in those who don't deserve it, and even if the pain stops at the individual, as we explore elsewhere in this book, hurt people go on to hurt people—many individuals who engage in unwarranted shaming have in the past themselves been the target of similar treatment, repeating the cycle of abuse. In remaining mindful of when we ourselves should feel shame, we must be equally mindful of when it's appropriate, and when it's not, to shame others. After all, more so than many other horror movies, *Carrie* could have had a happy ending.

Oh, the Humanity!

In John Bradshaw's *Healing the Shame That Binds You*, he writes, "Healthy shame lets us know we are limited. It tells us to be human is to be limited . . . the unlimited power that many gurus offer is false hope. Their programs calling us to unlimited power have made them rich, not us. They touch our false selves and tap out toxic shame. We humans are finite, 'perfectly imperfect.'"

On a good day, I resonate with "perfectly imperfect." I say, "on a good day" because even though I've been writing books on wellness for roughly ten years, I still struggle with every topic that

Preston and I have addressed in this book—and sometimes, a lot. But on those "good days," I do experience myself within the context of imperfectly perfect. It's the quirks—both inside and out—that make us the unique, and yes, even loveable beings that we are. And by using the practices provided throughout this book, many of them for several years, those "good days" seem to happen much more frequently—not a coincidence in my opinion.

Still, shame and guilt have had no problem making themselves known to me on any given day. Admittedly, for much of my life I didn't know what the difference between shame and guilt was. In case you may be wondering what the difference is yourself, here's everyone's favorite researcher-storyteller-author when it comes to all things vulnerable (including shame and guilt), Brené Brown, addressing the topic in her "Listening to Shame" TED Talk:

> Shame is a focus on self, guilt is a focus on behavior. Shame is "I am bad." Guilt is "I did something bad." How many of you, if you did something that was hurtful to me, would be willing to say, "I'm sorry. I made a mistake"? How many of you would be willing to say that? Guilt: I'm sorry. I made a mistake. Shame: I'm sorry. I am a mistake.

When distinguished in this way, Brown makes it quite clear how negative an impact shame can have in our lives. Whereas guilt can help us learn and grow from our mistakes, shame leads to all kinds of negative and skewed beliefs about ourselves, such as "I am a mistake." If you're reading these words right now and that sentiment resonates with any sense of truth, please know that *you are not a mistake.* Not only are *you not* a mistake, but *you are* worth every ounce of love, kindness, compassion, and good thing

this life has to offer just as much as anyone else—regardless of what anyone may have told you in the past or, perhaps, is even telling you currently (which, if so, says way more about them than it ever could about you—believe me).

Switching gears to Stephen King's classic novel *Carrie*, we're introduced to Carrie White, who, aside from the extreme bullying and abuse she receives from her classmates, also lives with a mother that is just as abusive (if not more), as well as fanatically religious. If only Carrie had access to the teachings of people like John Bradshaw and Brené Brown, all the pyro-crazed chaos she released upon her classmates and faculty could have possibly been avoided. That said, I find it best practice to use the rest of this chapter exploring shame-based thinking.

John Bradshaw breaks down shame-based distorted thinking into categories: catastrophizing, mind reading, personalization, overgeneralization, either/or thinking, being right, "should thinking," control thinking fallacies, cognitive deficiency or filtering, blaming, and global thinking. So let's explore each of these in greater detail.

Examples of **catastrophizing:**

1. When a spouse acts slightly frustrated, you think they are incredibly angry at you and that they will remain so for a long time, that there is nothing you can do about it, and it will lead to divorce. Reality: What is the actual percentage chance of this happening?

2. You hear a creek in your house while in bed at night and think it's the Babadook coming to kill you. Reality: Again, what is the actual percentage chance of this happening to you?

Examples of **mind reading:**

1. When someone doesn't talk to you, you think they are mad at you. Reality: Maybe they're overwhelmed or dealing with something difficult in their life. Gather evidence about what is really happening.

2. Your friend hasn't returned your text in a while, so you think they're either mad at you or perhaps have been slashed to pieces by Ghostface. Reality: They're probably just busy or maybe the battery in their phone died and it's charging. Or, fine, maybe they were hacked to pieces by Ghostface but most likely not.

Examples of **personalization:**

1. When someone constantly states that they're sick and tired, you think they're sick and tired of you. Reality: If another person is saying or doing something, assume it's about them and not you.

2. You're in the park and notice someone in the distance looking in your direction and automatically think they're planning on murdering you. Reality: Chances are that the individual is just admiring the beauty of nature—the trees, flowers, birds, and all that rad shit . . . unless your name is Laurie Strode, in which case, you're screwed.

Examples of **overgeneralization:**

1. When one thing about your relationship is a problem, you think the entire relationship is a problem. Reality: What is the evidence that supports your conclusion, and what is the evidence that doesn't support your conclusion?

2. When one thing about your relationship is a problem, like, your significant other asks you to read *Necronomicon* because it's their favorite book, you think the entire relationship is a

problem. Reality: Again, what evidence supports this conclusion, and what evidence does not?

Examples of **either/or thinking:**

1. Either a person is perfect, or the person is worthless. Counter: About 5 percent of the time I'm selfish, but the rest of the time I'm loving and generous.

2. Rob Zombie's *Halloween* remakes were great, or they were trash. Counter: Both parts one and two had their pros and cons. (*Note: I personally loved each of them, especially part two—yeah, I said it.)

Examples of **being right:**

1. If you think you're right, you're completely defensive about what you do, but if you can accept that you are human, you can just admit that it really doesn't matter whether you are right or wrong. Ask yourself: "What can I learn from the other person's point of view?"

2. Your classmate has an unnervingly clear vision of the plane you just boarded exploding during takeoff. You've always known this person to be of a completely sane and rational mind, but he swears he *knows* this is going to happen to the core of his bones. Ask yourself: What are the chances that my friend, who again, has always been completely sane and rational, may be right and his vision might come to fruition? Or you can just throw caution to the wind and take your chances.

Examples of **should thinking:**

1. This is the way things "should" be rather than this is what you want and fills your emotional needs. Think of the exceptions to the "rule" that you created.

2. You're a mother fixated on killing camp counselors because several years prior your child drowned at camp due to lack of counselor supervision. Instead, consider these counselors had nothing to do with it and get some therapy.

Examples of **control thinking fallacies:**

1. You think that someone outside you controls the way that you are. Reality: You need to take responsibility for your own emotions and let other people make their own choices.

2. "The power of Christ compels you." Reality: Take responsibility for your own emotions and don't try to shove your agenda down other's throats.

Examples of **cognitive deficiency or filtering:**

1. You are completely fixated on one bad thing and ignore the multitude of good things. Say to yourself, "This is distressing but not dangerous." Try to refocus your thinking on the things you have that are valuable to you.

2. Michael Myers's fixation on killing Laurie Strode. Sure, he killed a number of other people (and some dogs along the way), but had he not been so preoccupied with getting specifically to Laurie, his body count could have been so much higher. Skies could've been the limit, Michael . . . *skies*!

Examples of **blaming and global labeling:**

1. Blaming your unhappiness on other people. Have you honestly expressed how you feel to the other person?

2. You're a writer who caretakes a closed hotel for the winter with your wife and child. You slowly begin to lose your mind, and when your wife shows concern, out of insane annoyance you

tell her, "I'm not gonna hurt ya. I'm just gonna bash your brains in. I'm gonna bash 'em right the fuck in." I mean, shit, at least it's, um, honest?

Carrie White's existence was rooted in shame-based thinking, and what a miserable existence it was. As with all the other films covered in this book, herein lies another cautionary tale of a life run amok by letting things in our lives go unchecked and unexamined. Remember, shame tells us, "I am bad." Guilt tells us, "I did something bad." To live with the belief "I am bad" serves no other purpose than to divide us from the spectacularly magnificent being each of us is. "I did bad," on the other hand, can show us ways in which we've been unskillful in our lives and help us grow into becoming more aware and present beings.

The following steps are an exercise in coming back to ourselves with a spirit of gentleness, compassion, and the understanding that by default, we as humans are fallible; however, it's what we do with that fallibility that truly counts.

PRACTICE: Five Steps to Healing Toxic Shame

Toxic shame sucks but can be managed and new habits cultivated. You are absolutely worth every single good thing in this world just as much as anybody else—that's a fact. Now, here are a few ways you can begin working on healing from toxic shame:

1. **Talk about your shame:** Experiencing shame and suppressing it leaves us feeling disconnected and alone, but confiding in people we trust can significantly lessen this burden. Therapists, support groups, spiritual teachers, trusted

friends, whoever you feel comfortable getting vulnerable with will help significantly. This is easier said than done for most of us, especially my fellow introverts out there, but I promise it's doable. Just go at a pace that's comfortable for you and doesn't leave you feeling anxious or overwhelmed.

2. **Acknowledge and feel your thoughts in a nonjudgmental way:** It's so easy to believe our thoughts, especially self-negating ones, regardless of whether there's any rational proof to back them up or not. Working with the mindfulness practices provided throughout this book is a great place to start. Recognize the thought as just that, a thought. Don't get wrapped up in whatever story the mind wants to attach to it. It's just a thought. Acknowledge it, and gently let it go. Over time and with practice you'll see your awareness defaulting more toward the noting/releasing of thoughts rather than breathing life into them and causing unnecessary stress, fear, and anxiety in your life.

3. **Reframe your thoughts by turning them into something realistic and reaffirming:** Piggybacking off the previous step, as we become more aware of our self-negating, shame-based thinking, we can go a step further than noting/releasing our thoughts by using them as a way of compassionately reaffirming our humanness and that it's okay to not be perfect. An example of this, which happened to me earlier, was when I walked from my living room to my bedroom to grab a book. When I got to the bedroom, I forgot what I was going to grab and after racking my brain for a few seconds quietly said to myself, "You're a fucking

idiot." I walked back to the living room, sat on the couch, and caught myself in that "fucking idiot" mindset. Having worked with this practice of reframing for a while, I was able to relatively quickly catch this faulty belief and remind myself that I'm human and fallible and that's perfectly okay. So, instead of judging myself, I deferred to compassion, which shifted my mindset from one of judging to one of care and acceptance.

4. **Learn your triggers so you can either avoid them or learn to cope with them:** Being a recovering alcoholic who's experienced a number of relapses in their life, I've learned that for me, *anything* is a potential trigger. Is it raining out? "I should drink." Is it sunny out? "I should drink." Lost a job? "Time to drink." Got a promotion and raise. "Time to celebrate with a drink." In the twelve-step fellowships, which I think is also applicable to everyday life in general, triggers are categorized into three categories such as people, places, and things. So I invite you to explore those three areas of your life and take a rigorously honest look at whether there are in fact any people, places, and things that are not conducive to your overall well-being, contributing to toxic shame in your life.

5. **Practice self-compassion:** While self-compassion has already been touched on in these suggestions, I think it's worth further elaboration. Using self-love talk, which may feel inauthentic or awkward at first, can over time become something that feels organic, authentic, and refreshing. There's a saying, "Fake it till you make it," which I've never

really been a fan of, that is, until I started using it regarding positive self-talk and directly experienced the effectiveness of it. Why not give it a shot? What do you have to lose?

6. **Personal positive traits:** Another practice that may be difficult at first but with time does get easier is thinking about personal positive traits. Even if there's only one or two things you like about yourself, it's much more conducive to our well-being to think about that rather than shit on ourselves due to what we don't like (again, speaking from experience here). If you can't think of a single thing you like about yourself, ask a friend what they like about you, and try to work with that first. If you're not comfortable asking a friend, you can try to journal kindly about yourself as if you were journaling about a dear friend. If you were trying to lift your friend's spirits, what would you say to them? Explore how you might feel emotionally and mentally while telling them about all the various ways in which they're an amazing person, and then apply that—to the best of your ability—toward yourself as you write even just a couple of sentences about the positive qualities you embody.

Self-love and compassion can be exceptionally difficult to cultivate and work with, but as in the *Jaws* chapter, if you approach this in "bite-size pieces" you might just be pleasantly surprised. Truly, you're worth it.

ACKNOWLEDGMENTS

Chris Grosso:

Mom and Dad; Jay, Catie, Addie, and Ellie Grosso; Michele Martin; Preston Fassel; Ram Dass, Maharajji, the entire Be Here Now Podcasting Network, and the Love, Serve, Remember Foundation/Satsang; Ken Wilber, Corey DeVos, and the Integral community/family; Darcie Abbene, Lindsey Mach, and HCI/Simon & Schuster; Justin Mehl; Matt and Julie Winkley; Soluna Wellness: Antonion Hernandez and Emercelle Hernandez; Kelli Raymond; Desiree Serrano; Ric Scales; Jackie Ibañez; Sah D'Simone and Benjamin Decker; Rushford; Angie Palamara; Alicia Anop; Kim Kelly; Amy Scher; Eben Sterling; Noah Levine; Alice Peck; Lisa Braun Dubbels; Karie Winchester, James Winchester, Ava Winchester, Wyatt Winchester, Ian Winchester; Tim Singer and Deadguy; William Saunders and fourth.Media; Steve Austin and Today Is the Day; Chris DeBari; Norman Brannon; Nicole Gonzalez; Donny Crooks; Anthony Lacafta; MusicCares, Shireen Janti, Rip, Trevor, Lance Porter, and the "G" House; the staff at

Retreat (PA Location); Joi Honer; Ritch Grindel; Mark O'Connell; Dan Cortese and family; Jessica Pimentel and Tomas Haake; Alex and Allyson Grey; John Harris; Mirabai Bush; Raghu Markus; David Silver; Siobhan Edwards; Chris and Jenny Hinman; Audrey Ducas; Jamison Monroe; Katie Dawn Broach; Laci-Ann Mosher; Amy Hanks-Cornelious; David Skyler; Bree LeMasters; Alanna Kaivalya; Lissa Rankin; Jennifer Lui and Morgan Walker; Dawn Robertson; Silvia D'Adarrio; Neekól Mavi; Michael James; Cassie and Richie Neff; Amy Elizabeth; Greg "Doobie" Russell; Anne Jones; McCallister Detox Center/New; Charlotte Macera; Sheena Ruiz; the cities of Los Angeles and San Diego; Luis Romero and Fuck Fentanyl; Brittany Brooks; Michael Byrd; Adam Carmen; Brian Rizzo; the Way Back; Ralph Ramirez; Vince Garside; Aaron Vandarwarka; Jeff West; Jason Miller; Richard Freitas; James Lichter; Joe Sternberg; Anthony Simone; Tia Metcalf; Tony Manson; Craig Warren; Ölamy Massey; and Gregory Thomas and Ronnie Toms.

Preston Fassel:

As always, primary thanks goes to my wife, Kayleigh, my editor, soundboard, emotional support system, and soul mate. Without her, neither this book nor anything else I've ever written would've seen the light of day, and I'm eternally grateful.

Thanks, too, to my parents and brother, who still love me even though I write the stuff I do.

Thanks to my cat, Tiberius, who helped hold down the fort while I worked on this and kept the Texas springtime roaches at bay.

Very special thanks to my dear friend and colleague Dr. Erin Chernak, whose insight proved invaluable in the writing of this

book and who was always around to lend a supportive ear and new perspective whenever I ran up against a wall. Without her, I'd *still* be working on *The Thing* chapter.

A special shout-out to the psych professors who helped shape, mold, and guide me the most, in no particular order: Dr. Daniel Fox, Dr. T. C. Sim, Dr. Karen Buckman, and Dr. Kathleen Monahan.

Appreciation to my writing peers Jason Alvino, Mihael J. Seidlinger, Celso Hurtado, Zachary Ashford, Max Booth III, Katey Nelson, Amy Lou Ahava, Jon Abrams, Kevin Hoover, Mary Beth McAndrews, Sadie Hartmann, Izzy Lee, Grace Reynolds, Kevin Lucia, Richard Chizmar, Sean Duregger, Mark Alan Miller, Christian Francis, Janine Pipe, Rob Saucedo, Josh Millican, David Fitzgerald, and so many others for their wonderful support.

Grand appreciation to the staff of the Half Price Books flagship store in Dallas who graciously provided me sandwiches, seltzer water, and a quiet place to work. The bulk of this book was written there.

Special thanks to my attorney Paula Yost, who provided invaluable legal aid and advice as well as moral support.

Thanks to agents Michele Martin and Yfat Reiss Gendell, who respectively soldiered this through to completion and provided me wisdom and guidance on this and future work.

Thanks to the usual suspects: Jessie and Shay Hobson, Cory Brown, Bradley-Steele Harding, and Dan Gremminger, and "Mad" Ron Roccia. Love to y'all.

NOTES

Chapter 2: Taking a Chain Saw to the Unnecessary Masks We Wear

1. Gunnar Hansen, director, *The Texas Chainsaw Massacre: 2 Two Disc Ultimate Collection*, Dark Sky Films, 2006.
2. Tobe Hooper, director, *The Texas Chainsaw Massacre: 2 Two Disc Ultimate Collection*, Dark Sky Films, 2006.
3. David Cronenberg and Chris Rodley (ed.), *Cronenberg on Cronenberg* (London, UK: Faber and Faber, 1997).

Chapter 4: The Power of Christ Compels Us to Explore Spirituality and Religion

1. Max Planck, "Das Wesen Der Materie" ("The Nature of Matter"), Lecture, Florence, Italy, January 1, 1944.

Chapter 7: Letting Ourselves (and Others) off the Hook

1. Tara Brach, "Where Does It Hurt? Healing the Wounds of Severed Belonging," Tarabrach.com, February 26, 2017, https://www.tarabrach.com/hurt-healing-wounds-severed-belonging/
2. Ibid.

3. Ibid.

4. Toni J. D. Bernhard, "How to Live Compassionately: Forgive Yourself, Forgive Others," *Psychology Today*, January 5, 2016, https://www.psychologytoday.com/us/blog/turning-straw -gold/201601/how-live-compassionately-forgive-yourself -forgive-others?amp.

5. Mayo Clinic Staff, "Forgiveness: Letting Go of Grudges and Bitterness," Mayo Clinic, January 26, 2022, https://www.mayoclinic .org/healthy-lifestyle/adult-health/in-depth/forgiveness/art -20047692.

Chapter 8: The Guts of What Really Going with the Flow Looks Like

1. Hal Williamson and Sharon Eakes, "The Science of Change: Working with—Not Against—Our Inner Systems," The System Thinker, January 1, 2006, https://thesystemsthinker.com/ the-science-of-changeworking-with-not-against-our-inner -systems/.

2. H. G. Moeller, "Taoism," Science Direct, January 1, 2012, https://www.sciencedirect.com/topics/social-sciences/taoism.

3. Colin MacRae, "13 Principles for Practicing Taoism," Mindful Stoic, December 6, 2020, https://mindfulstoic.net/13 -principles-for-practicing-taoism/.

Chapter 9: Strangers in a Strange Land (and Learning to Make Our Way)

1. Elizabeth Yuko, "This Is What It Looks Like to Set Healthy Boundaries," *Real Simple,* March 1, 2023, https://www .realsimple.com/health/mind-mood/emotional-health/how

-to-set-boundaries.

2. Chantelle Pattemore, "10 Ways to Build and Preserve Better Boundaries," *Psych Central,* June 3, 2021, https://psychcentral .com/lib/10-way-to-build-and-preserve-better-boundaries #what-are-boundaries.

3. Ibid.

Chapter 10: The Hell That Is Life Lived Without Gratitude

1. Abhimanyu Das and Charlie Jane Anders, "All the Weirdest Secrets You Never Knew About Clive Barker's Hellraiser," Gizmodo, October 24, 2014, https://gizmodo.com/all-the-weirdest -secrets-you-never-knew-about-clive-bar-1650487166.

Chapter 12: The Blackest Eyes, the Devil's Eyes, and Carl Jung's Shadow Self

1. Diane M. Hamilton, "The 3-2-1 Shadow Process," Integral Life, January 1, 2023, https://integrallife.com/the-3-2-1-shadow -process/.

About the Authors

Preston Fassel is an award-winning novelist and journalist whose work has appeared in *Fangoria, Rue Morgue,* and *Screem Magazine.* His debut novel, *Our Lady of the Inferno,* and debut novella, *The Despicable Fantasies of Quentin Sergenov,* won the Independent Publisher's Gold Medal for Horror in 2019 and 2022, respectively. His debut nonfiction book, *Landis: The Story of a Real Man on 42nd Street,* the first published biography of film critic and magazine founder Bill Landis, was nominated for the 2022 Rondo Hatton Award for Book of the Year. His second novel, *Beasts of 42nd Street,* was published in March 2023. He graduated cum laude from Sam Houston State University in 2011 with a BS in psychology.

Chris Grosso is an artist, counselor, writer, and film producer with Fourth Media. He is also the development manager for Soluna Wellness, an outpatient mental health facility located in Hillcrest, San Diego. Chris is the author of *Indie Spiritualist, Everything Mind, Dead Set on Living,* and the children's book *I Love Drums* (cowritten with Mark O'Connell, drummer of Taking Back Sunday). You can usually find Chris in San Diego up to some kind of spirited mischief. You've been warned.